DESERT WATER

by Graphic Arts Books

HannoArt

Sappi offers HannoArt using a special triple coating process that produces an exceptionally smooth, uniform surface, providing distinctive print results every time. The result is an amazingly even ink lay that can hold crisp details and equally impressive dense solids. HannoArt provides a clean, European, high, bright blue-white shade—perfect for four-color process and precise color reproduction. For your convenience, HannoArt is readily available throughout North America and Eastern Canada. Its wide range of basis weights, along with its complimentary gloss and silk finishes, make HannoArt ideal for annual reports, brochures, catalogs, posters, direct mailers, and advertising inserts.

Book Production Notes:

Printed on HannoArt Gloss Text 100# and HannoArt Silk Text 100#.

The digital pre-press, image setting, and color proofing were done by Haagen Printing, Santa Barbara, CA., with CREO Brisque Impose w/ScenicSoft Preps Imposition Software and CREO TrendSetter Spectrum Platesetter/Proofsetter with DuPont Thermal WaterProof®.

The book was printed in four colors on a Heidelberg 102 Speedmaster 5-color w/aqueous coater (28" x 40") at Haagen Printing. Haagen's Heidelberg Speedmaster Press is equipped with the Delta® Dampening System from EPIC® Products.

The edition binding was done at Lincoln & Allen Co. in Portland, OR. Signatures were smythe sewn on a Muelle machine and bound on a Kolbus Kompact 2000 edition binding line.

sappi

sappi Paper Samples

Desert Water

HannoArt Gloss Text 100lb/148 gsm

Printer: Cenveo/Graphic Arts Center

COM-6105

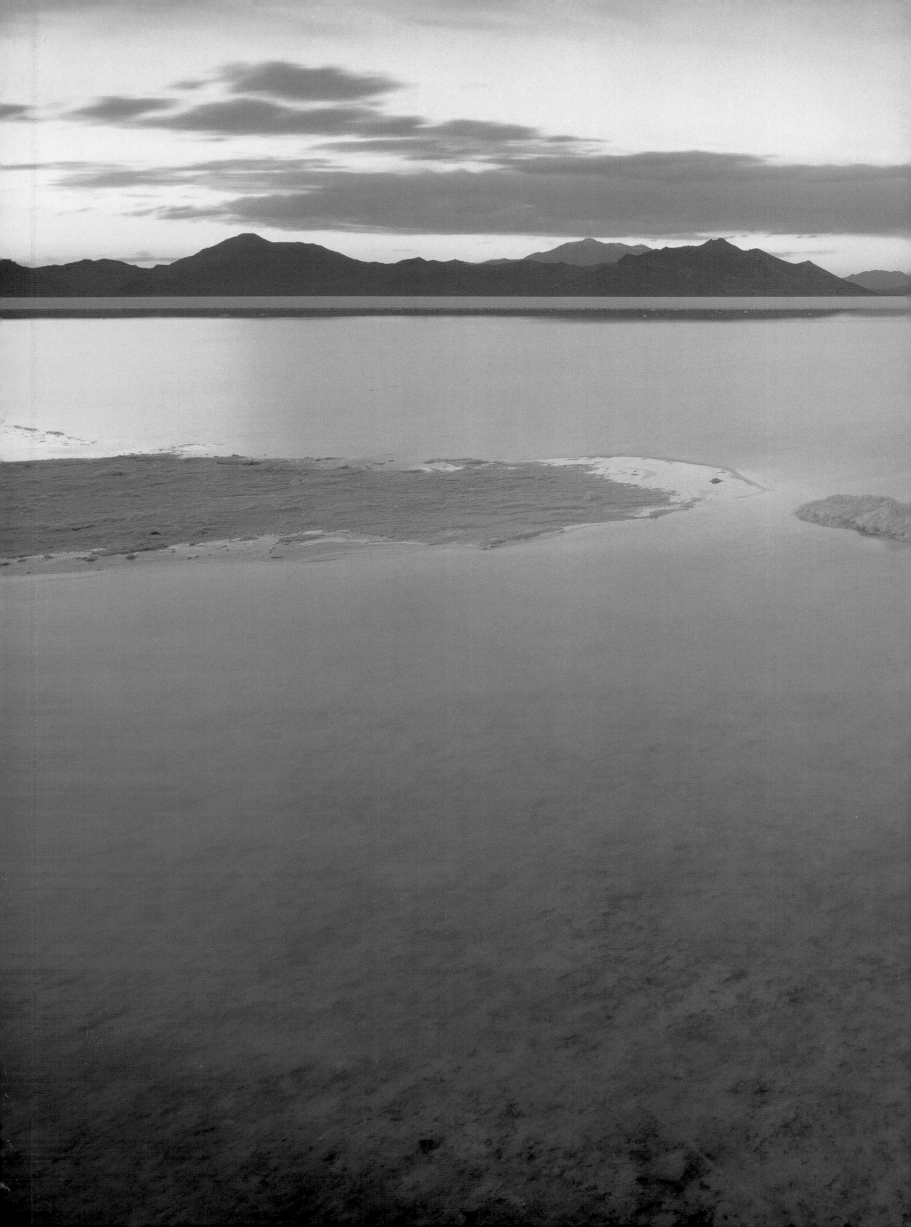

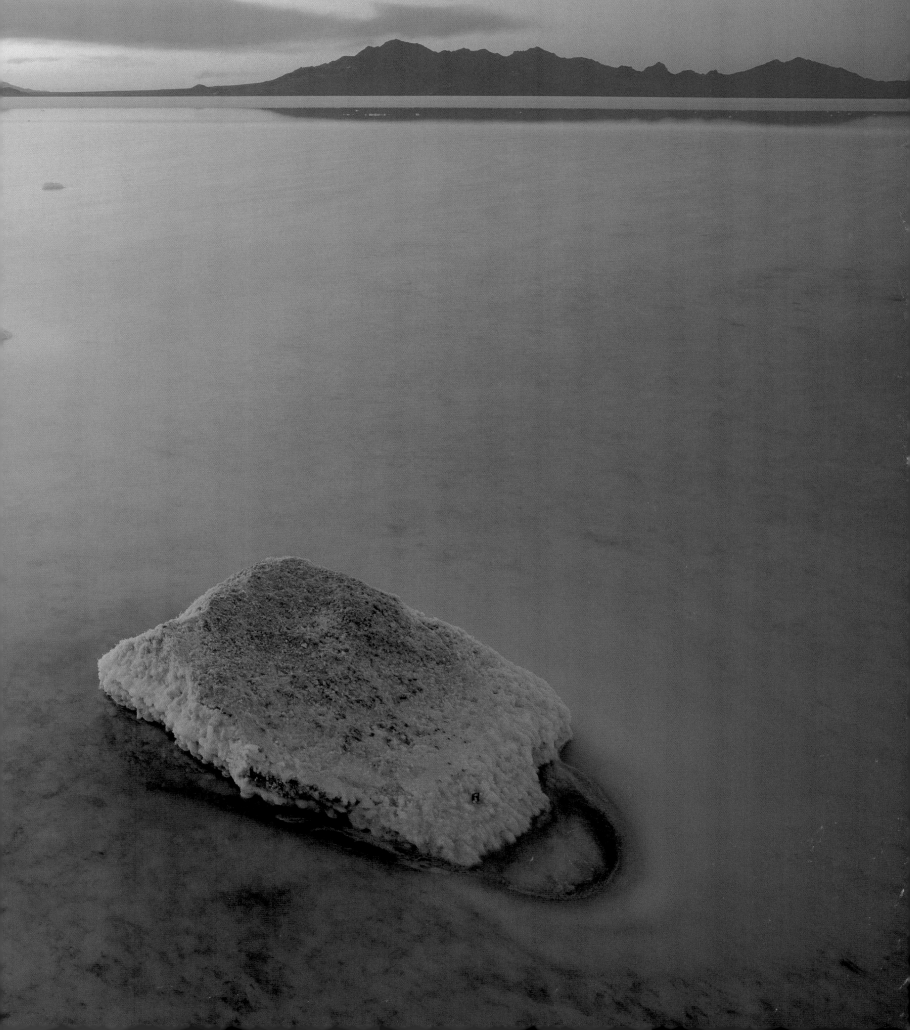

DESERT
WATER

Photography by Mark Lisk Essay by William Fox

Library of Congress Cataloging-in-Publication Data
Lisk, Mark W.
Desert water / Photography by Mark Lisk ; Essay by William Fox.
p. cm.
ISBN 1-55868-858-7 (hardbound)
1. Landscape photography —West (U.S.) 2. Deserts —West
(U.S.) — Pictorial works. 3. Photography of water —West (U.S.)
I. Fox, William L., 1949- II. Title.
TR660.5.L77 2005
779'.3678'092 —dc22 2004012037

Graphic Arts Books
An imprint of Graphic Arts Center Publishing Company
P.O. Box 10306, Portland, Oregon 97296-0306
503/226-2402
www.gacpc.com

PRESIDENT Charles M. Hopkins
ASSOCIATE PUBLISHER Douglas A. Pfeiffer
EDITORIAL STAFF Timothy W. Frew, Tricia Brown,
Kathy Howard, Jean Andrews, Jean Bond-Slaughter
PRODUCTION STAFF Richard L. Owsiany, Heather Doornink, Vicki Knapton
DESIGNER Mary W. Velgos
EDITOR David Abel
DIGITAL PRE-PRESS Haagen Printing
PRINTER Haagen Printing
BOOK MANUFACTURING Lincoln & Allen Co.

Printed and bound in the United States of America

(PAGES 1 AND 7) Windblown patterns in the sand at Bruneau Dunes State Park, southwestern Idaho, are interrupted by a tenacious plant.

(PAGES 2-3) A salt-encrusted rock rests on the flat surface of the Bonneville Salt Flats, Utah. The 30,000-square-acre playa, or intermittently dry lake, floods every winter then dries out each summer, when it becomes a favored site for amateur rocketry clubs, professional land speed trials, and car commercials.

(PAGE 5) The Snake River cuts through basalt cliffs just below Shoshone Falls, Idaho.

(PAGE 6) Pale orange and blue reflections highlight patterns created by silt deposits of the San Juan River in southern Utah.

(PAGES 8-9) The Colorado River, 470 feet below, is viewed from the Navajo Bridge in Marble Canyon, Arizona. The bridge stands at the upper end of Grand Canyon National Park, and the next crossing of the river is 600 miles away.

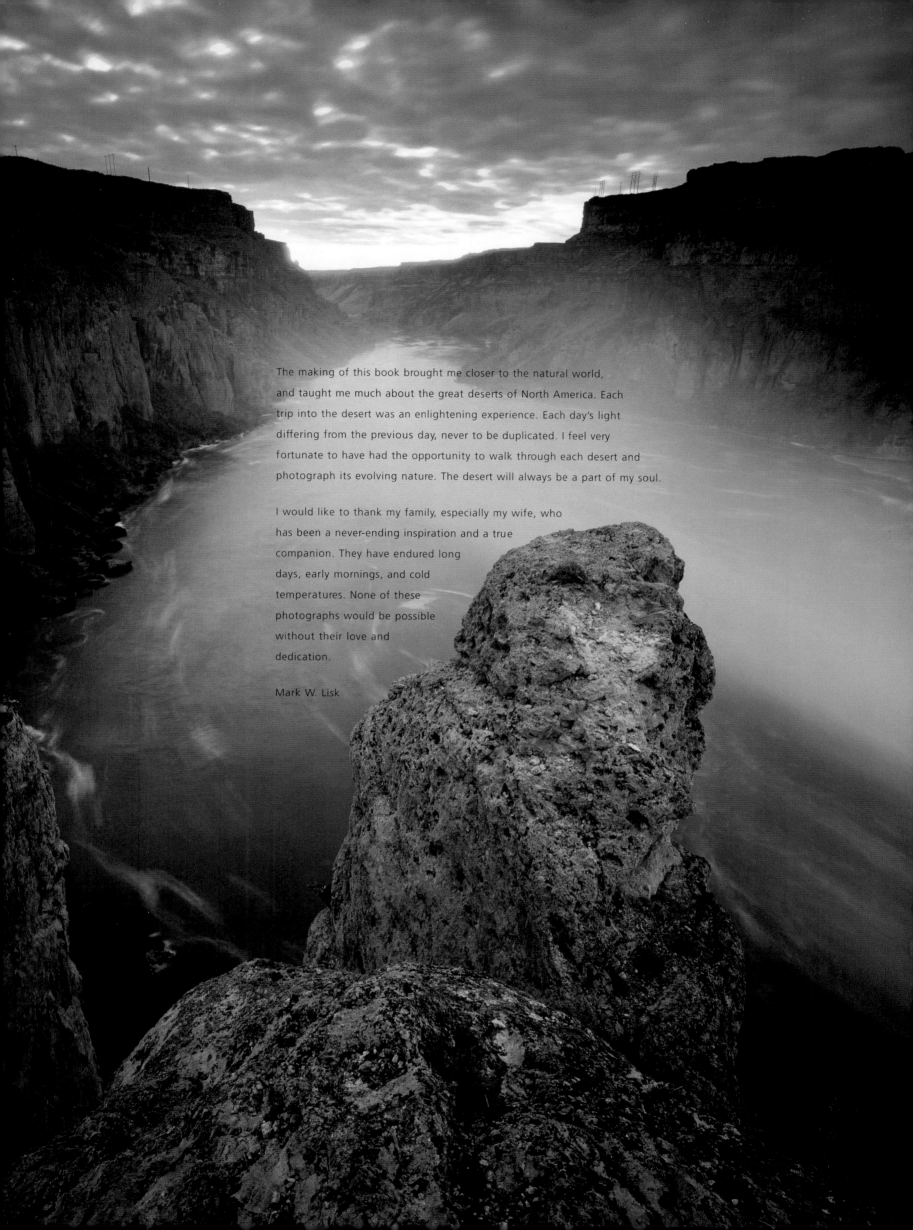

The making of this book brought me closer to the natural world, and taught me much about the great deserts of North America. Each trip into the desert was an enlightening experience. Each day's light differing from the previous day, never to be duplicated. I feel very fortunate to have had the opportunity to walk through each desert and photograph its evolving nature. The desert will always be a part of my soul.

I would like to thank my family, especially my wife, who has been a never-ending inspiration and a true companion. They have endured long days, early mornings, and cold temperatures. None of these photographs would be possible without their love and dedication.

Mark W. Lisk

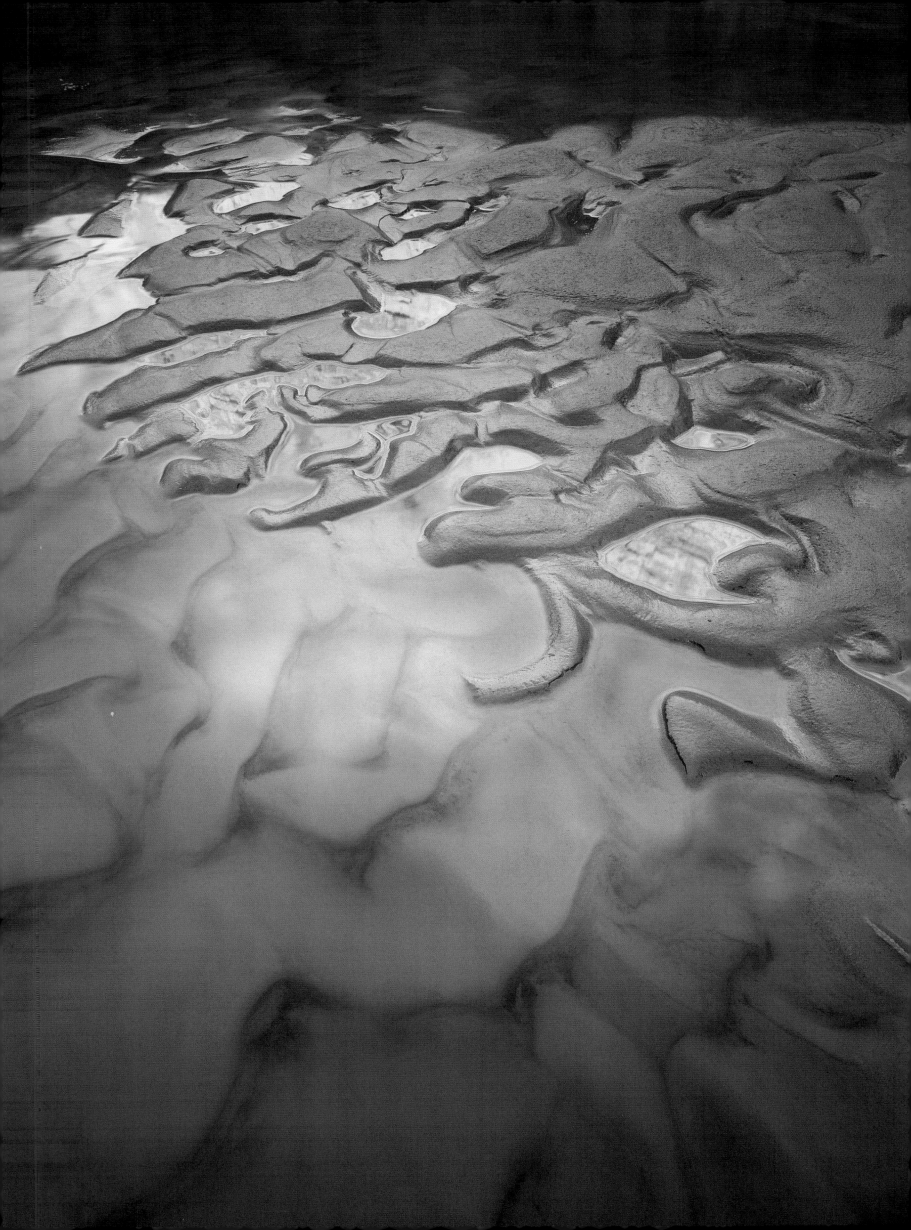

DESERT
WATER

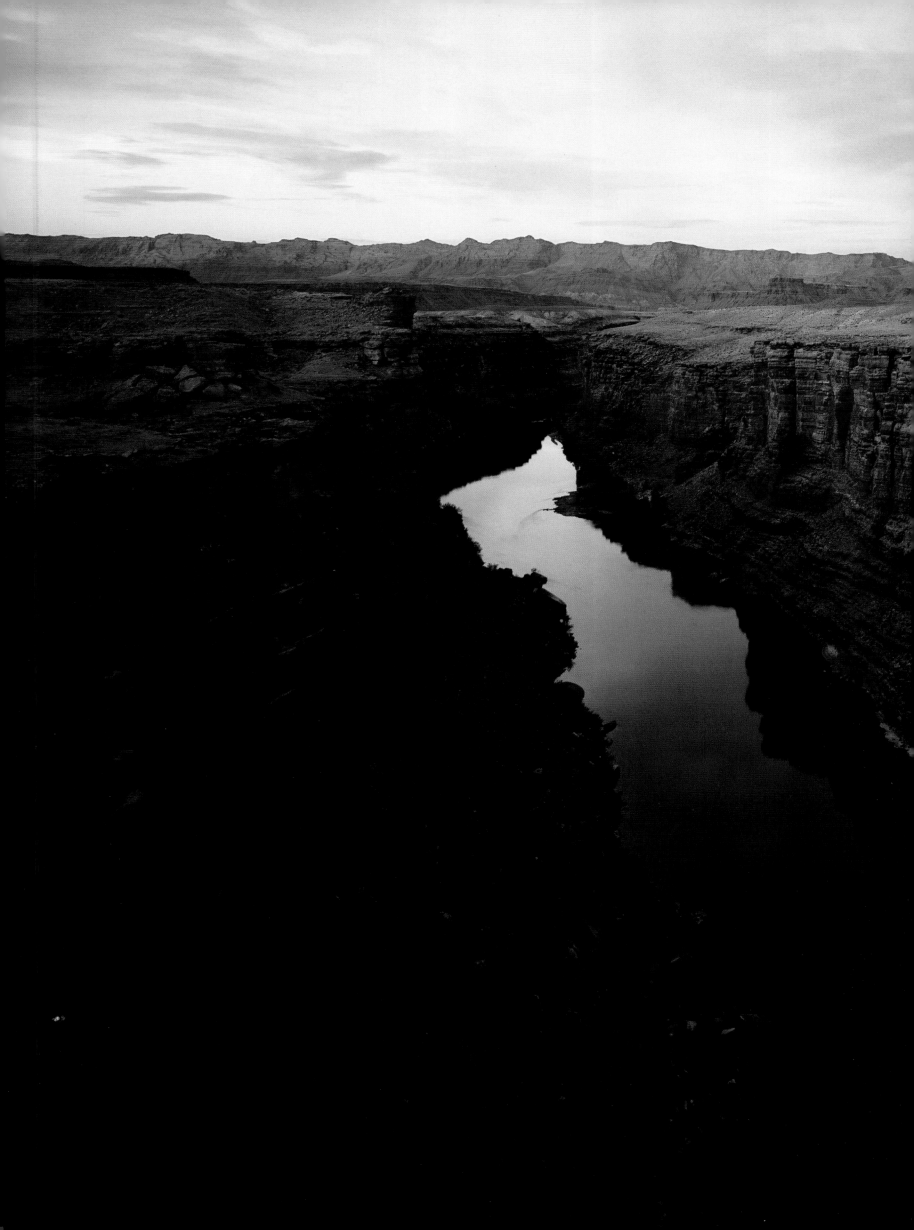

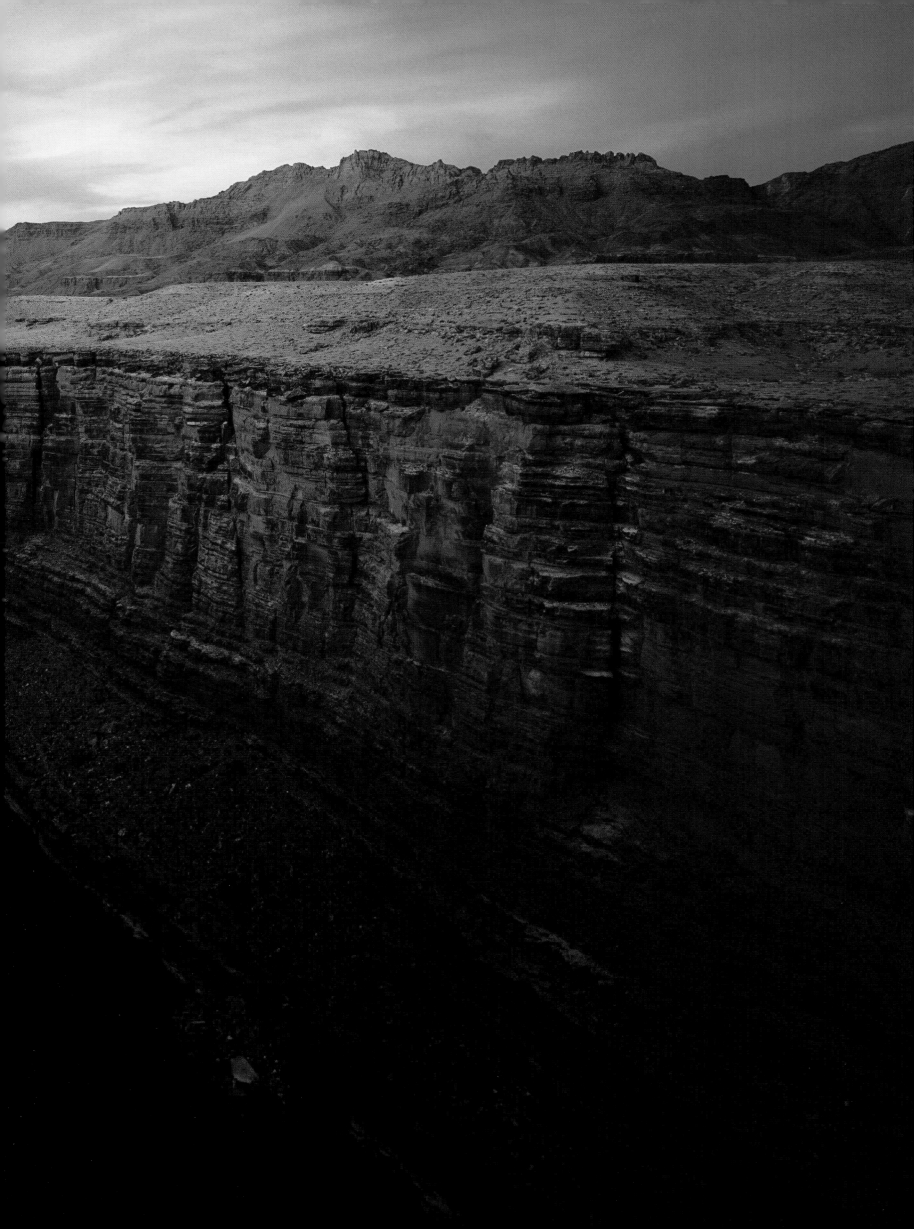

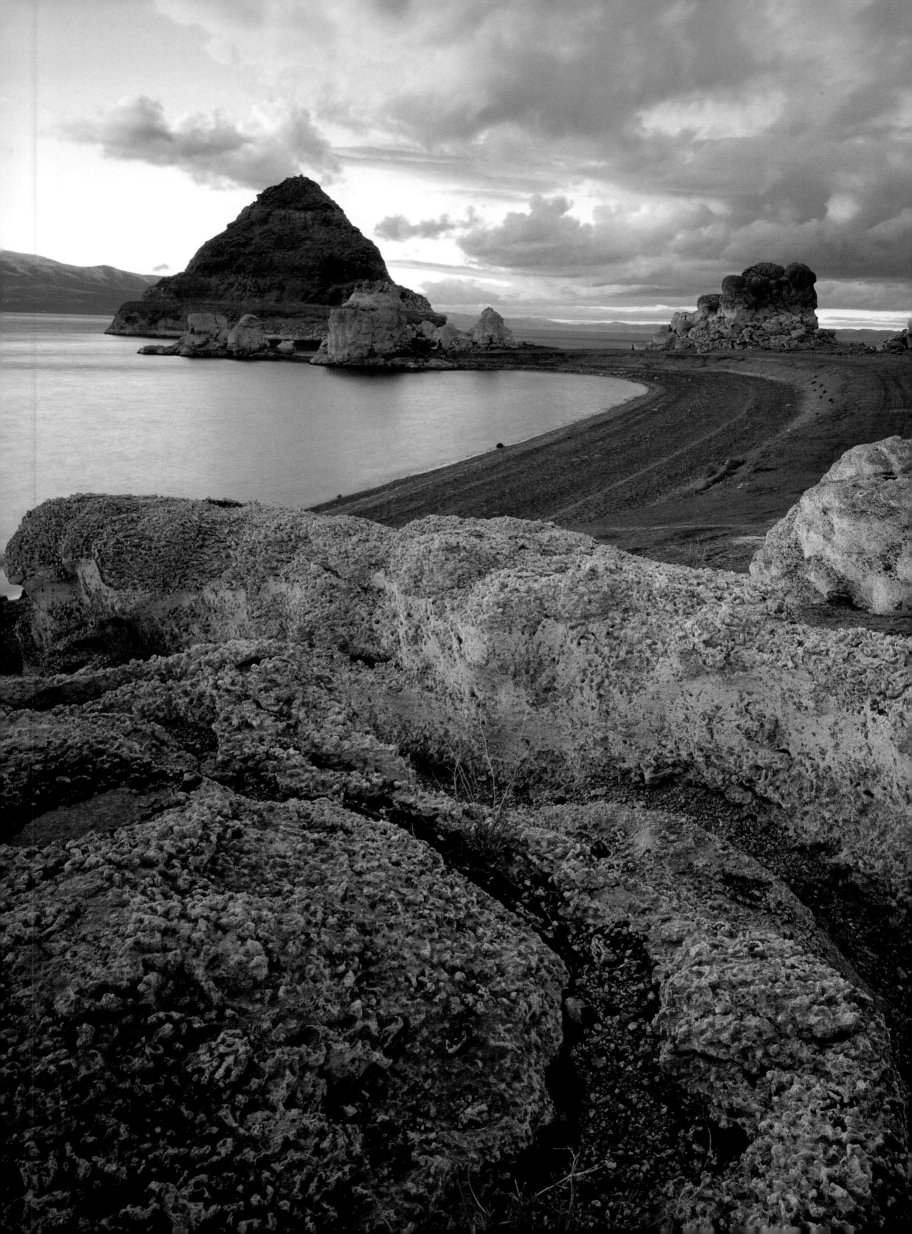

SPRING

DESERT
WATER

THE PINNACLES OF WELDED TUFF IN SOUTH CENTRAL

Nevada are soft formations, volcanic ash glued together with heat and pressure, outcroppings in a layer of geological time that covers millions of square acres. Their individual surfaces oxidize over millennia in the desert sun, covering the rock with a rich, almost leathery desert varnish. Scratch the dark patina and you reveal the light-colored rock underneath, an effective drawing method. Between 4,000 and 1,500 years ago the people who lived in these arid lands incised anthropomorphic figures into the rocks, petroglyphs that anthropologists call Pahranagat figures. Their alien-like rectangular bodies are blocky and sometimes richly patterned, and often feature antenna on top of their heads. The one in front of me has its arms akimbo and gaze fixed out over a dry wash to the north.

I walk around to the opposite side of the fifteen-foot-high pinnacle looking for a way up. Scientists sometimes try to interpret rock art as an interlocking series of self-referential symbols, or as shamanistic devices. Alvin McLane, the leading surveyor of Great Basin rock art, has convinced me otherwise through years together in the field. "Look for context," he commands. And I do. Scrambling up to the top of the

Low water reveals unique tufa formations at Pyramid Lake on the Paiute Indian Reservation north of Reno, Nevada. Tufa was once thought to be the remnant of an organic, coral-like encrustation, but is actually a massive form of calcium carbonate deposited when freshwater springs well up underwater in the salty lake.

outcrop, I spot a thin flat rock the size of a serving platter. I crouch to move it aside and find a *tinaja*, a shallow basin eroded by wind and weather. It has not rained here in weeks, but the *tinaja* (Spanish for a large earthenware jar) is filled with clear water. Pahranagat figures almost always appear underneath water, or are looking at it. They may have other symbolic functions, but one thing is certain—they are often associated with what is the single most important context for desert life: water.

Water pockets. Potholes. Tanks. *Tinajas.* All are names for depressions hollowed out of rock by water, some by the circular scouring of sand in a river, others by chemical and physical weathering as water infiltrates tiny seams and pries apart the rock. Pockets can be small and hold only a sinkful of water; or, they can be deep enough to dive into and contain the volume of an Olympic-sized swimming pool. I dip my fingers into the two or three gallons held here. Despite the midday heat, the water is cool.

Eastward from my perch run the White River Narrows, a valley where surface waters no longer flow, but underneath which a huge river of artesian water runs southward into the Colorado River Basin. The narrows pass here through a transitional desert; its biotic community makes it part of that highest and coldest of the five North American deserts, the Great Basin, but that underground flow connects it to the Mojave, the lowest, and hottest of the group. Deserts are defined as regions where more water is lost annually through evapotranspiration—evaporation from soil and plants—than received through precipitation. A third of the world's landmass is desert or semidesert, which includes much of the American West, where precipitation averages less than twenty inches annually and frequent winds carry away much of the moisture. The five actual deserts of the West tend to receive less than half that.

Twelve great hot desert regions exist in the world, scattered on all the continents save Europe and the Antarctic (the latter itself being a cold desert that receives an average of less than three inches of precipitation per year). Most of the hot deserts are found within a belt between the Tropics of Cancer and Capricorn, which is to say within a few degrees of the Equator, where the atmosphere is most heated and thus least able to hold moisture. The largest desert in the world is the Sahara, which covers more than two million square miles. The Mojave, at only 25,000 square miles, is one of the smallest. The desert region of the American West is bound on the east by the Rocky Mountains and on the west by the Sierra Nevada and totals a not inconsiderable 500,000 square miles.

The Great Basin is the largest of the North American deserts, covering approximately 200,000 square miles, and includes most of Nevada, much of western Utah, and parts of southern Oregon and Idaho. The Mojave sits to its south, and includes Las Vegas, Death Valley, and most of San Bernardino County. To the south and east is the Sonoran, a subtropical desert with the greatest biodiversity of the four. Even farther south and east, and lying mostly in Mexico, is the Chihuahuan, a 175,000-square-mile maze of badlands, dry riverbeds, and vegetation so fiercely spiked that it shreds even leather chaps.

The Colorado Plateau is more properly an arid region than a desert proper, given that it receives more than ten inches of rainfall per year, but it is a geophysical province that includes landscapes such as the red rock terrain of Utah and the tiny Painted Desert of Arizona, and shares hydrology and biota with parts of the Great Basin and Sonoran Deserts. Despite its features overlapping with the other deserts, many of us count it as the fifth one within the United States.

Unlike most of the other desert regions in the world, which tend to lie atop huge horizontal bedrock plains, our five sit within a series of depressed basins and eroded plateaus, which is why we have both Death Valley and the Grand Canyon. Temperatures in the Great Basin can drop to less than −30°F, but the ground surface of Death Valley can soar to 190°F. What binds together a region as variable in its climate as the desert West is its severe aridity.

Most of the desert lands in North America are relatively young, dating from 8,000 to 10,000 years ago, when global temperatures warmed, the glaciers of the Pleistocene retreated, and much of the water in the West dried up. Nevada and Utah were once mostly covered with shallow lakes, of which Pyramid Lake north of Reno and the Great Salt Lake are the largest remnants. Using a canoe during the Pleistocene, and with only a few portages, you could have paddled from Reno in the west to Salt Lake City in the east, a distance of 520 miles by interstate freeway. Now, most of the desert West receives less than ten inches of rain annually. Here in the White River Narrows the yearly precipitation is perhaps three to six inches per year.

Looking around me, I can see individual tree branches on the summit of Mt. Irish more than three

Fresh water gathers in the Willow Tanks of the Waterpocket Fold in Capitol Reef National Park, Utah. The 100-mile-long fold, a warp in the earth's crust exposed by erosion 15 to 20 million years ago, holds countless such basins eroded out of the sandstone.

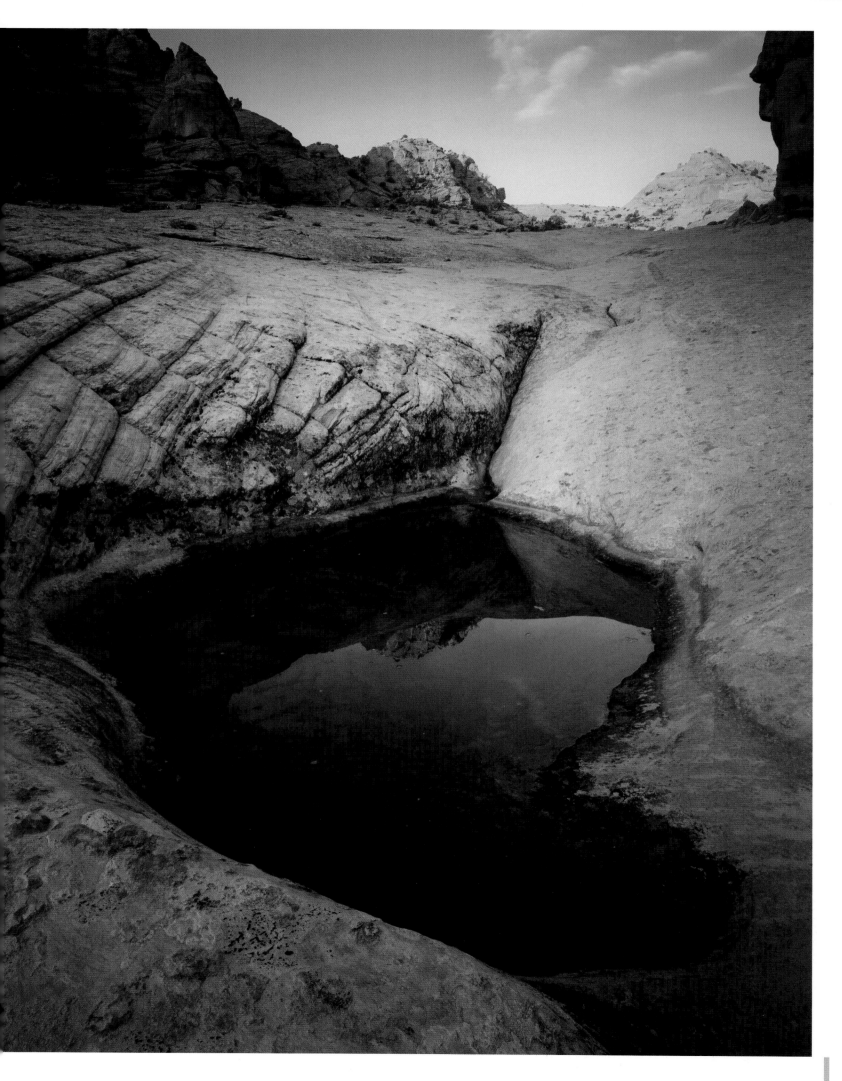

miles away. The air is dry and crystalline, the ground sparsely populated by a piñon-juniper woodland. To the east it's even more arid and the bare bones of the land are exposed. The underlying tectonic forces, as well as the volcanic and sedimentary history of the basin-and-range region are evident here in upthrust peaks and eroded cliffs, but it's not only geology that's visible. Look carefully enough, and you can also discern layers of the human mind. People often ask: what good are deserts? Humans have already inhabited or visibly affected 83 percent of the land on Earth. It would seem wise to preserve a few places where the process of our own cognition is open for inspection, and none better than where water meets desert. The Pahranagat figure serves to beckon thirsty travelers who are alert to their presence. I bend my head to the *tinaja* and drink. My reflection stares back at me. Rock and water, I think, the archetypal elements of the desert.

Water is ubiquitous in the universe. Molecules of it drift through interstellar space, clump into the snowballs we call comets, and pool as ice in craters at the south poles of the Moon and Mars. Liquid water is found under the frozen shell of Europa, a moon of Jupiter, and as a gas even in those cooler regions of the Sun that we identify as sunspots. It is, however, rare to find it covering a planet in its liquid form. On Earth it throws a blue blanket over 70 percent of the planet's surface, and it comprises a like percentage of the human body. Its molecules hinge together so that water flows over any surface and yet seeks to maintain contact with itself. It displays a surface tension that maintains individual raindrops on your windshield, but once touching one another, immediately merge into a sheet. A universal solvent, it enables your body to cast out the waste byproducts of hiking in the desert, such as lactic acid, but also erodes the very rocks you tread.

It is somewhat of an anomaly that human beings even live on land and not in the water. As the British scientist and writer Philip Ball points out in *Life's Matrix: A Biography of Water*, life has existed in the waters of Earth for as long as 3.8 billion years, but only crawled up onto land within the last 450 million or so. Deserts are places we define as absent of life to varying degrees precisely because they are at the opposite end of that hydrological spectrum, and their inhabitants remind us of how dependent on water we are.

Desert plants and animals spread themselves out in space and time much more than in temperate climes. Individual creosote bushes, the most ubiquitous of shrubs in the American desert region, are evergreens

that not only have deep root systems enabling them to survive for up to two years without rain, but also exude a toxin to prevent other plants from growing underneath them, thus eliminating competition for water. Growing in ever-widening rings of clones, the oldest known specimen is 11,500 years old, a Mojave resident that is one of the most ancient living things on the planet.

Most desert insects and animals burrow underground by day and come out at night in order to escape the heat and preserve their bodily fluids. The tiny prehistoric shrimp that live in waterpockets can crystallize their tissues for centuries in order to wait for the next available pool of water to form. All the adaptations of desert wildlife center around or are connected to surviving aridity, and taking advantage of water when it is available. Part of the adaptation is in containing population sizes to what that water can support.

Deserts are likewise places that humans tend to desert; when given a chance, most of us traverse them as quickly as we can to get somewhere else more temperate. Before the advent of air-conditioning in automobiles, most people suffered the drive across Utah, Nevada, and Arizona only in order to reach California, and it was a drive often done at night in order to avoid the daytime heat. There are always people who find a kinship with the desert landscape, and who deliberately seek it out in its most extreme manifestations—desert rats, we still call them—but unlike the sagebrush and the saguaro, we're not well adapted as a species to the desert.

The branch of primates from which we evolved lived in a temperate climate and consisted of forest creatures not at all suited to functioning in a desert. When primates came down from the trees and out of the forest, they foraged in a relatively well-watered savanna of trees, grasslands, and waterholes. It was a landscape in which they could locate food and water, and find protection. They could scale the length of their arms and legs—their limbs—to those of the trees. They knew how far things were and how close, thus how long it would take to cross open ground until they reached the next tree and concealment—or, if necessary, how long to climb it.

We developed a visual schematic that enabled us to survive on the savanna, a predilection for what some anthropologists define as a "conceal-and-reveal" landscape. Trees in the foreground formed a frame behind which we could hide while observing what lay on the other side. Often our ancestors were watching the activity around a waterhole near which they lived—water and the game animals that visited it were

both crucial to sustaining life. In the background the atmosphere thickened into the distant hills.

The lack of water in a desert means that there are often no trees behind which to hide, and none in the midground—that space in the landscape between what we see at our feet in the foreground and those mountains in the far background. Without such predictable vertical marks in view, we have trouble understanding our scale in the landscape. We don't know how far away things are—how long it will take us to reach the other side of what is visible, or where it is safe. And that is to fall prey to the environment and whatever prowls it that's higher on the food chain than we are. Deserts could not have been places where most of our ancestors felt secure. Even then they would have been places to cross as quickly as possible.

It's not simply the lack of water on the ground that constrains us in the desert, but its absence from the air, as well. Look into the distance over a landscape that

receives more than ten inches of rain a year, and chances are there will be enough moisture in the air so that objects within a mile or two will begin to turn hazy and a bit blue in the distance. This atmospheric perspective, caused by the scattering of light in the atmosphere as it bounces off water molecules, thus shifting colors from the red toward the blue end of the spectrum, is a measurement humans commonly understand. In the desert, not only is the ground relatively free of vegetation, but the air is dry. The ridgelines of mountains twenty miles away remain sharply etched and brown. We take that to mean they are closer than they really are.

Without water and vegetation around us, we lack the safety of perspective and scale, and often feel insecure. If you look out your living room window (a deliberately constructed frame taking the place of foliage) and see a lawn outside planted with trees that are being watered, you're looking at a re-creation of

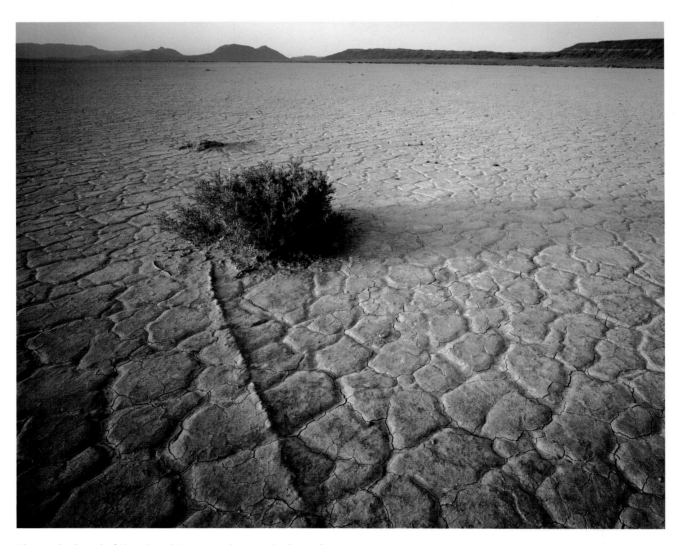

The cracked mud of the Alvord Desert, a playa at the foot of Steens Mountain in southeast Oregon, forms an interlocking pattern of polygons. The cracks are formed by desiccation, and are nature's most efficient way of relieving stress on a flat surface.

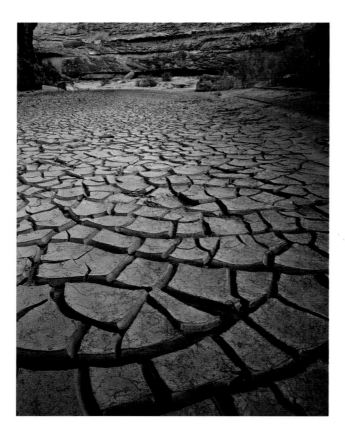

The cracked bottom of Oljeto Wash follows a familiar pattern. The wash, a popular camping spot for river runners on the San Juan River below Mexican Hat, is part of the Monument Valley drainage.

our species' most favored view. And, in fact, if you survey people around the world about what kind of paintings they prefer, even for the inhabitants of arid climates, you'll find that most like best those landscapes with a frame of dark foliage in front, a water feature lit up in the midground (preferably with people near it), and mountains fading into the background.

Then there's the issue of how we encounter temperature in the desert. "It's a dry heat" we say of Las Vegas and Phoenix, and other cities in the American Southwest. "It doesn't feel as hot as it does in Houston or Honolulu," where there's more humidity in the air. When we step out of the car on that vacation drive through Death Valley National Park, our sweat evaporates almost instantly, so we don't perceive the effects of the heat. Couple the lack of felt perspiration with the missing visual clues about scale and distance, and what you get are people wandering away from their cars without a water bottle or hat to visit what appear to be the nearby hills. Rangers routinely rescue people from such misadventures every week in the park during the summer, and sometimes people die having strayed too far from the safety of their vehicles.

Our perceptions of the desert and how we act in it, therefore, are based primarily on the absence or presence of water, and when we stumble across it, we are curious, awed, joyful. We know our lives have been saved, at least metaphorically if not literally. When we find water in the desert, it mystifies and delights us, whether it is an oasis at the foot of sand dunes in the Gobi of Mongolia, or water pockets in the red rock country of Utah. Besides drinking it, we smile and take pictures of it, take off our clothes and swim in it, and sometimes simply sit quietly beside it and meditate, as I am doing this spring morning next to the *tinaja*. It's when doing so that we can see the great paradox of the desert: that it is dry, but utterly shaped by water. As is often remarked by dwellers in arid lands, there are two ways the desert can kill you, by thirst or by drowning.

The water beside me has taken up residence in the rock. It is still and reflects the place it has made for itself with its partner, the wind. I think of the Black Rock Desert to the north of Reno, its 400-square-mile central playa, or dry lake bed, a blank slate to be written upon each summer by tire- and footprints. Sometimes that playa is referred to as the heart of the heart of the Great Basin Desert.

By definition, playas hold water only seasonally, fed by the rain that makes it over the mountains surrounding them, but more readily by meltwaters that descend each spring from the snows up high. The rivulets and streams flowing into the valleys over thousands of millennia bear with them silts and salts that precipitate out of the waters as they evaporate. When you make the mistake of driving out onto what looks like a dry lake in spring, but is in reality only a thin crust above the mud, you sink up to your axles in a goo that may extend downward a mile or more.

During the winter the desert playas may contain lakes that are hundreds of square miles in surface area, but only a few inches deep. During a cold spell great sheets of the waters freeze and wind pushes them around as if polishing a mirror. When dry enough the following spring to venture out on with safety, the evidence of most activity before the winter will have been erased. Now the surface will shrink as it desiccates, and the polygons of patterned ground will appear as nature seeks a geometry through which to most effectively relieve the stress. What was mud will curl and crack in the desert sun like dried plates fired in a kiln. Sometimes the polygons will be only inches across, sometimes yards—and at times so large they can only be traced from the air. The cracks may be hairline thick and a tenth of an inch deep—or be trenches a foot across and extend downward for yards. All this is the effect of water standing still. When it moves, it is the most persistent sculptor on Earth.

Standing atop karnak ridge outside Lovelock, Nevada, on a midsummer day, I am dazzled by the inland sea 3,000 feet beneath me. It has been a wet El Niño year, and the playas that run south from Lovelock toward Fallon through the Forty Mile Desert are covered in enormous sheets of water. It's not a sight that will last long. The water will retreat quickly during July and August until the alkaline flats emerge once again. Only the shallow wetlands in the Stillwater Wildlife Refuge and a few lush stands of reeds south of Lovelock will be left as reminders, once again, of the Pleistocene Lake Lahontan that once covered the valleys beneath me. I take as many pictures as I can, knowing that I will not see this again in my lifetime.

Stretching away from me to left and right are prismatic columns of rhyolite, which form a natural colonnade at the crest of the ridge. Karnak was named by Clarence King during his 1867–70 survey of the Fortieth Parallel, and documented by Timothy O'Sullivan, the first great photographer of the American desert. King, like many explorers of the American West, found in the desert geology a divine architecture that rivaled that of European cathedrals, stone monuments that were far older than Chartres. To impart to readers of his reports the antiquity of his discoveries, he borrowed the nomenclature of Egyptian monuments, and Karnak Ridge shares its name with the great funerary city on the Nile that dates to 2600 B.C.

Deserts and photography have a shared history particular to landscape and art in the Western imagination. Until Napoleon sent his 50,000-troop excursion into Egypt in 1798 in an abortive attempt to expand France's imperial interests, the deserts of the world were considered by Europeans and early Euro-Americans to be lands beyond the borders of the maps. They were represented by blank spaces on the charts, and every attempt was made when possible to circumnavigate them. The people who lived there were held by the public to be savages. Napoleon's expedition helped to change all that.

It was known to Napoleon that the ancient Egyptians had dug a canal from the Mediterranean to the Red Sea

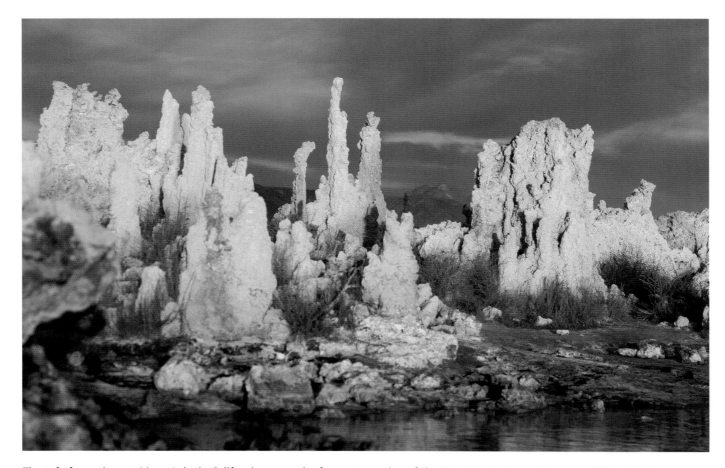

The tufa formations at Mono Lake in California are on the far western edge of the Great Basin. Formed between 700 and 900 years ago, they were written about by Mark Twain and are among the most studied and photographed examples of tufa in the world.

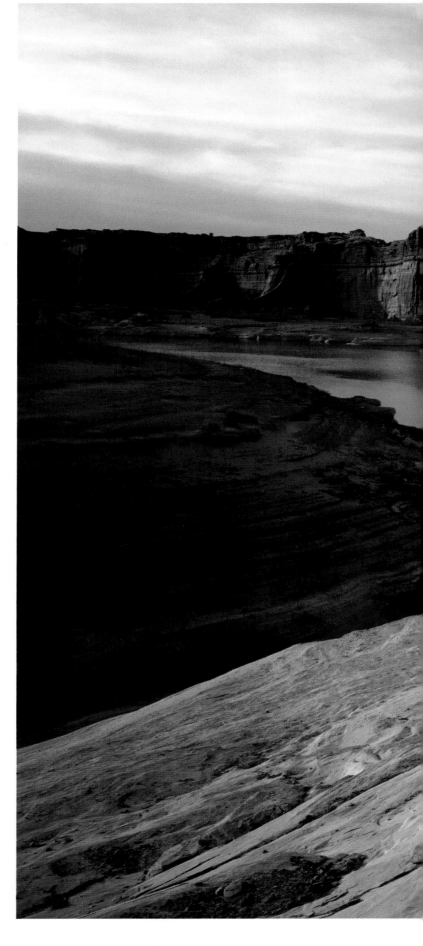

for the sake of commerce, and the ambitious general envisioned the reestablishment of such a waterway as a route around the stranglehold on French shipping held by the British. When he led his forces against the tribal Egyptians, he also took with him 165 scholars, among them topographical draftsmen and artists. It was known that Egypt contained monuments from antiquity, and Napoleon meant to lay claim to them, as well as the cotton-growing fields of the valley so richly fertilized by the Nile.

The military effort was a failure, but the artists brought back images of a lost civilization that captivated the imagination of the French public, and soon all of Europe. Painters such as the Englishman David Roberts would make entire careers during the nineteenth century out of documenting the desert wonders of Egypt and the Holy Land. But it wasn't until the invention of the daguerreotype, announced in Paris during July 1839, that the public would have a chance to see beyond the pyramids and temples and into the sea of sand itself.

By November of that year the first daguerreotypist was in Cairo, and by the end of the month another was traveling up the Nile by boat. Scores of photographers followed. Just as Roberts published folios of exotic lithographs, so traveling artists such as Francis Frith published edition after edition of photographic albums dealing with the monuments. (Frith, in fact, took the views of Karnak in the 1850s with which King and O'Sullivan most likely would have been acquainted.) Almost all of the pictures, paintings and photographs alike, focused on the monuments, which by necessity had been built next to or very near the Nile. Rock and water are the two predominant elements in the images. Glimpsed everywhere in between the temples are the great desert sands and cliffs that frame the river.

When John C. Frémont reached Nevada in 1844 during his great circumambulation around the West (and in so doing discovered that the region was an enclosed "Great Basin"), he named Pyramid Lake after the Egyptian edifices because it made it possible for his audience back East to correlate a new and unknown territory to an exotic land previously cataloged. The same was true of Clarence King when he came through the Great Basin in 1867, and turned what was locally known as Crab's Claw Peak into Karnak Ridge.

O'Sullivan had been taught photography by his neighbor Matthew Brady, who took the younger man with him onto the battlefields of the Civil War. O'Sullivan learned how to cope with fragile glass plates and fuming chemicals while working inside a portable horse-drawn studio, an expeditionary tactic he would deploy as he followed King and other geologists around the arid West. His work set a standard for clarity and composition that would later be admired by prominent photographers, Ansel Adams among them.

The American public was eager for photographs of the American West, and the government no less keen to furnish them. During the 1850s, the government

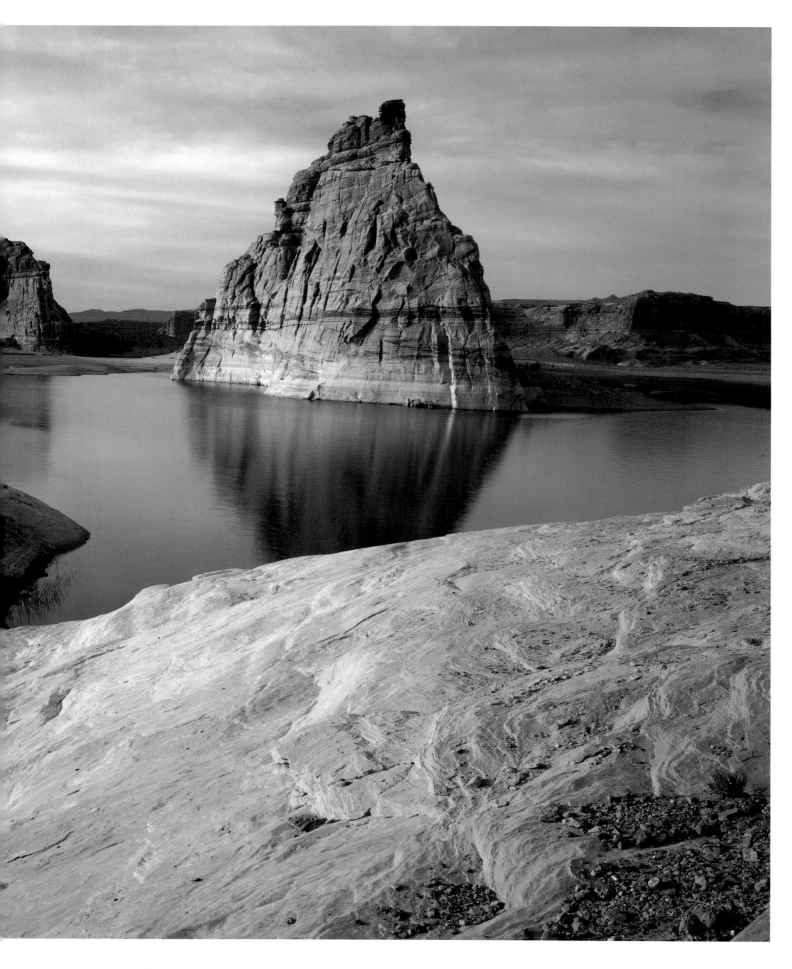

The Colorado River is backed up by the Glen Canyon Dam into Lake Powell. Almost three million people visit the reservoir's 2,000 miles of shoreline every year, making it one of the most popular desert watering holes in the country. This view, near Page, Arizona, shows how the reservoir has begun to drop during a multiyear drought.

encouraged settlement of the West as it sought to establish a commercial unity from coast to coast. At one point up to a third of the annual national budget was devoted to funding surveys and their publications, and Congress was appropriating up to three times what the expeditions themselves cost on the printing of the reports, and the widespread distribution of hundreds of thousands of copies.

The early railroad survey photographers who shortly followed O'Sullivan had a vested interest in downplaying the extent of the aridity, and highlighting the supposed abundance of water in the West, but as American photographers in the late nineteenth and early twentieth centuries came increasingly to consider themselves artists as well as documentarians, they began to find the desert a subject worthy of contemplation in its own right. Carleton Watkins, although better known as the first major photographer to work in Yosemite Valley, was making portraits of saguaros in the Sonoran in 1880. By the 1920s and '30s, artists such as Ansel Adams and Edward Weston were photographing in the Mojave and across the Colorado Plateau, and creating images that would be published by the Automobile Association of America to promote tourism.

The advent of color photography in the desert was brought about through many routes, but nowhere more noticeably than in the pages of the most famous of all desert tourism publications, *Arizona Highways Magazine*, published by the Arizona Department of Transportation. The magazine was started in 1925 and in the mid-1940s was the first national consumer magazine to run an all-color issue. The black-and-white pictures of Ansel Adams soon gave way to color images by Josef Muench, then later his son David, as well as Eliot Porter, Philip Hyde, and Jack Dykinga.

Porter (1901–1990), who was heavily influenced in his early years by Adams, was given an important exhibition of his black-and-white work in New York City during 1938, but shortly thereafter switched to color, a much more difficult medium in which to work. Adams and others tried printing in color, but gave up. Porter, trained as a biomedical researcher, had the lab skills to persist, and labored almost without recognition for twenty years. In 1962, however, the Sierra Club published *In Wildness Is the Preservation of the World* in celebration of the centennial of Henry David Thoreau's death. The words were by Thoreau, the photographs by Porter. It was the organization's first color book and a huge success, and is partly responsible for Porter's reputation as being the father figure of color landscape photography. His photographs captured not the deep, monumental space and far horizons for which Adams had become famous, but instead concentrated more intimate views into a single picture plane that highlighted patterns in nature. Perhaps it is more accurate, as Rebecca Solnit points out in *Eliot Porter: The Color of Wildness*, that Porter wasn't as much photographing landscapes as inventing a nature photography that revealed the complex connections within the environment.

The artist was then asked by the Sierra Club to document Glen Canyon, a tributary of the Colorado River that was due to be drowned upon the construction of a new dam—a structure to be built upriver from Hoover Dam because, among other reasons, silt was flowing so fast down the Colorado that it threatened to fill up Lake Mead. The result is the most famous book of desert water photography ever published, *The Place No One Knew: Glen Canyon on the Colorado*. Although the beauty of the place and the photographs, and the widespread success of the book all fueled a huge public outcry against the Glen Canyon Dam, it was nonetheless built. While Lake Powell rose to cover the canyon, what the photographs created was an indelible record of what we had lost, at least for now, one of the most beautiful and contemplative places on Earth.

Another photographer who studied with Adams, and appeared frequently in *Arizona Highways* and various environmental publications, is Jack Dykinga. Using a large-format camera and color film, the former photojournalist has cultivated a style pioneered by David Muench, that of creating a continuous field of "near-far" focus that sweeps you into the immediate foreground with close detail and propels you through the middle ground and out to the horizon. In some ways Dykinga synthesizes Adams's sense of space and Porter's attention to color as pattern. It is within this tradition that Mark Lisk works, and one perfectly suited for documenting an endangered species of landscape, water in the desert.

Sitting atop the columns of Karnak Ridge, I ponder how water in the desert is always a transitory phenomenon. The *tinajas* and larger water pockets of the West fill and then empty into the thin air. The rivers flow above ground, only to empty into lakes with no exterior drainage—once again, the waters evaporate. Or the rivers go underground to slowly replenish the aquifers that hold water left over from the fluvial times of the Pleistocene. Everywhere in the desert where mankind has diverted the waters to keep afloat hydraulic societies—think of Mesopotamia and ancient Egypt, and of the now-disappeared civilizations in the desert Southwest of America—the waters dried up and the cities themselves were buried in sand.

Photography is all about capturing a moment in time, about fixing in front of our vision that which disappears. What better medium could there be with which to depict desert water? As if to answer my own rhetorical question, I've run out of film trying to document this flood season below me, and start my walk back down into the valley.

THE PRIMARY INTENT OF WESTERN LANDSCAPE PHOTOGRAPHY IN AMERICA DURING THE MID-1800S had been to promote land for settlement. The competition with Europe to legitimize America's place in history—a struggle abetted by photographs of the exposed geology of the arid West to rival the ruined glories of Egypt and Greece—dovetailed perfectly with American policies to encourage Westward emigration. Commerce would be served not only by settlement, but also by tourism to our own exotic locales. The French and English would tour the Nile; Americans would take the railroad to the Grand Canyon. All would be lured to their desert destinations by photographs.

Porter, Adams, and others drove photography in a different direction, seeking to protect what was by the mid-twentieth century obviously a diminishing resource, the desert wilderness. Water would often be the focal point of the images and the environmental movement. While Porter, Muench, and Hyde were intent on making photographs that kept human presence out of the frame, a deliberate attempt to preserve visually what the uninhabited desert could offer, others took the opposite tack. Photographers such as Mark Klett, Robert Dawson, and Wanda Hammerbeck worked in the Water in the West project during the 1980s and '90s to document how humans were reengineering its uses.

The most-visited man-made monument in the American desert has attracted both schools of thought. It sits within the Black Canyon of the Colorado River, which is located in the lower reaches of the Grand Canyon on the Nevada-Arizona border. This is the last major abyss before the river debouches out onto the relatively open terrain of the Mojave Desert. The monument is more commonly known as Hoover Dam, though I prefer its original name that more accurately describes what it is: Boulder Dam. At just before dawn

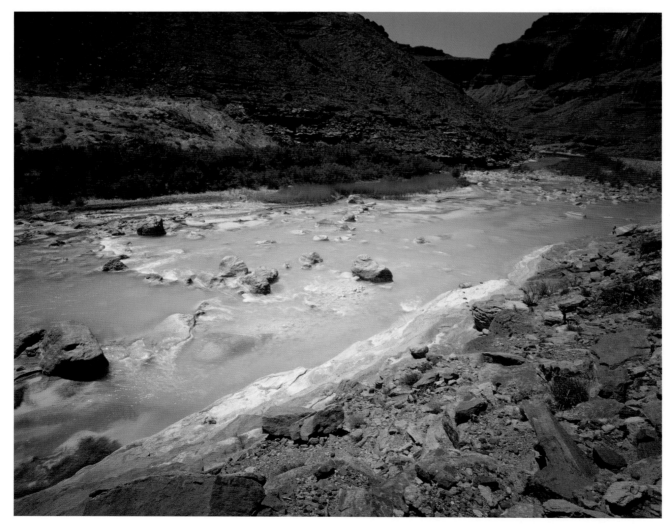

The waters of the Little Colorado run turquoise at its confluence with the Colorado in Grand Canyon National Park. The Little Colorado, which usually runs red, carries high loads of sediment due to upstream mining and rangeland practices.

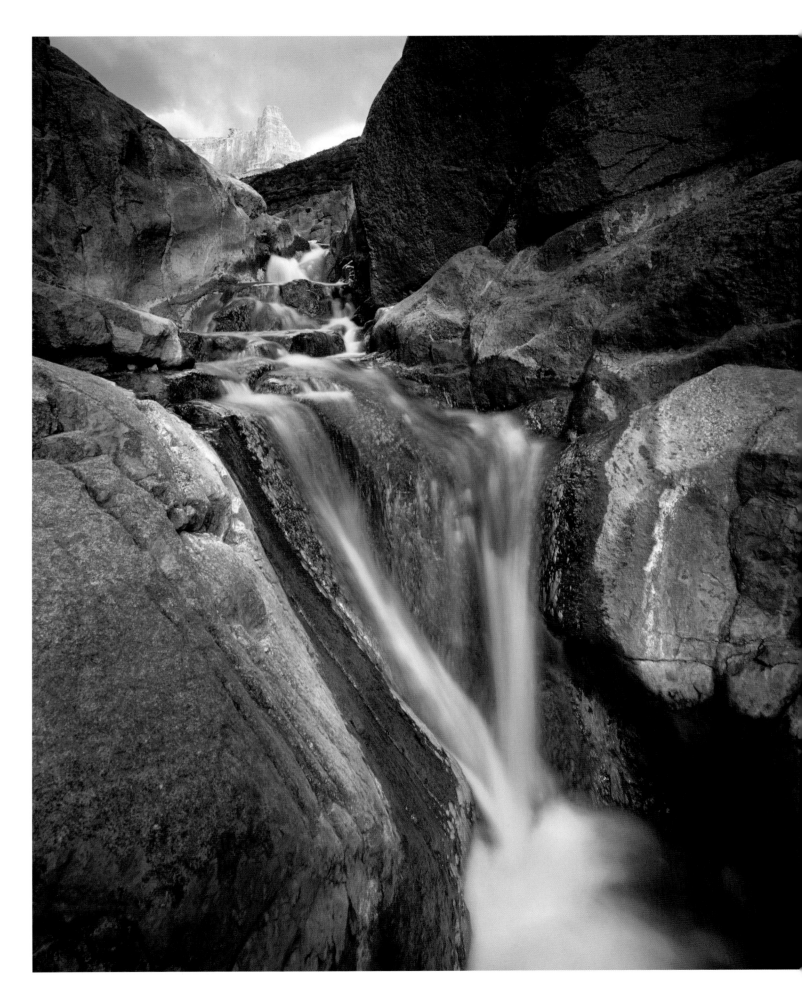

this June morning, the top of the dam is illuminated with orange lights. The steep cliffs down which the two-lane highway switchbacks are a deep mauve.

The river itself is invisible, its original channel under almost 3,700 feet of water, but the waters in Lake Mead already carry a hint of blue on the surface. A bathtub ring of bleached rock 50 feet high glows faintly along this portion of its 1,960-mile shoreline. It's been the driest year on record for the Colorado River Basin upstream, and the reservoir is a third below its capacity. It will keep dropping for at least another two years, even if this winter should prove a wet one. Desert water keeps its own rhythms.

I often pause at one of the turnouts above the dam, get out of the car, and peer over the handsome rock walls constructed during the 1930s. Hoover Dam used to be one of the more readily accessible pieces of mega-engineering on the planet—what a *tinaja* becomes when it is scaled up by a hydraulic society to meet the needs of cities the size of Los Angeles, versus a band of hunter-gatherers. Now the pullouts are closed, trucks are forbidden to cross the dam, and shadowy figures are visible sitting in military vehicles parked on either side of the river. Even at this early hour I was stopped at the police checkpoint for a brief inspection. The dam, its water, and hydroelectric power are strategic resources to be guarded against terrorism. I'm the only vehicle visible on the road and keep moving under the watchful eyes of soldiers carrying automatic weapons.

Rock and water. The Colorado is only 5.3 million years old, but it has cut 4,000 feet down through sandstones and the tougher limestones of the Colorado Plateau until it hit the obdurate Vishnu schist, the hard rock basement of the river that is 1.7 billion years old, and in so doing has washed away into the Sea of Cortez 1,000 cubic miles of dirt. The Colorado is the nation's sixth-largest river and drains 246,500 square miles along its 1,700-mile length—one-twelfth of the continental United States. Before it was dammed it could carry up to 18 million acre-feet of water annually, and one-fourth of a pound of silt per cubic foot of water, ten times the amount carried by the Nile and seventeen times that by Old Muddy himself, the Mississippi. The name Colorado means "red," red from the sandstone and oxides of the Colorado Plateau that used to flow through Black Canyon, before Hoover Dam was built, at the rate of almost 160 million tons a year. River and rock.

Why we dam rivers that flow through deserts has everything to do with where water falls and

doesn't, and where people live and don't. According to the United Nations Population Fund, the world population tripled in the last seventy years to 6.1 billion people, but the use of water grew twice as fast, or sixfold. Ninety-seven percent of the water in the world is salty; of the remaining 3 percent, 2 is locked up in polar ice. Of the remaining 1 percent, 70 percent is used worldwide for agriculture, of which more than half is wasted. In the year 2000 it was estimated that 508 million people lived in water-stressed, or water-scarce countries—a figure that by 2050 could rise as high as 4.2 billion of what will then be the world's estimated 9.3 billion people.

Eighty percent of all rivers flow through more than one country, and many of them through deserts, creating increasing geopolitical strife. Think of dams being built upstream in India that divert the Himalayan flows before reaching arid Pakistan, or in Jordan along the Jordan River before it enters Israel. If you make a connection between political strife, deserts, and the scarcity of water, you get it. The Colorado is no exception.

The flow of the Colorado is divided among seven arid states and Mexico, according to a formula that was based on its volume during an anomalous and extremely wet period in the early twentieth century. That original estimate was 18 million acre-feet per year (maf), one acre-foot being about what it takes to support a family of four for a year. The legal entitlements for the river are currently at 17.5 maf, but the actual flow in an average year is less than 15 maf. Needless to say, the river no longer reaches the Sea of Cortez, and where it enters Mexico is a toxic concentrate from industrial pollutants and agricultural runoff. The Colorado is subject to a "total use" program that makes it more of an industrial pipeline than a desert river.

The estimated population dependent upon the Colorado is 25 million people; that's estimated to rise to 38 million no later than 2020. Furthermore, when the Bureau of Reclamation proposed in 1941 to subject the river to total use with a chain of reservoirs, the original estimation of evaporative rates were that a body of water the size of Lake Powell—the reservoir upstream from Lake Mead—would lose 5 acre-feet per year. In 1996 the reservoir lost through evaporation and seepage about a million acre-feet, or 8 percent of the river's flow. If we suffer cognitive dissonance when trying to gauge distance in the arid air of the desert,

Stone Creek, which features waterfalls and bathing pools, cuts through travertine ledges in the Grand Canyon on its way to the Colorado River.

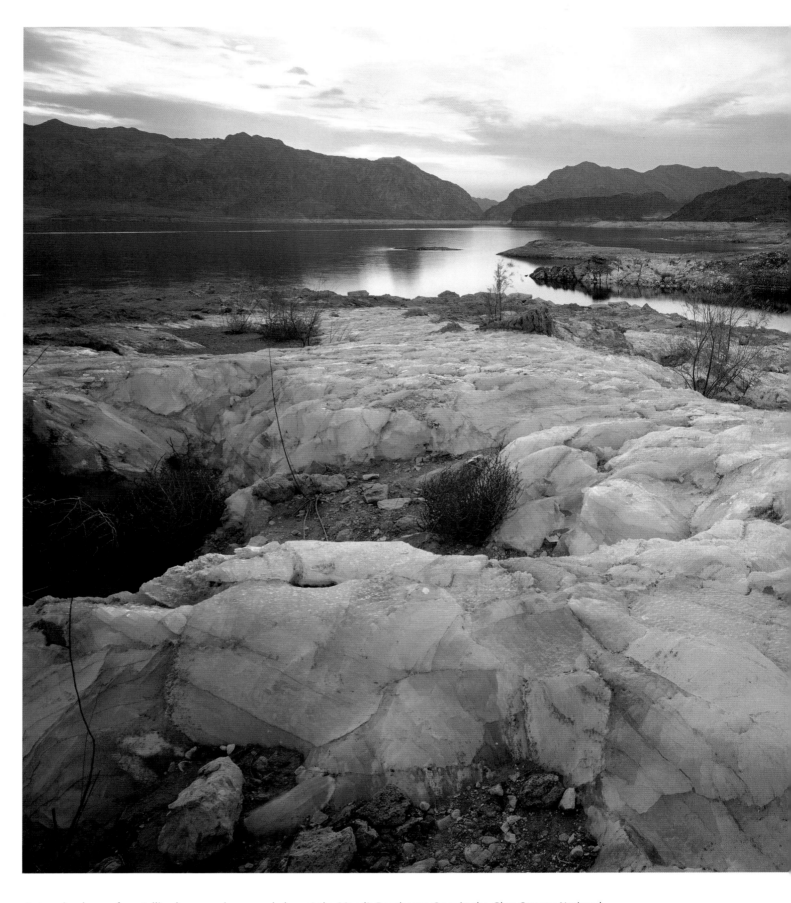

A stunning layer of crystallized gypsum is exposed above Lake Mead's Boathouse Cove in the Glen Canyon National Recreational Area.

we fare even worse when attempting to calculate the behavior of water here.

The average use of water in America is 40 gallons per person per day, about a hundred times that of your average African living in a country such as Uganda. The use of water in desert cities using Colorado River water is stunning by comparison. In Tucson it's 160 gallons daily, in Los Angeles 211, and in Las Vegas an astonishing 360 gallons, 60 percent of which is used to

irrigate lawns and golf courses. Just one of the latter can use up to a million gallons of water a day. (Tucson has been actually lowering use from a high of more than 200 gallons per day in the 1970s, its residents having been forced by severe water shortages to give up any illusion of living in a well-watered savanna.) Put it another way: your average American consumes approximately 1,500 pounds of food annually, which takes about 1.5 million gallons per year to grow and

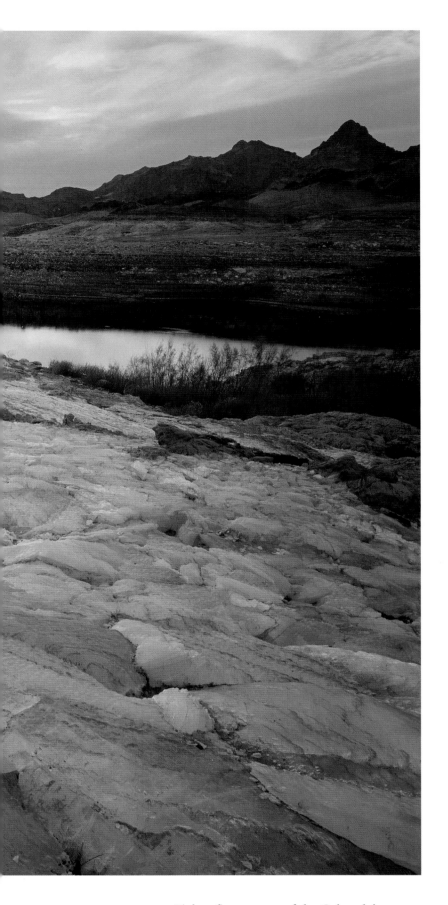

watering, and casinos and golf courses recycle gray water. But, as things stand today, Las Vegas runs out of existing water supplies to meet new needs around 2025.

As Marc Reisner pointed out in *Cadillac Desert*, his polemic against the U.S. Bureau of Reclamation, water does sometimes flow uphill—toward money. This has led to the neon city's quest to tap the aquifer under the White River Narrows, the fossil waters of which may been been stored there since the Pleistocene. The effort was beat back once during the 1990s by a coalition of ranchers and environmentalists, but it's a struggle that is typical of urban areas seeking to mine water from underneath deserts. When they succeed, they lower the watertable and springs stop flowing, biotic communities dry up, and the very boundaries of the desert begin to expand.

Deserts are indicator regions for the global environment because they are relatively simple ecosystems (in comparison with, say, a rain forest or a savanna). Change and imbalance become apparent much more quickly—and the lack of vegetation makes them more readily visible. Desert water is the political fulcrum, and photography a prime tool in the dynamic. As I drive up the Arizona side of the Colorado River and progress out of the Mojave and into the Sonoran Desert down by Kingman, I catch glimpses of the river deep in the canyon. Thousands of feet below me it gleams an improbable metallic blue, as if it were the blade of a sword.

Every shape we see in the desert is carved by water—from the endlessly fractal gullies of the Colorado Plateau that grow into its awesome canyons, to the smooth palimpsest of the playas. The process happens both gradually, through eons of erosion, but also in catastrophic increments, because that's more often than not how the rain falls here. It can go for as long as two years in the Mojave without raining, yet a year's worth of precipitation can fall within a night. The stony desert soils don't absorb water rapidly, and runoff begins to build almost immediately. To my east, on the other side of Flagstaff, the Little Colorado during a big storm has been known to carry off nine inches of topsoil per square mile into its larger sibling. Thunderstorms in the Grand Canyon have dislodged 200-ton boulders the size of office buildings and blocked the entire flow of the river for months. Boulder Dam, indeed.

It behooves us to look at the photographs of desert water. To notice how quiet the water is in a stream flowing through the fluted walls of a hidden canyon. To notice that the walls are hundreds of feet high and polished into surreal curves by unimaginably savage floods.

process. Eighty-five percent of the Colorado's allocations are dedicated to agriculture.

One of the lessons to be learned by contemplating desert water is the foolishness of using it to grow cotton—an extremely thirsty crop—in Arizona west of Phoenix. Or alfalfa at the foot of the Forty Mile Desert in Nevada outside Reno, the requisite diversion of the Truckee River to water said crop making it the most litigated waterway in America. If half of the region's agricultural water were transferred into municipal usage, for instance, you could support quadruple the current population. And conservation will help. Las Vegas now limits lawn

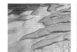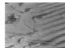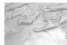

THE CHISOS IN WEST TEXAS ARE THE SOUTHERNMOST MOUNTAIN RANGE IN THE UNITED STATES, AND THEY

form the backbone of Big Bend National Park; its peaks afford us some of our country's greatest desert viewsheds. Rising to almost 8,000 feet, they offer a respite from the heat below, and on a clear day you can see more than 200 miles into Mexico across the border formed by the Rio Grande. This early December morning it's downright chilly in the shade as I walk through the Chisos Basin to Oak Spring and the Window, a narrow declivity cut by waters pouring out of the valley. The basin, eroded from the volcanic peaks into a 2,500-foot-deep bowl, is filled with oak, piñon, and juniper. Two white-tailed Chisos deer bolt from their bed in a thicket, startled by my early presence. Like many desert mountain ranges, the Chisos are an island of biodiversity, cut off from other ranges by the increasing heat and aridity when the last Ice Age finished retreating 8,000 years ago. These deer are found only in the Chisos, held to it by water.

My path, a well-worn tourist route, drops down into a dry creek bed, but for the last few hundred yards a trickle of water from the spring flows over slickrock and into a series of pools, the largest of which is almost five feet deep and supports a luxuriant growth of algae. This is one of the few permanently flowing waters in the park, and human artifacts dating back to the conclusion of the Pleistocene are scattered throughout the Basin. The trails ends abruptly where the water flows over the rounded lip at the bottom of the Window—and the stream just evaporates. It's far too arid here for the water to reach the desert floor below, much less the Rio Grande, roughly fifteen miles to the northwest.

Water is a fugitive substance. The water flowing over the lip here will wander through the atmosphere for an average of nine days before descending elsewhere as rain or snow. Water will rest in lakes for less than a decade, and most groundwater rejoins the surface within centuries. Even in the oceans the deepest and most isolated reservoirs will be pushed up to the surface and lifted into the atmosphere within a few millennia. Nowhere else is the restless nature of water so apparent as in the desert. The water I'm watching first fell above in the peaks, percolated down through the fractured rhyolite, then collected underground where it generated enough hydraulic force to push its way to the surface, where it enters the hydrological cycle once again.

I decide to finish my year of tracing desert water by visiting one of its great cathedrals, the 1,500-foot-deep Santa Elena Canyon carved by the Rio Grande, a sepulchral slot that in some places is only 30 feet wide. On the drive down from the Chisos and across the floodplain, I can only marvel at the stands of ocotillo, that thorny shrub with its multiple 6-foot-tall "coachwhip" stalks. During dry months the ocotillo, which is often mistaken by newcomers for a cactus, bristles like a dead bundle of prickly sticks. Give it a good rain, however, and no matter the time of year it quickly sprouts bright green leaves all up and down the stalks. You can't tell by looking at the ground, which seems as dry as ever, but several weeks ago a front moved through West Texas and dropped just enough moisture to provoke the change. Now, with the cooler temperatures, the leaves have turned golden, the desert version of fall color, a trace of desert water that has come and gone.

The Chihuahuan Desert is split by the 1,960-mile-long river, which arises in the San Juan Mountains of southern Colorado, runs through the center of New Mexico, and then wanders south to form the border between Texas and Mexico before attempting to debouch into the Gulf of Mexico. Actually, that's a bit of a fiction. The river that flows from Colorado is completely consumed by irrigation and other uses by the time it reaches El Paso, and is only reconstituted 250 miles downstream with the confluence of the Rio Concho, which flows out of mountains in Mexico.

Half of the Rio Grande's watershed lies in Mexico, where the water is dammed just as sternly as in the Unites States. The flow for this second section of the river is regulated by the Granero Dam, and its waters first irrigate the fields of eastern Chihuahua before joining the Rio Grande upstream at Presidio. In most years the regulated releases lack enough water to cut through the sandbar that inevitably builds up at the mouth of the Rio Grande, despite the Army Corps of Engineers' best efforts to keep open the flow into the gulf. One hundred miles west, the Colorado suffers a similar fate, reaching its delta only during El Niño years.

Even so, when you're deep in the canyon if you listen carefully you can hear the silt of the river scouring away at the rocks. The erosion may be slowed, but it has all the time in the world. And during floods,

Prickly pear cactus bloom on a cliffside of the Rio Grande in Big Bend Ranch State Park, Texas.

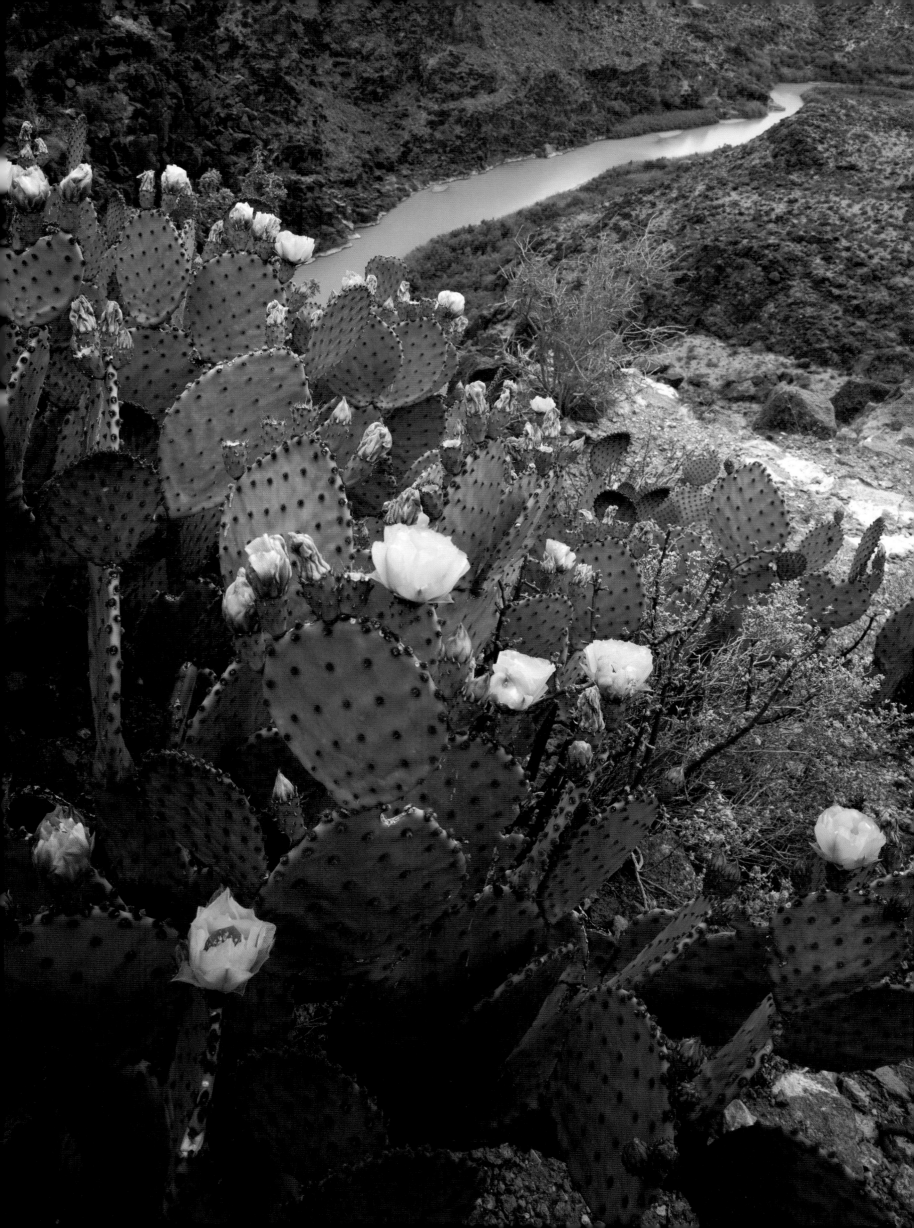

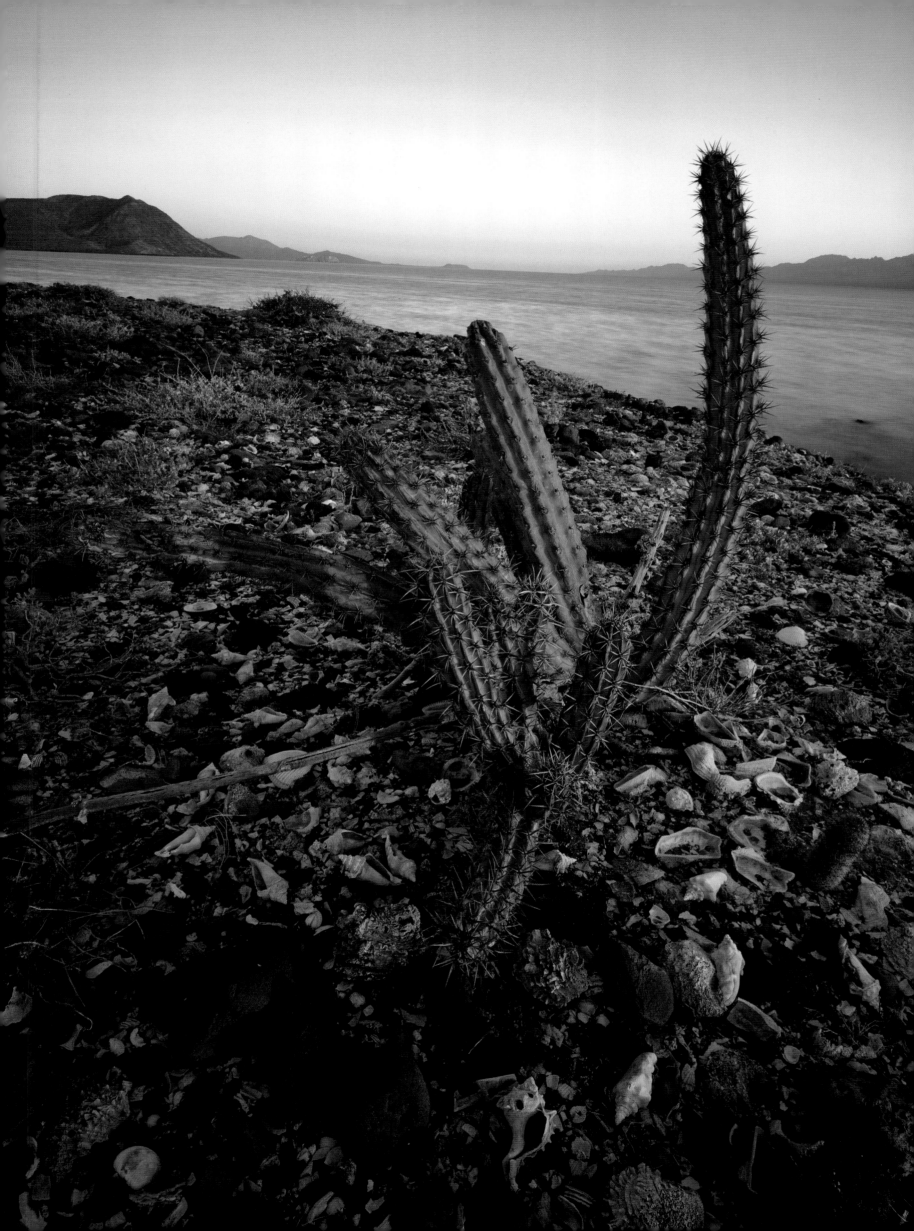

the unimaginably fierce currents can make dramatic changes in the riverbed. The highway that parallels the river from Presidio to the park crosses hundreds of washes feeding into the Rio Grande. Many of them have flood gauges posted conspicuously next to the pavement, numbered posts that rise higher than the roof of my car.

Down by the river it's close to eighty degrees, and it's with relief that I pass through thick stands of tamarisk, desert willow, and giant river cane to reach the shadow of the limestone walls. The river this year has run at only 13 percent of its average annual flow, and as I climb up the eastern wall a few steps, I can see sandbars visible through the turgid jade waters. Almost anywhere along the river in Texas you literally can throw a stone into Mexico—here it feels as if you could take a running jump right into it. I put my hand out and touch the layers of buff-colored stone. Seashells. Small fossils from hundreds of millions of years ago when the region was a shallow sea. Rock and water.

Fugitive water, as elusive a presence as the border itself, is an idea between nations. I look upstream and see no one, our presence erased by flowing time and water.

An old cactus rests on the shell and rock shoreline of the Sea of Cortez, Baja California.

Snow (overleaf) flocks winter reeds in the Stillwater Refuge east of Fallon, Nevada. The shallow marshes are the terminus of the Carson River, which flows into the Great Basin from the Sierra Nevada. The refuge sits near the southern end of the Forty Mile Desert, a hostile stretch of alkali flats that was infamous in the annals of nineteenth-century emigrants crossing to California.

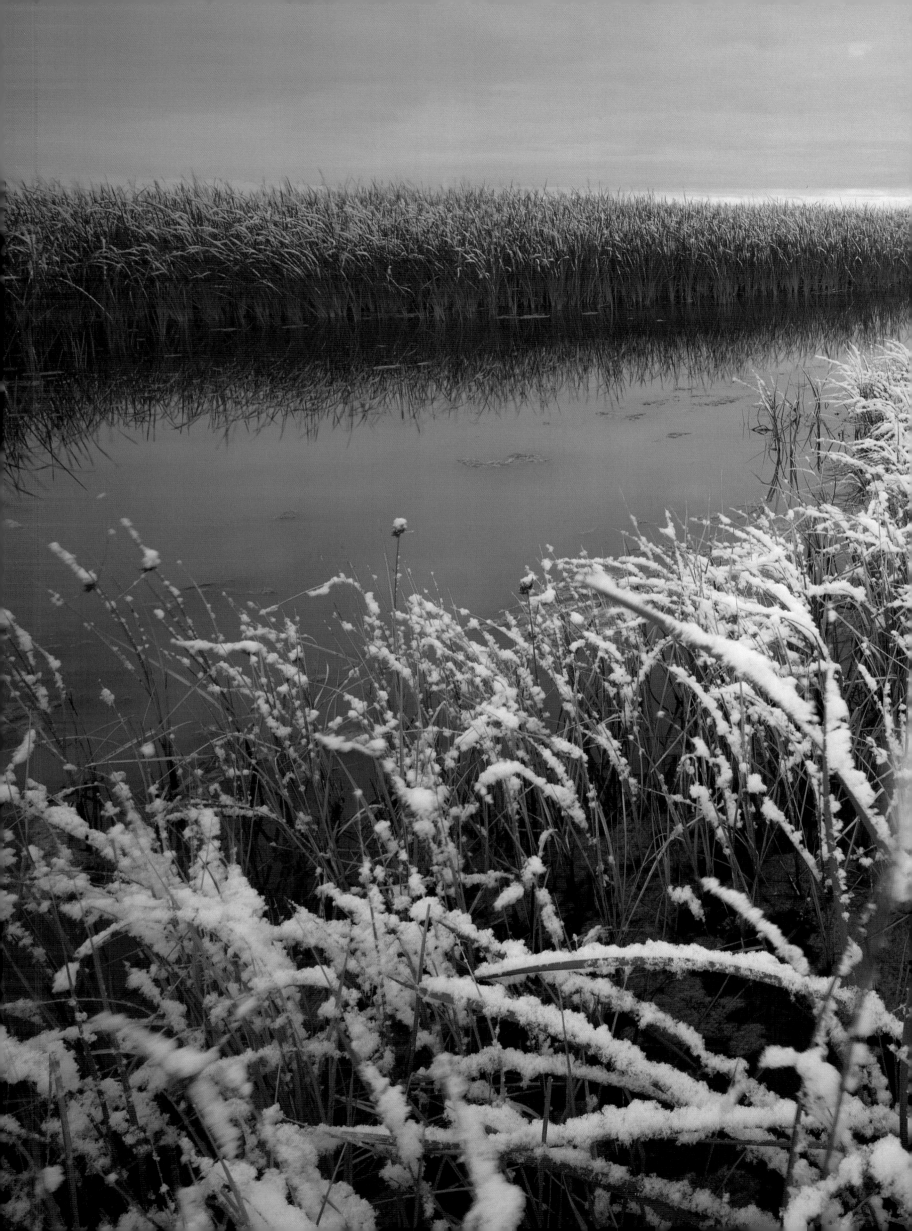

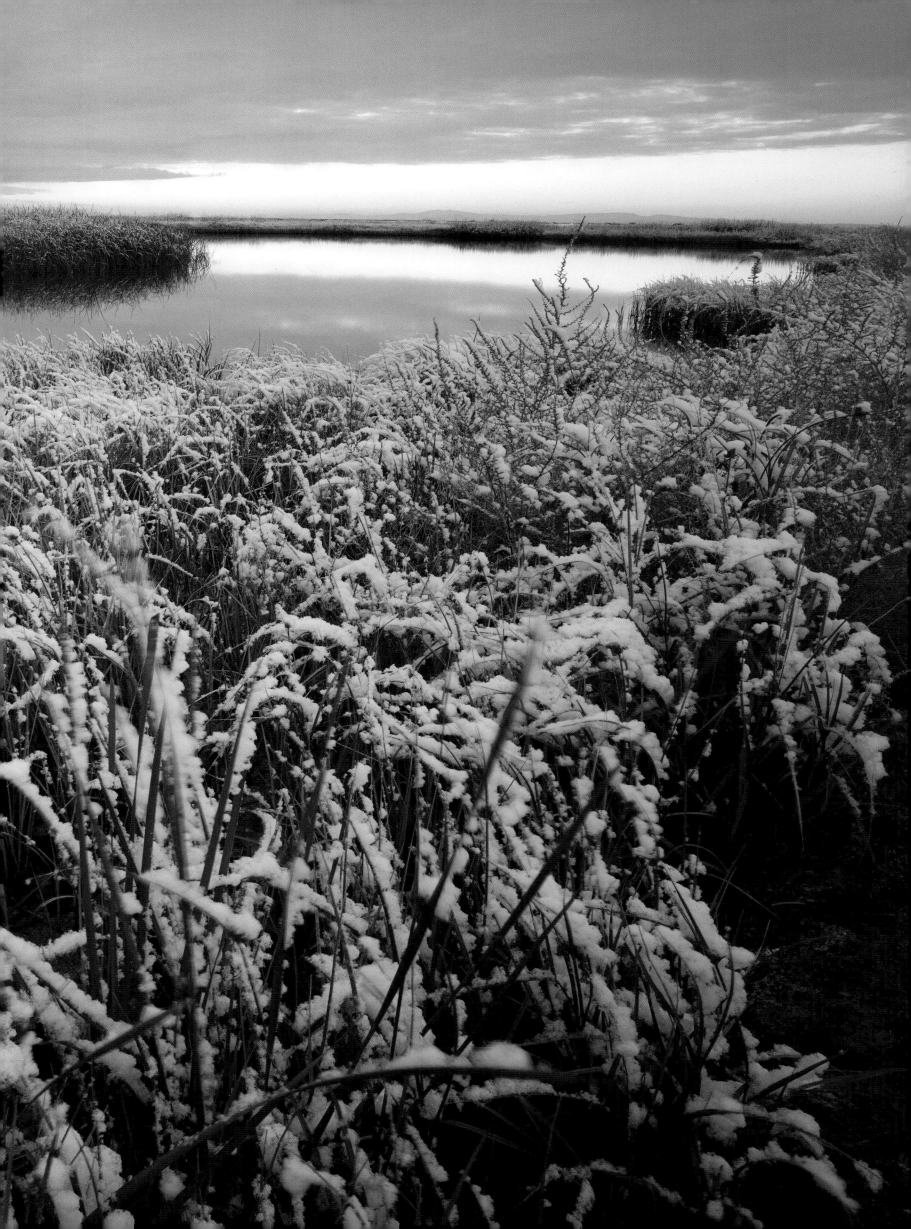

DESERT
WATER

AT 200,000 SQUARE MILES the Great Basin is the largest of the five deserts in the United States, and occupies almost half of the desert region of the West. It covers most of Nevada and western Utah, includes portions of southern Oregon and Idaho, and even a sliver of eastern California. It is the highest and coldest of our deserts, and was first defined in 1844 by the U.S. Army explorer John C. Frémont as a region that had no outlet to the sea. Today the Basin is seen to encompass an area larger than the hydrologically enclosed basin, and is defined as much by its biotic boundaries as its hydrology.

Its terrain alternates between basins averaging 4,000 feet in elevation and more than 300 separate mountain ranges, many of which rise to 10- and 12,000 feet. Frémont noted its resemblance to the enclosed desert basins of central Asia; indeed, along with Afghanistan, the Great Basin is one of the most mountainous arid regions in the world. It wasn't always so.

During the late Pleistocene, from about 75,000 to 12,000 years ago, the Great Basin was covered by two enormous bodies of water, the ancient Lahontan and Bonneville Lakes. The former covered almost 8,500 square miles, the latter 20,000. With a couple of long portages, you could have rowed a boat from Reno to Salt Lake City, passing along the way thousands of islands that today are peaks in the numerous mountain ranges. Pyramid Lake in Nevada is the largest remnant of Lahontan, while the Great Salt Lake is an even larger fragment of Bonneville. Salt flats and dry lake beds, or playas, are frequent reminders of wetter times in the region. Mono Lake, at the far western boundary of the Great Basin, which may date back a million years, is one of the oldest lakes in North America and is twice as salty as the ocean.

The Great Basin offers fewer species of plant and animal life than the other deserts, its primary vegetation the low-growing sagebrushes and shadscale. As a result, green shades to gray in its valleys, which tend to run north to south and are so long that their far ends disappear over the curvature of the earth. The mountains—which host deer, mountain lions, the ubiquitous coyote, and numerous rodents—are virtual biotic islands, their resident species isolated by the impassably arid valleys.

The snowcapped Sierra Nevada on the eastern rim of Yosemite National Park stand high above Mono Lake. Although the lake receives only five inches of precipitation per year, the crest of the mountains captures forty-five inches, runoff from which annually replenishes the ancient body of desert water.

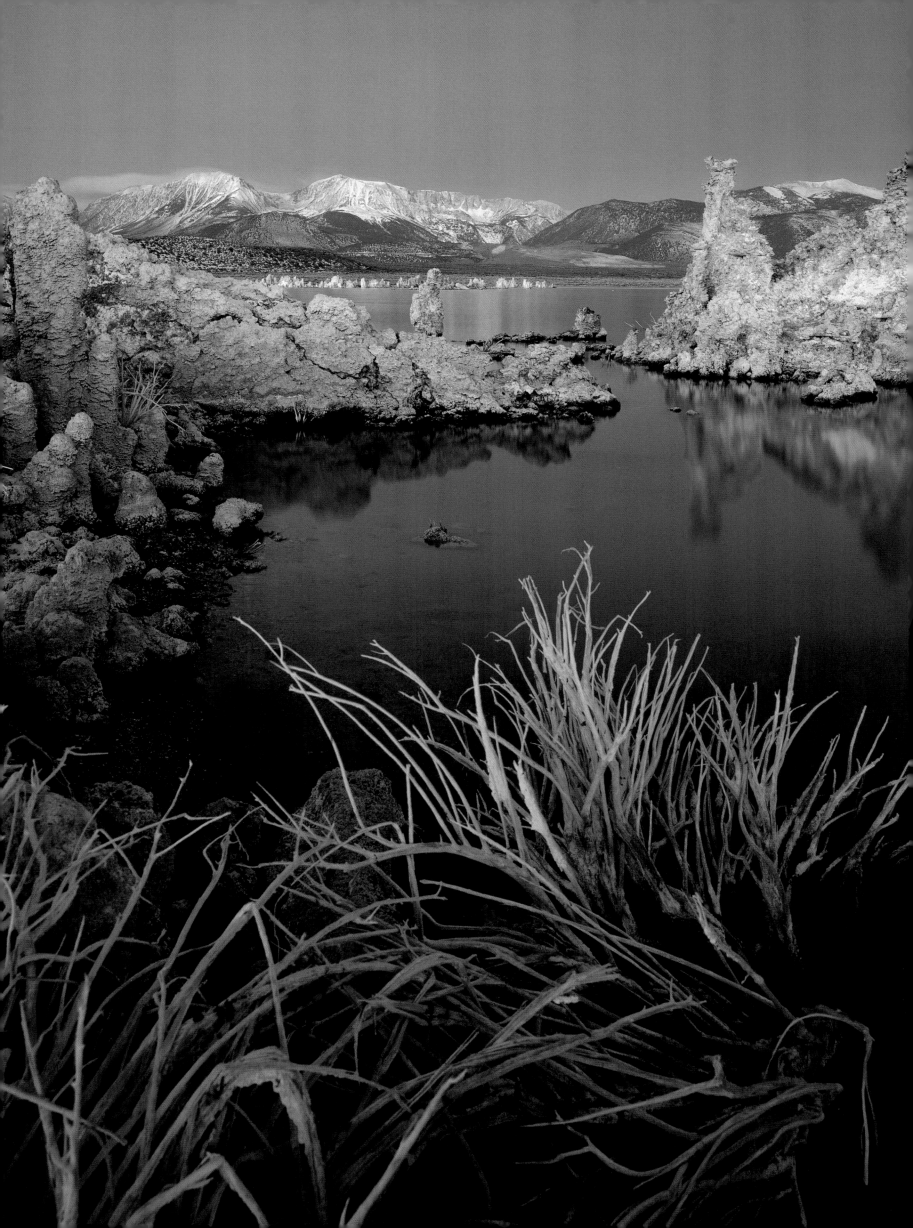

This dry alkaline pond on the edge of the Montana plains, where the terrain begins its transition eastward out of the desert, is virtually a miniplaya.

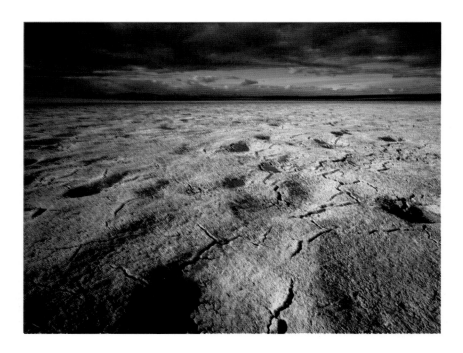

Storm clouds fill the sky over the granite crags of southern Idaho's City of Rocks National Reserve. The park is located on the northern edge of the Great Basin, receives ten to fifteen inches of precipitation annually, and is a rock climber's paradise.

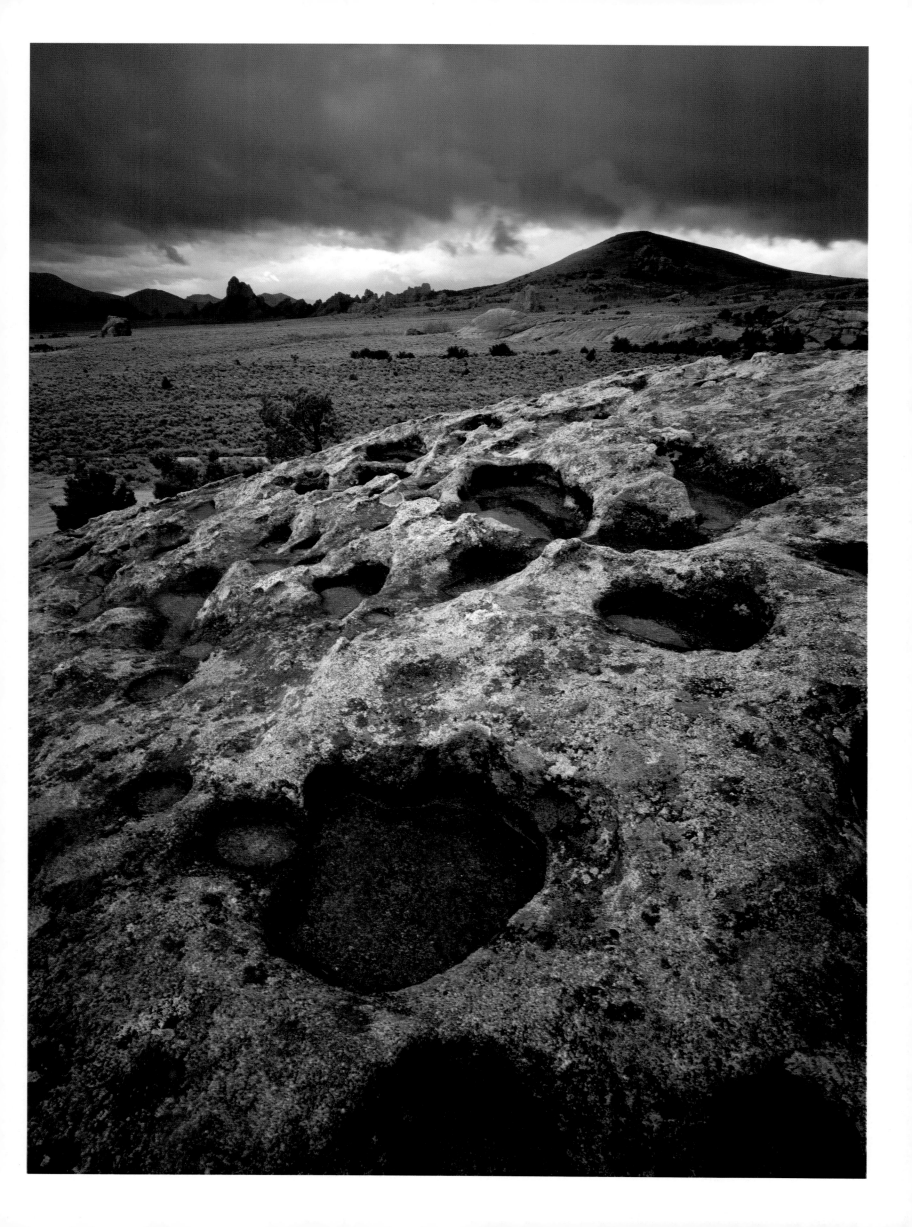

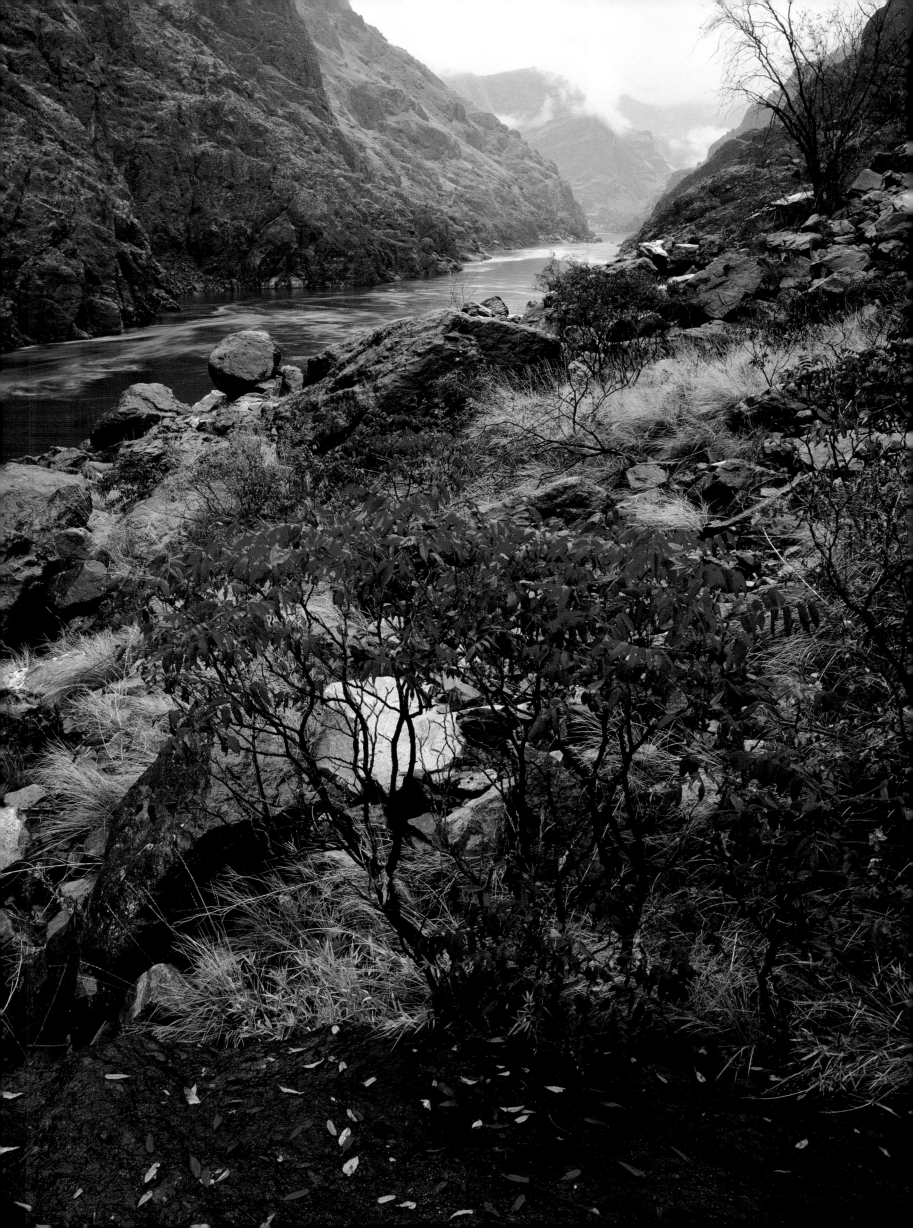

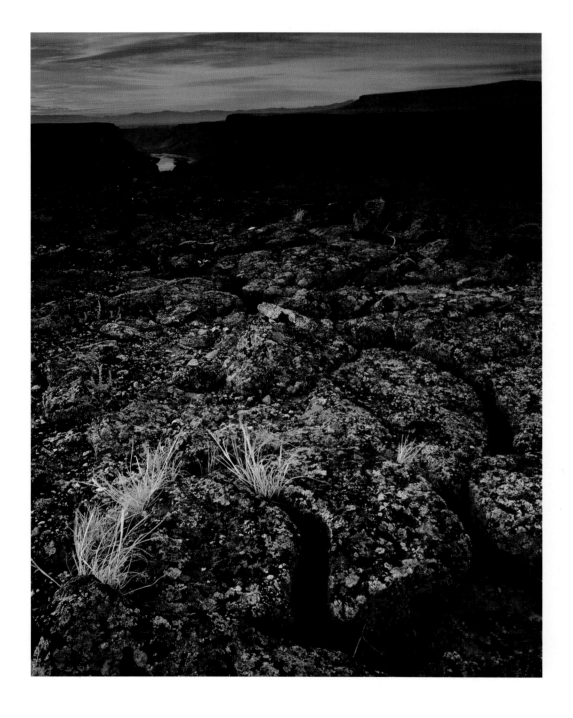

Sumac is in full fall foliage along the Snake River in Idaho's Hells Canyon
National Recreation Area. Hells Canyon, which plunges more than a mile below
Oregon's west rim, and 8,000 feet below snowcapped He Devil Peak of Idaho's
Seven Devils Mountains, is the deepest river gorge in North America.

Buckwheat blooms on the dark black cinder of Craters of the Moon National Monument, Idaho.

Clouds form above the dry Bruneau Sand Dunes on the northern edge of the Great Basin Desert.

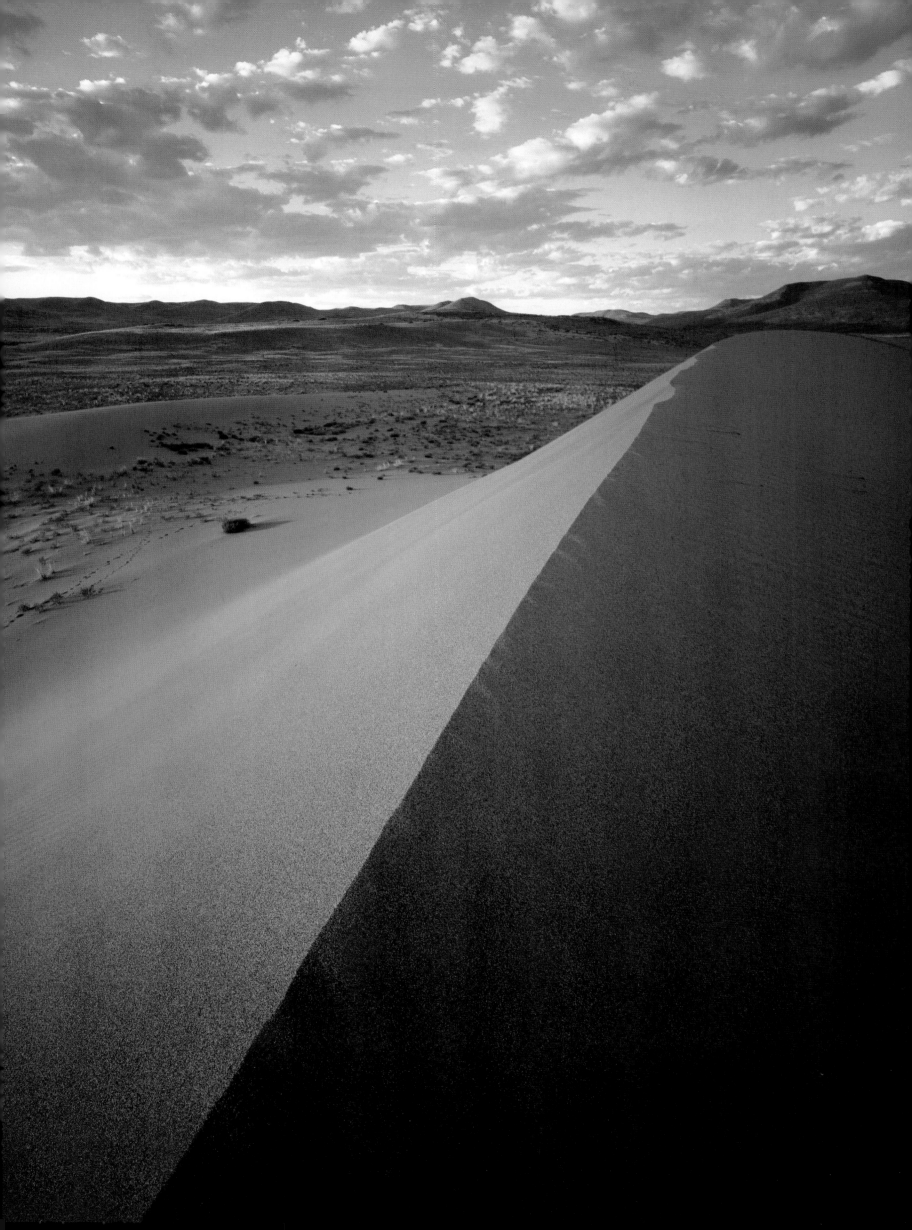

Vivid layers of ancient ash from the onset of volcanism in the Cascades stripe the Painted Hills Unit of the John Day Fossil Beds National Monument in eastern Oregon.

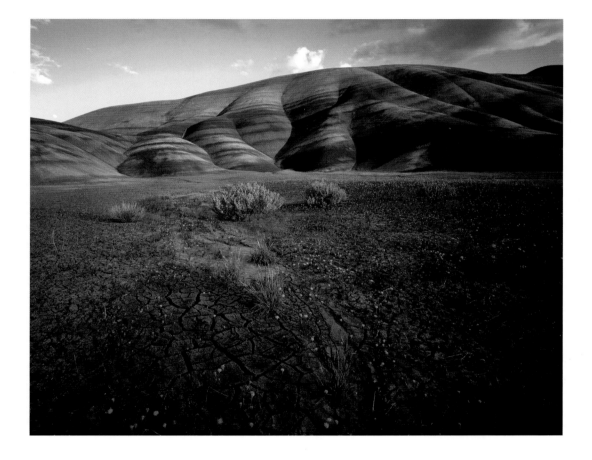

Although the John Day area is technically a semidesert to the north of the Great Basin, its juxtaposition of playalike mud, sagebrush, and desert grasses shows how the arid boundaries overlap with wetter zones.

Rugged volcanic tuff outcroppings (overleaf) define the desert landscape of Leslie Gulch in southeastern Oregon.

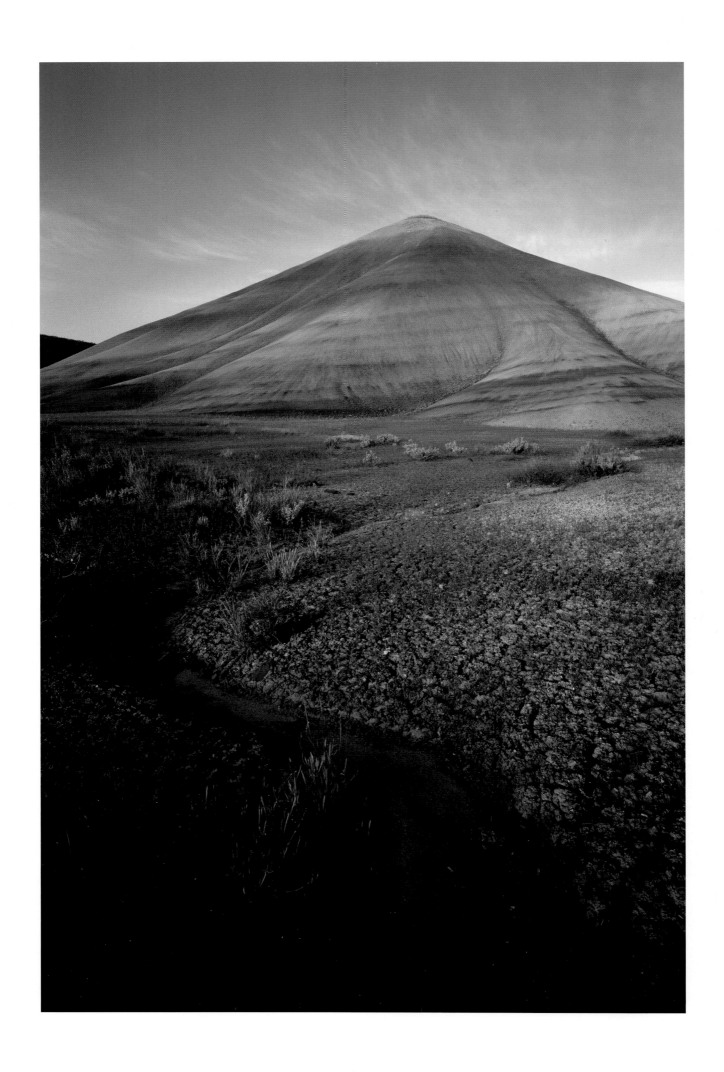

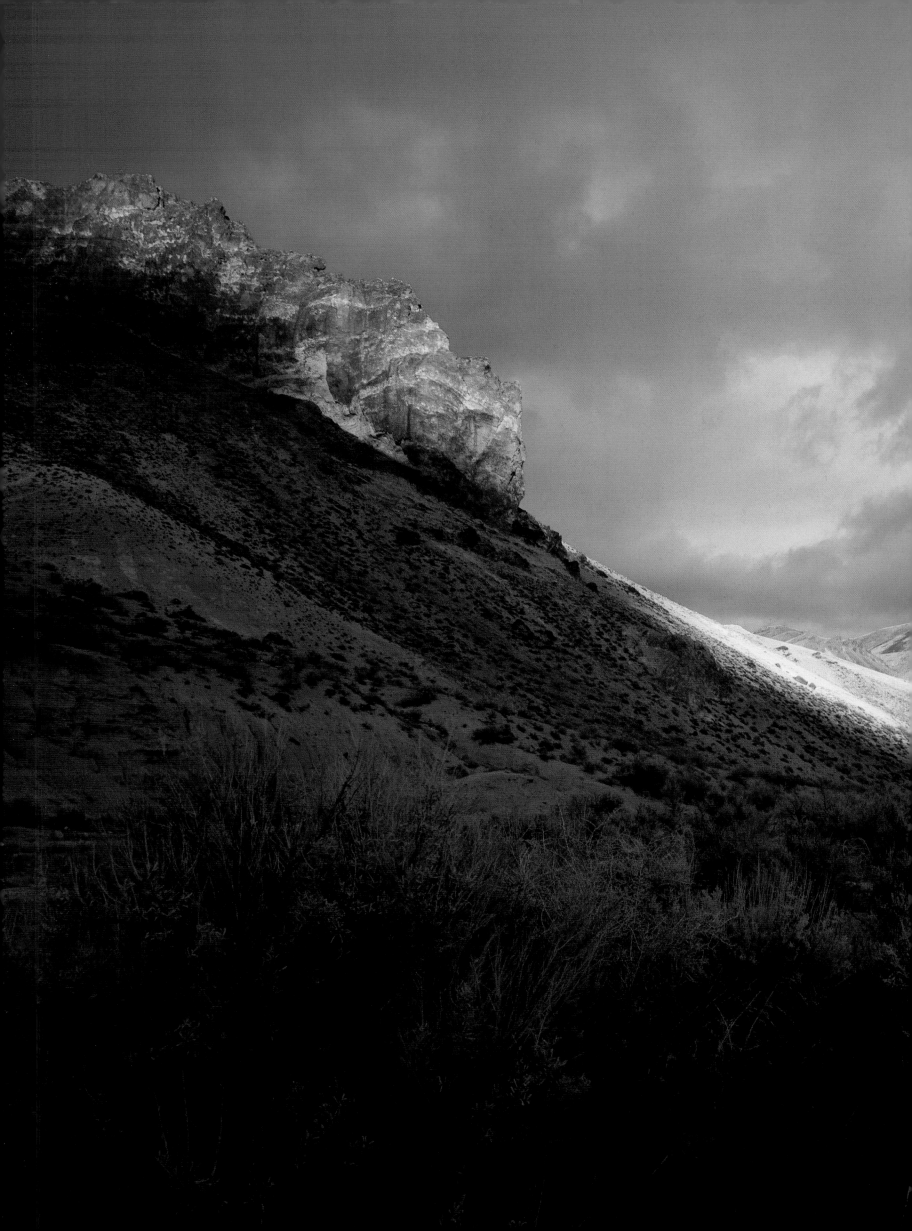

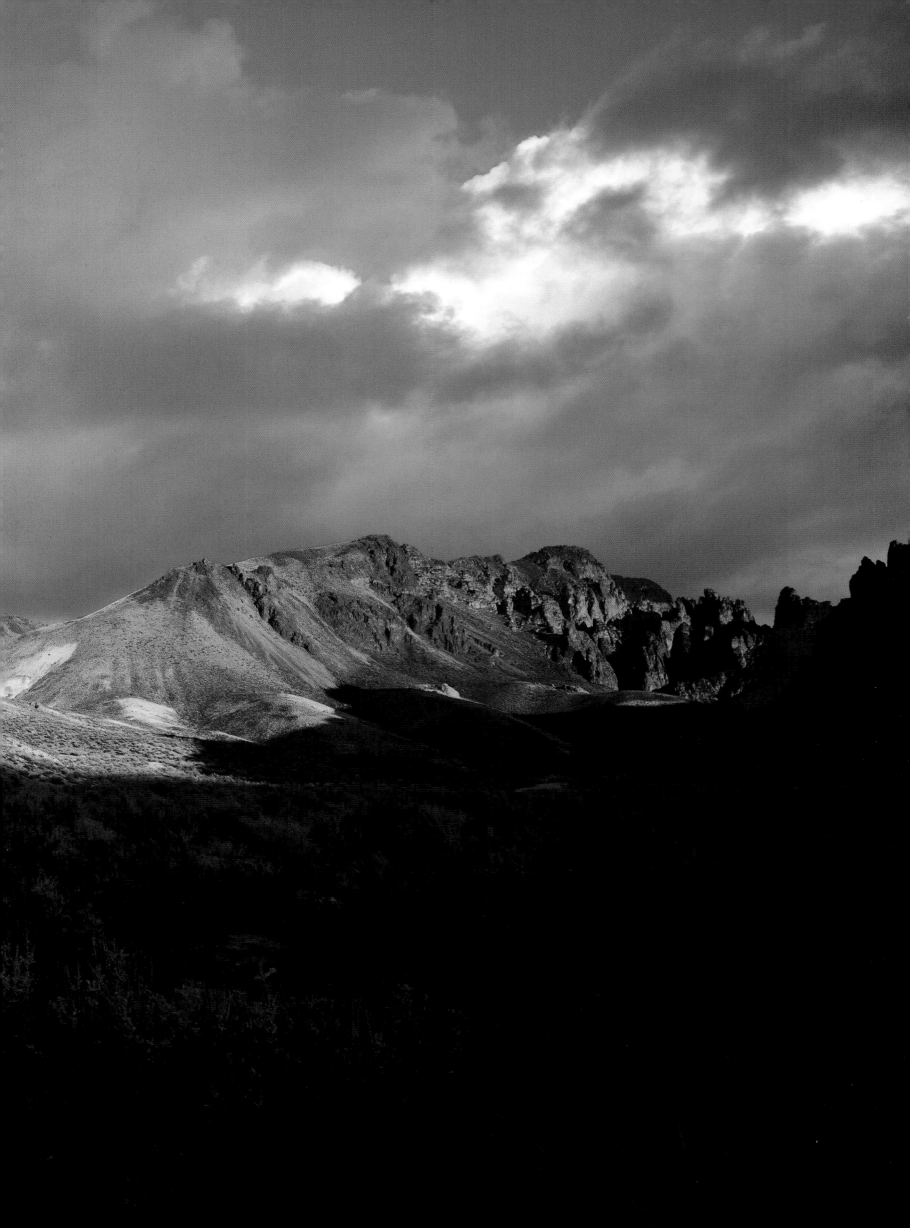

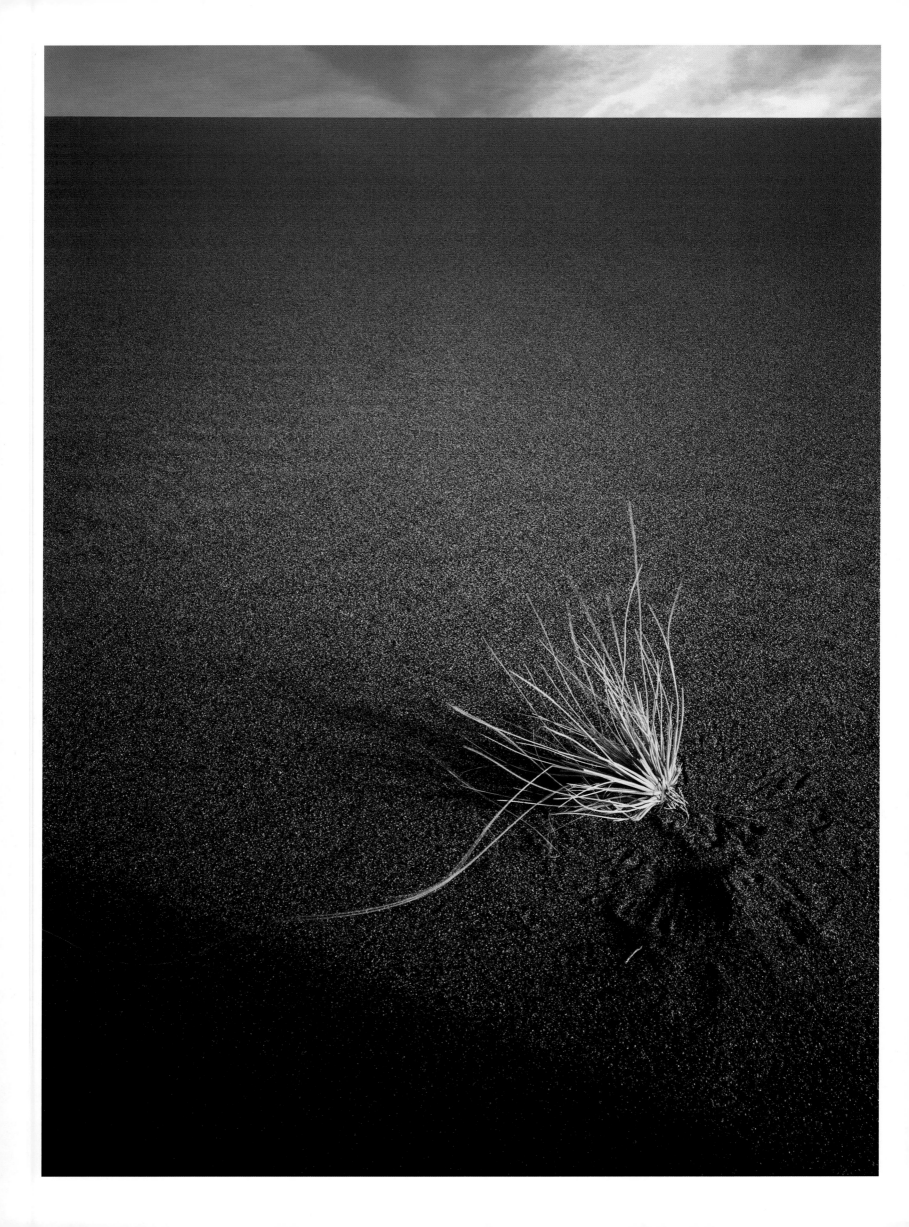

Dried grass covers the high desert of the Owyhees in southern Idaho. The Owyhee–Bruneau area extends north from the Jarbridge Wilderness Area in northern Nevada into southern Idaho and Oregon, and covers a region twice the size of Yellowstone National Park.

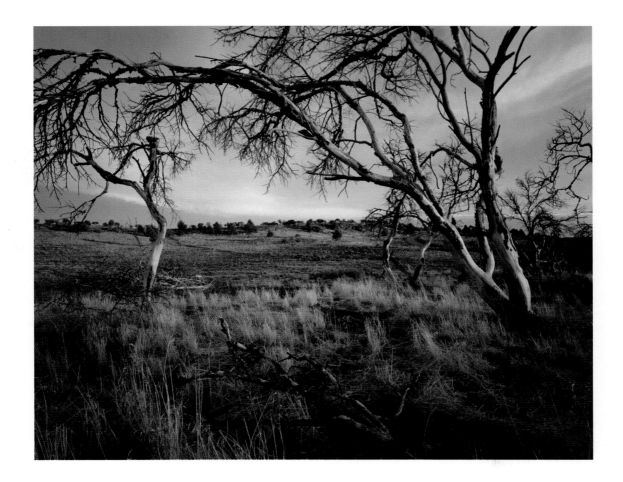

Hearty desert vegetation (left) struggles to survive in the harsh Owyhee desert. The Owyhee-Bruneau Canyonlands, which cover almost three million acres, range from deep-river canyons to an inland sagebrush sea, and to high plateaus covered with piñon-juniper woodlands.

Snow-covered cliffs (overleaf) rise high above the Snake River Birds of Prey National Conservation Area. With more than 800 pairs of hawks, eagles, falcons, and owls nesting in the lava cliffs and surrounding desert plateau, this is home to the densest population of nesting birds of prey in North America.

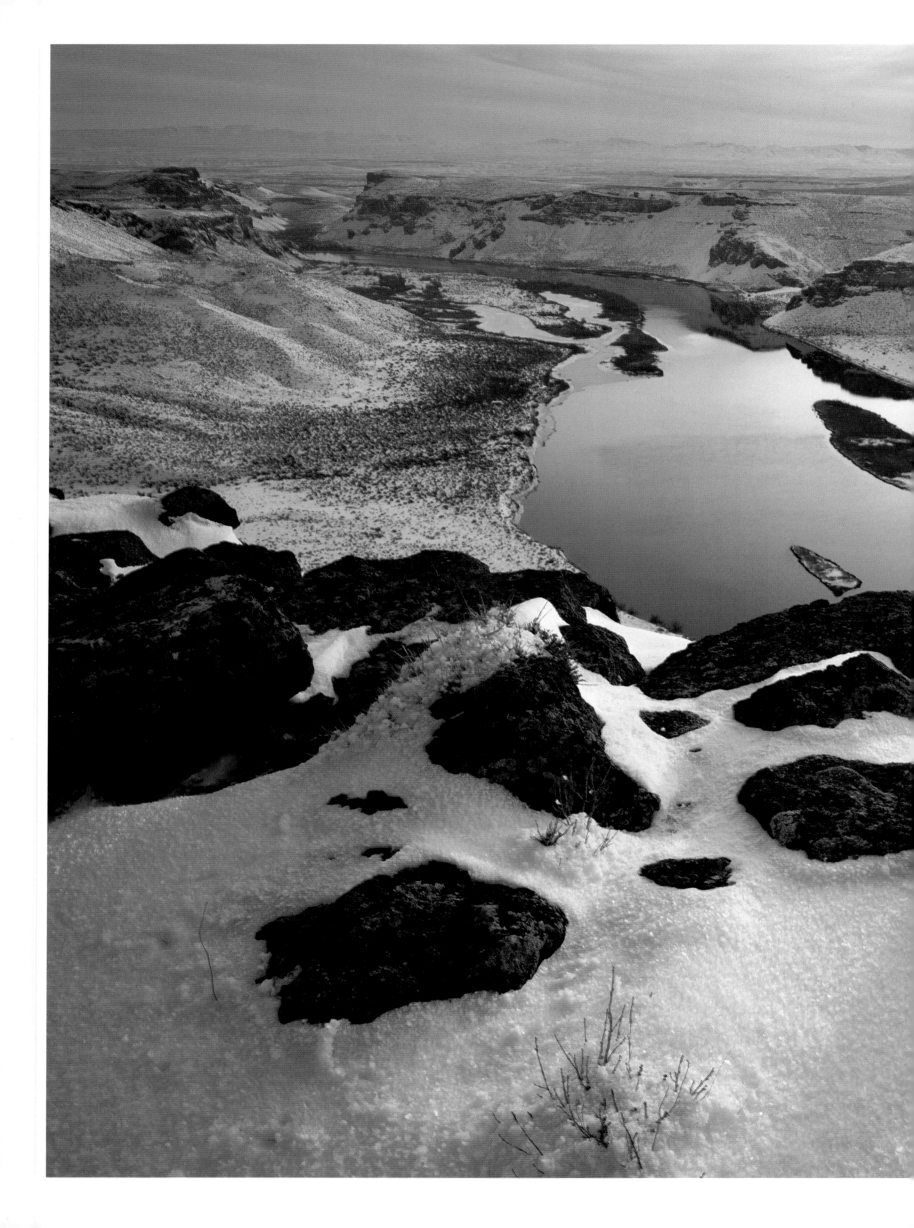

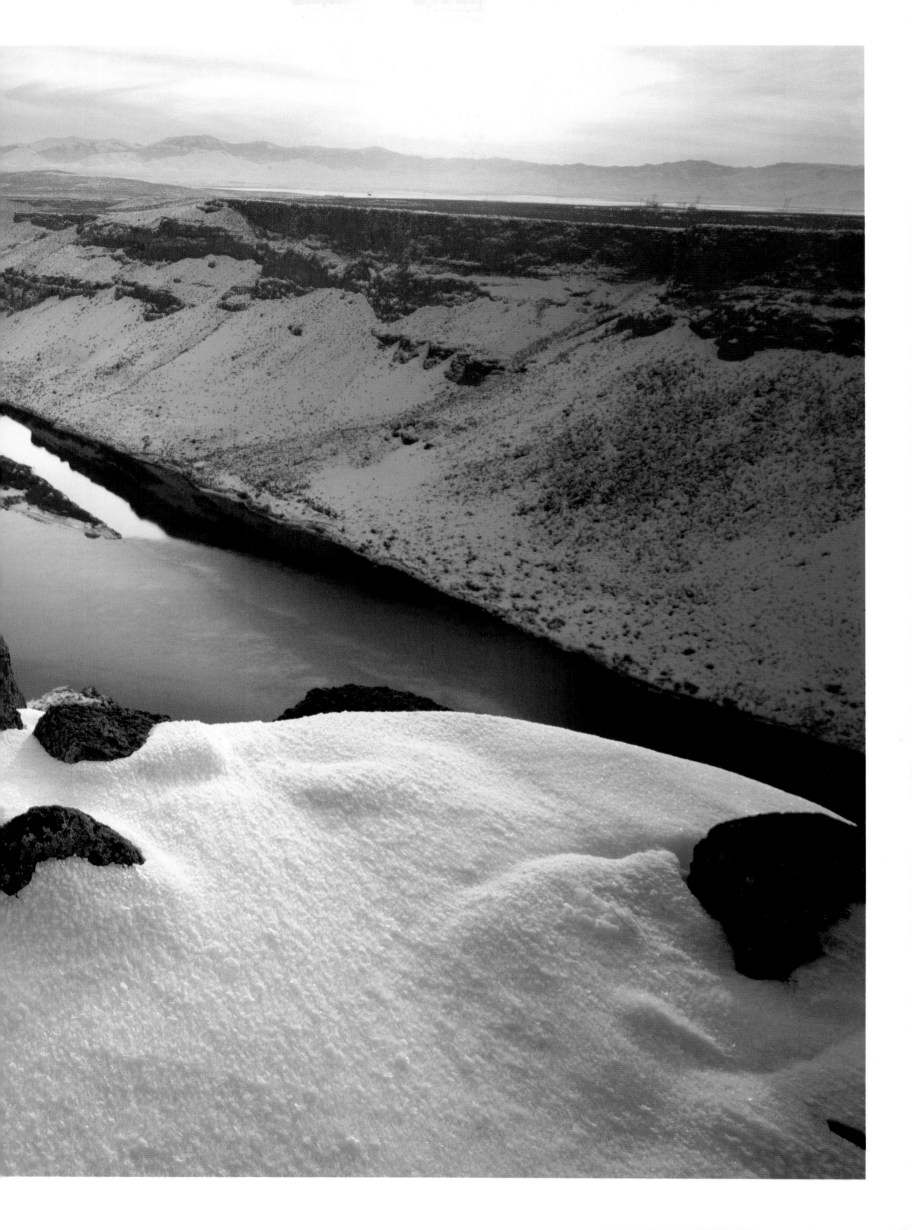

The Camas Prairie, Idaho, an arid region east of Hells Canyon—and the easternmost extension of the Columbia River basalt field—was an important gathering area for the Nez Perce. Its sediments were laid down by the outflow of yet another Pleistocene inland sea, the ancient Glacial Lake Missoula in the Idaho Panhandle and Western Montana.

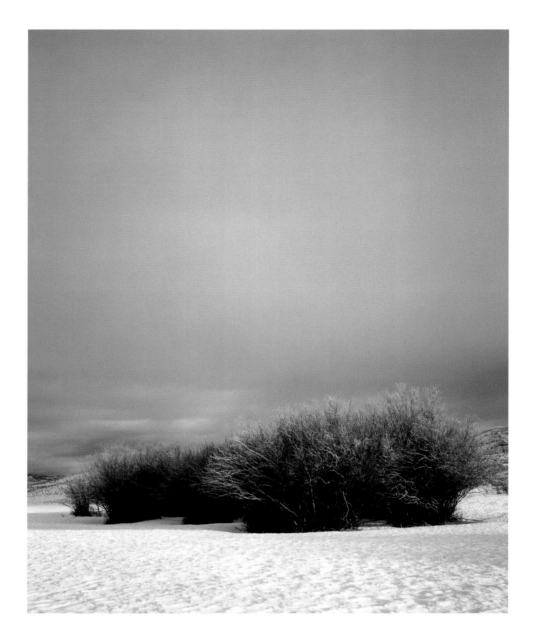

Ice crystals form around rocks in the North Fork of the Owyhee River.

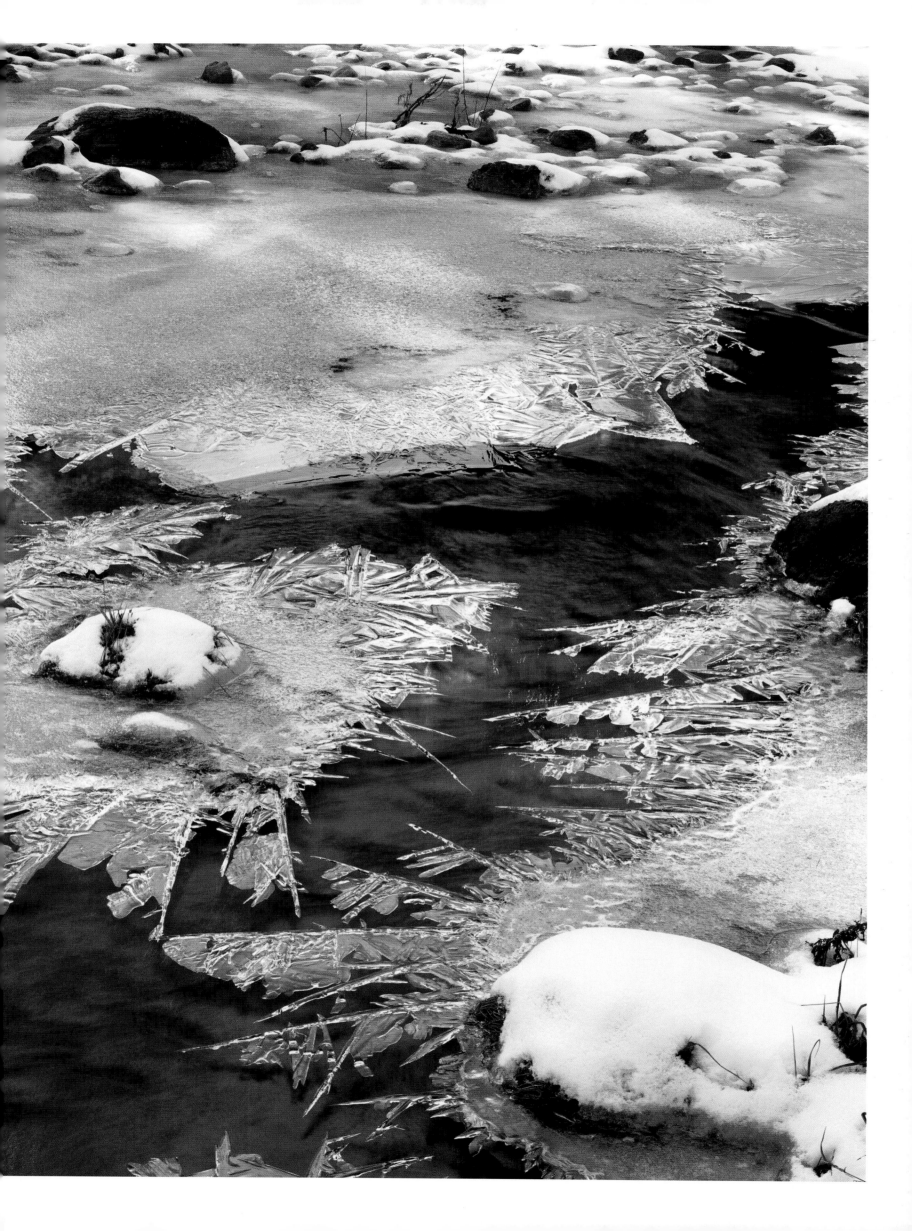

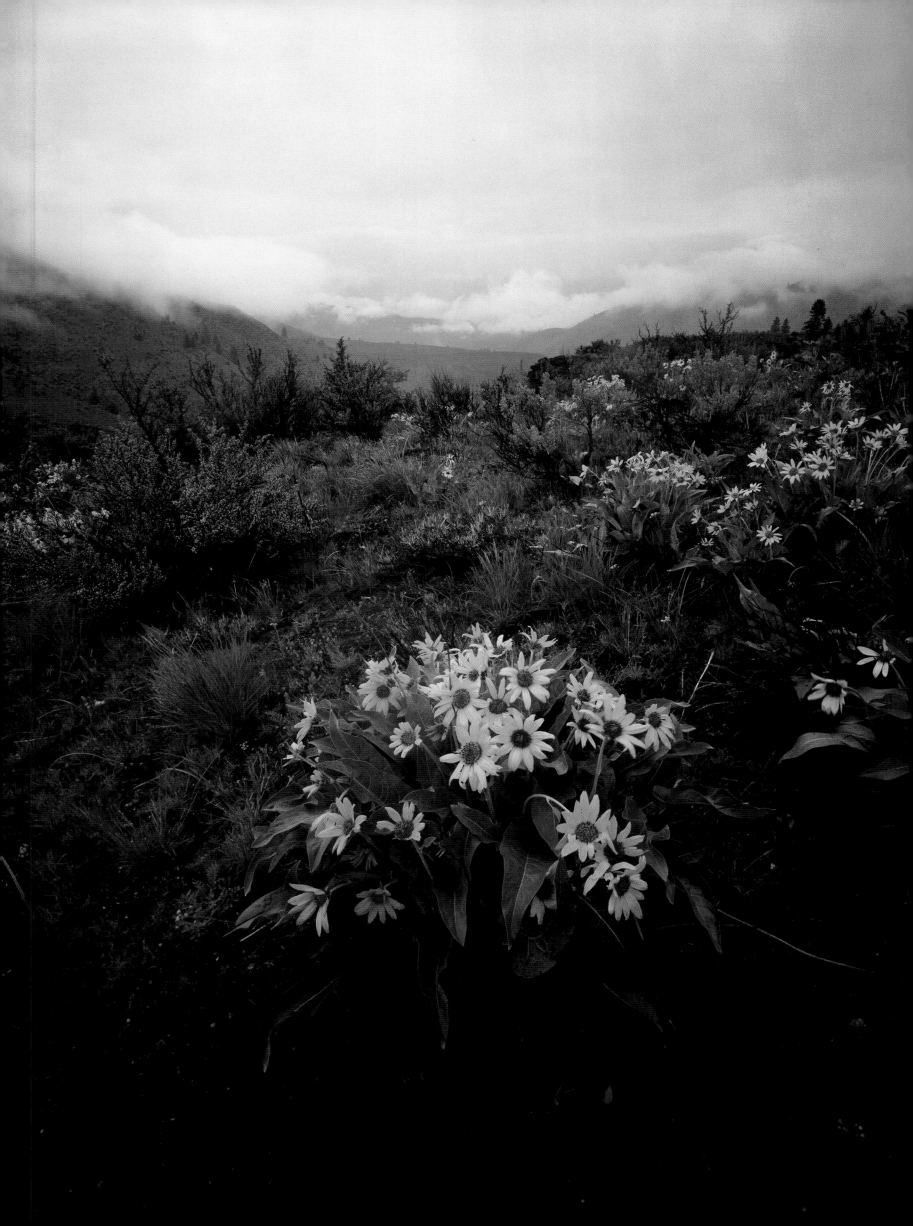

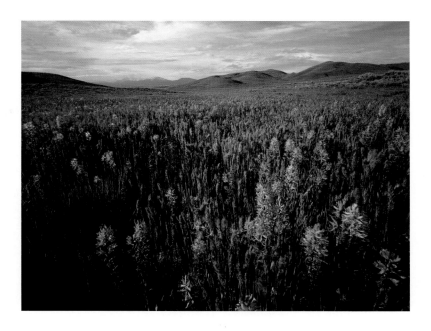

Purple camas bloom (right) near Fairfield on the Camas Prairie. Prior to the advent of modern agriculture in the area, the Nez Perce harvested the camus root as a staple food source.

Yellow lupine (below) dot the hillsides below Steens Mountain in southeast Oregon, a 9,670-foot-high fault block that is the largest mountain mass in the northern Great Basin.

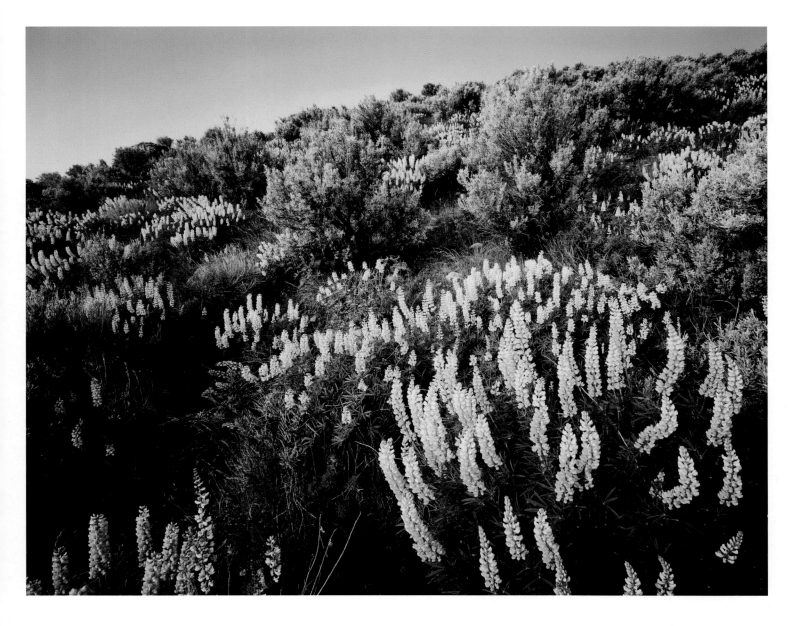

Arrowleaf balsamroot (*Balsamorhiza sagittata*), which blooms here in the foothills of the Boise National Forest, is a widespread and hardy member of the sunflower family.

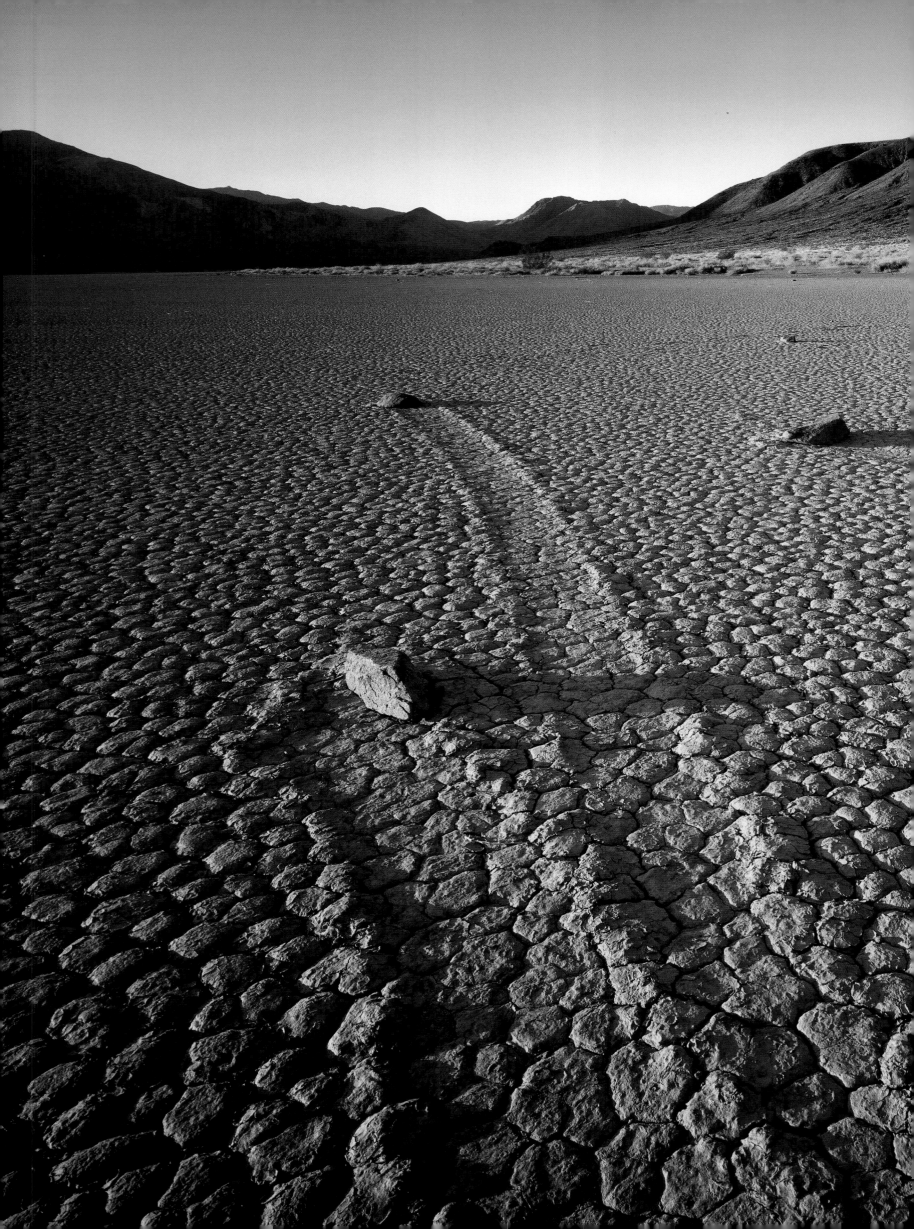

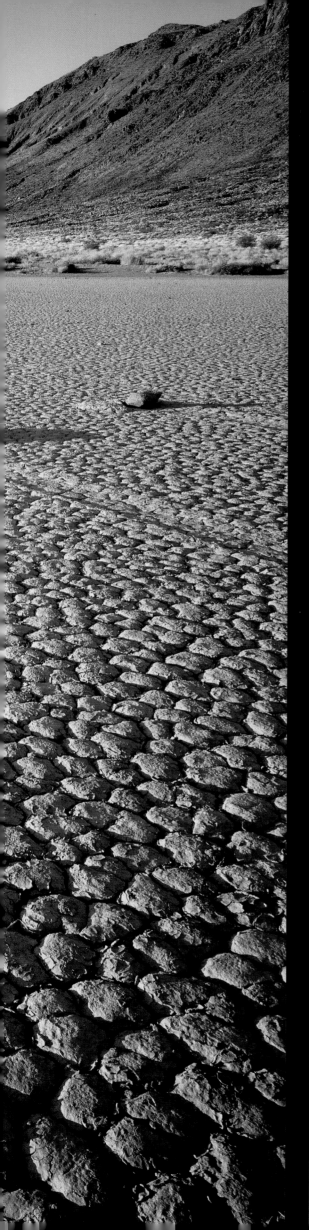

DESERT
WATER

THE MOJAVE, most of which is located in California to the north and east of Los Angeles, is one of the smallest of the five American deserts. Its 25,000 square miles, which straddle the transition from the Great Basin desert to the north and the Sonoran to the south and east, host what is one of the hottest and driest places in the world, Death Valley. Daytime air temperatures there have been measured at 134°F, while the ground surface can reach 190°F. Its annual rainfall is a scant 1.7 inches, and in some years no rain falls at all within the valley. The Mojave has a relatively low base elevation and contains the lowest point within the country—282 feet below sea level at Badwater in Death Valley—yet it also boasts peaks over 11,000 feet.

Water in the Mojave arrives mostly as precipitation during the winter, but unlike the higher and colder Great Basin, this more southerly desert has approximately 250 species of annual flowers that can bloom in the spring, given sufficient rain. Eighty percent of them are endemic to the Mojave, and the tall yucca known as the Joshua Tree—actually a member of the lily family—tends to grow around the higher elevations defining the borders of the Mojave. The most prevalent shrub of this small desert is the creosote bush, which can dominate up to 70 percent of its terrain. The creosote grows outward in cloned rings, and individuals in the Mojave are among the oldest living things on Earth.

Because of its location in between Hollywood and Las Vegas—between both the movie industry and major universities—it is also the most frequently filmed, well-studied, and visited desert on the planet. As a result, a large portion of it is now protected within the Mojave National Preserve, Death Valley National Park, and Joshua Tree National Park.

Rocks on the Racetrack of Death Valley National Park are pushed across the valley floor when it is wet and windy, leaving shallow grooves across the playa.

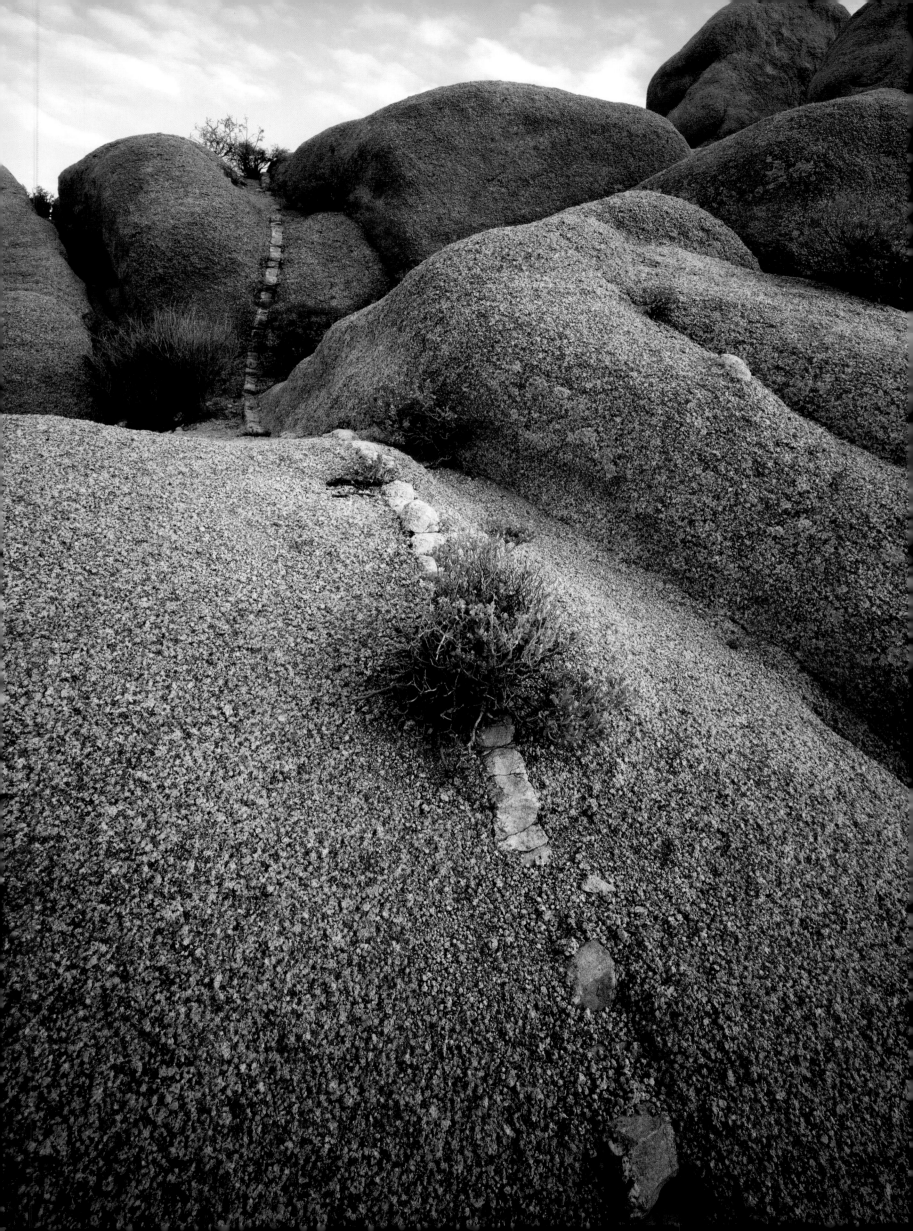

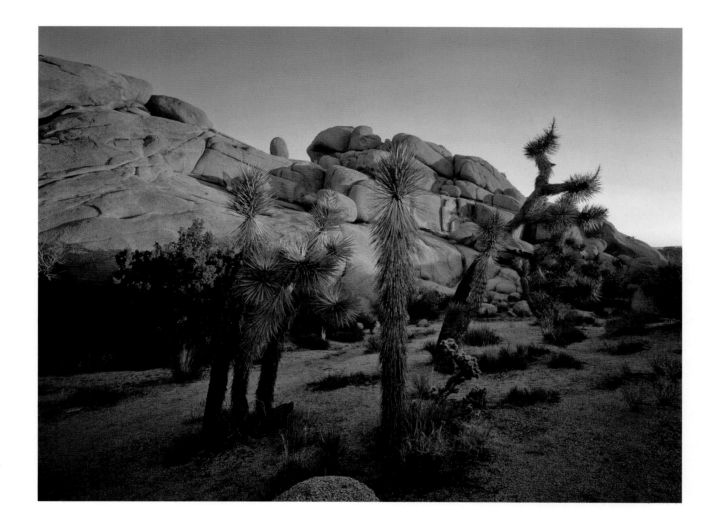

An intruded dike (left) of quartz stair steps up through granite crags in Joshua Tree National Park.

California poppies *(Eschscholzia californica)* and desert phlox *(Phlox tenuifolia)* (overleaf) fill the hillsides of Antelope Valley during spring in the Mojave Valley north of Los Angeles.

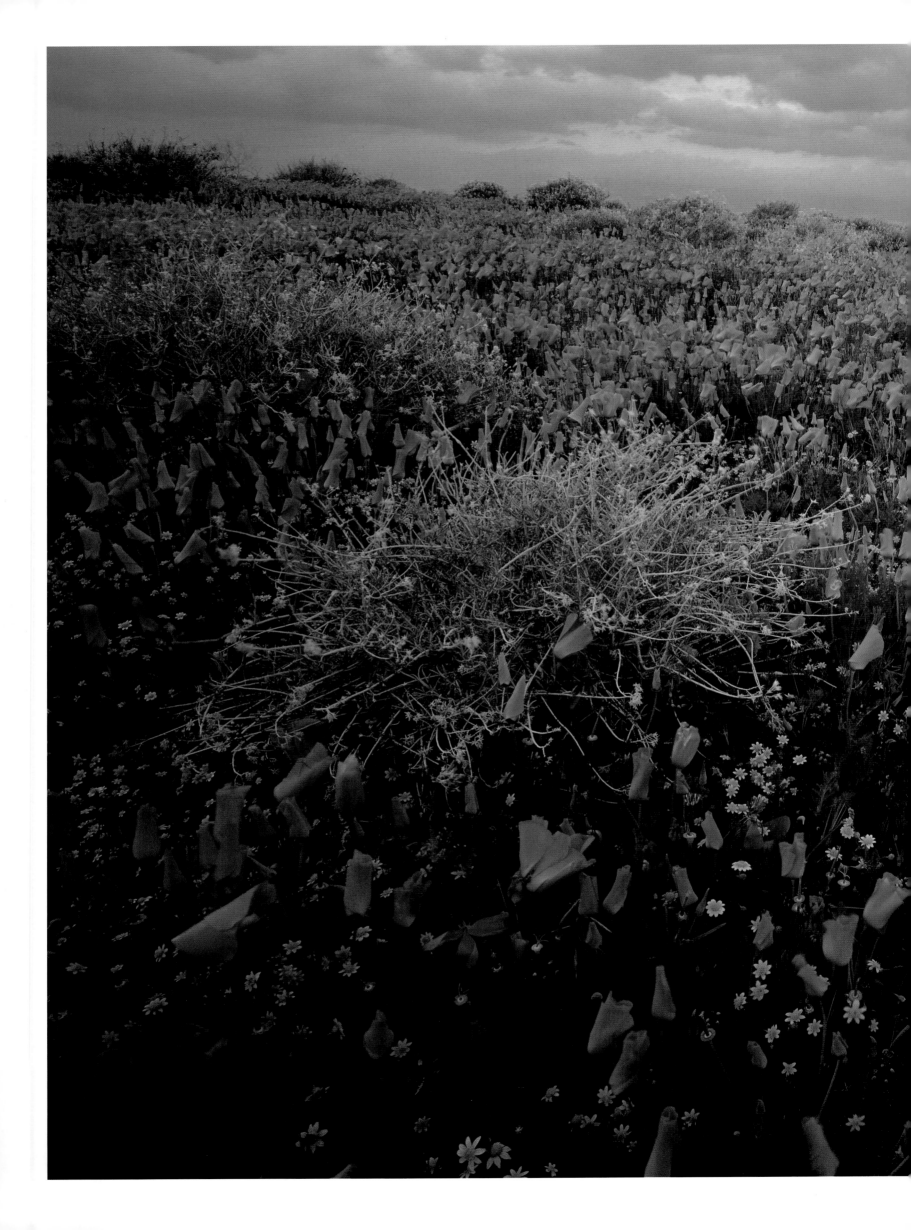

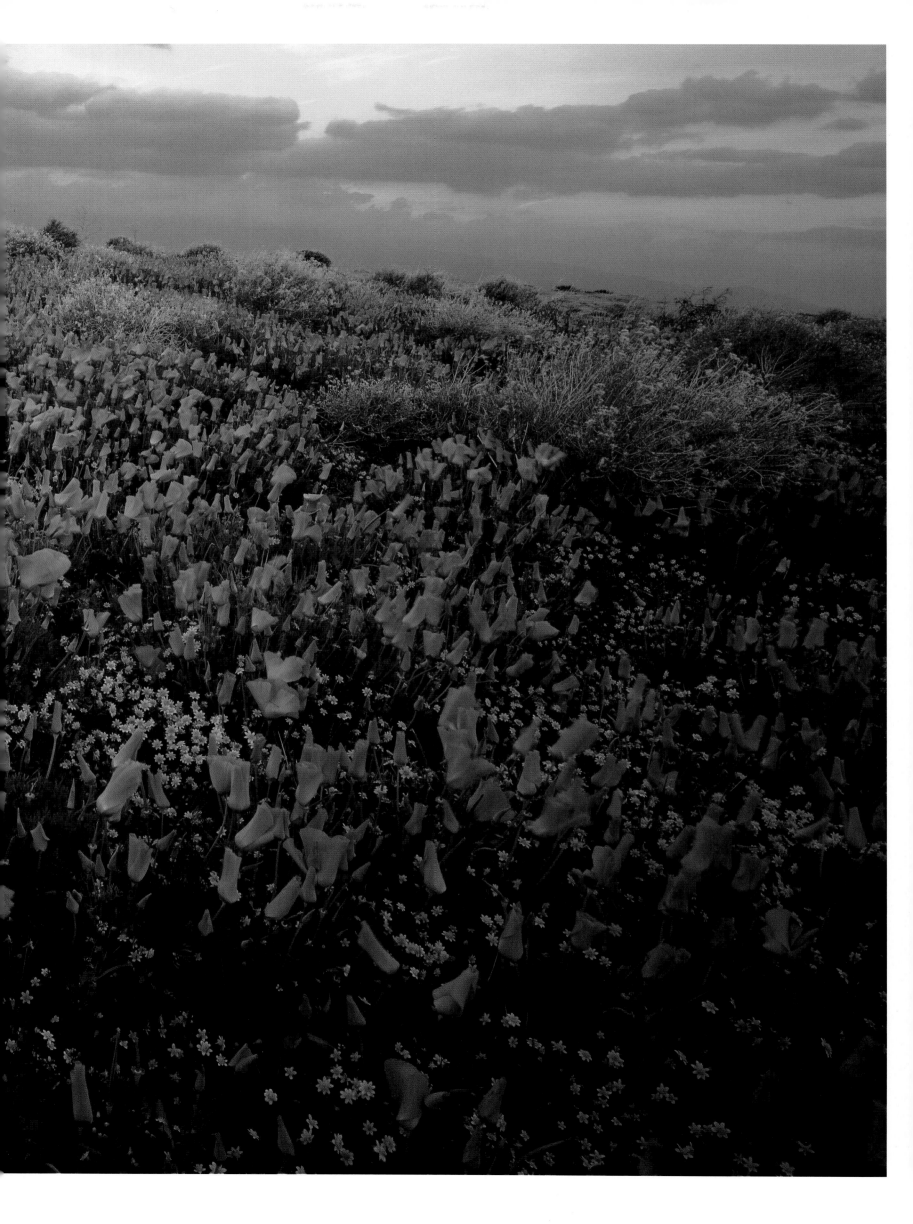

The crystallized salts of Death Valley's Devil's Golf Course were deposited originally by a lake that vanished more than 2,000 years ago. Minerals continue to be deposited on the patterned ground when rainstorms flood the salt pan.

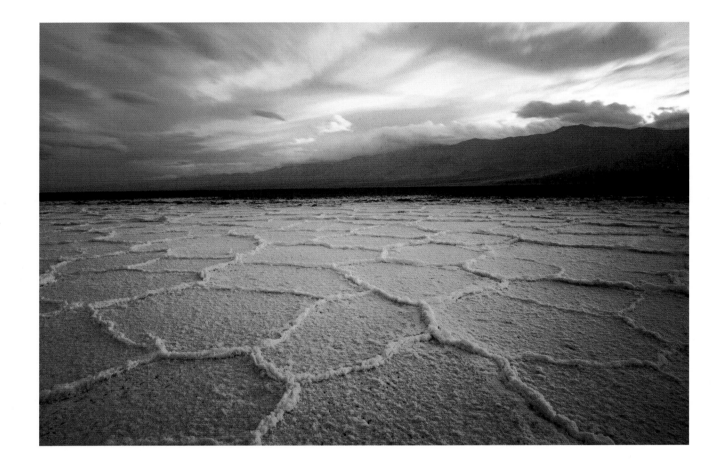

Hardened polygons resemble giant cobblestones at the base of giant dunes in Death Valley.

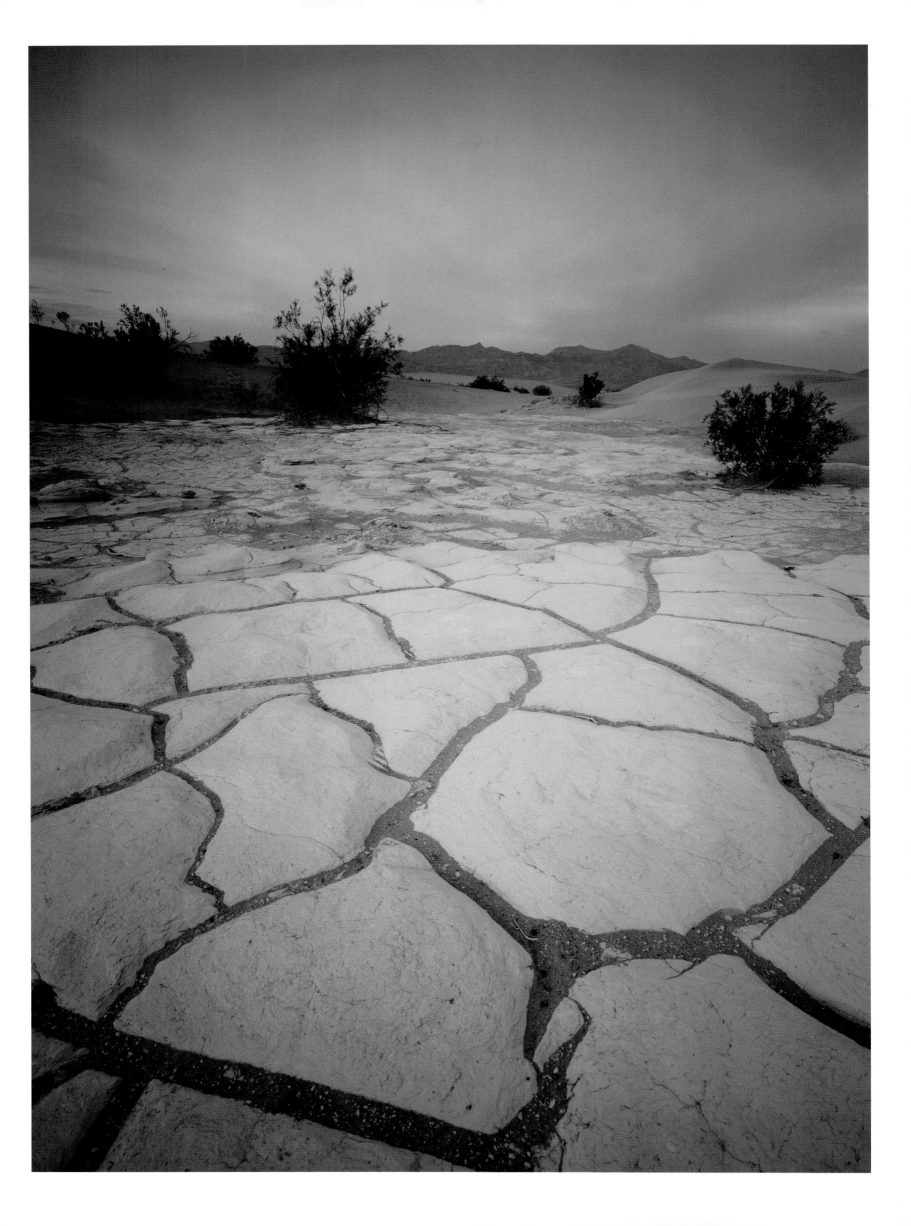

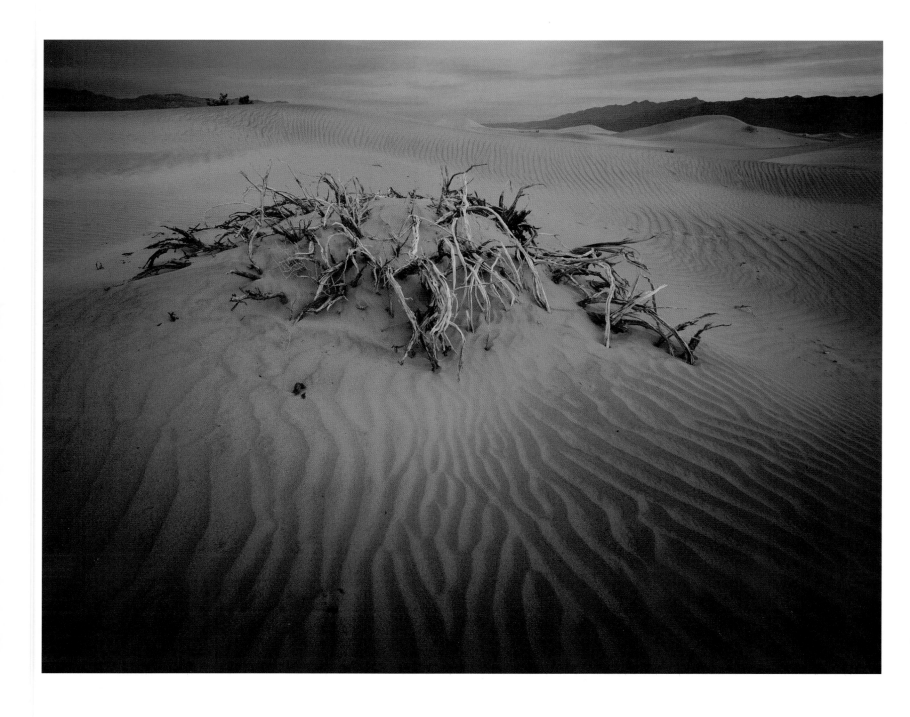

Pink clouds illuminate the dunes of Death Valley National Park. Plants growing on dunes often depend on long taproots to reach groundwater. The blowing sands are trapped by the foliage, then slowly push it ever higher each year until it can no longer reach the water. When the plant dies, the sand disperses, only to build up underneath new growth nearby.

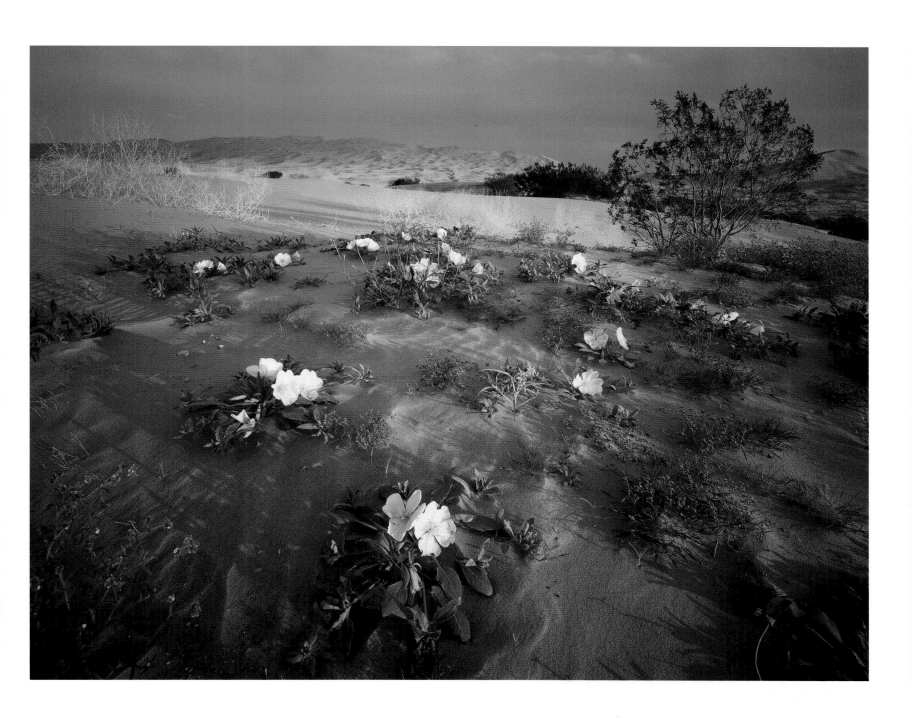

Desert primrose *(Oenothera deltoides),* which bloom at sunset, grow in the warm sands of the Kelso Dunes in the Mojave National Preserve of California.

Mojave yucca *(Yucca schidigera),* also known as Spanish dagger, is an evergreen shrub. Shown blooming here in the Mojave National Preserve, it depends on the tiny pronuba moth for pollination. The female moths gather pollen, which they roll into small balls that they then deposit into another flower of the yucca. She also lays her eggs at the same time, the larvae from which feed on the developing fruit.

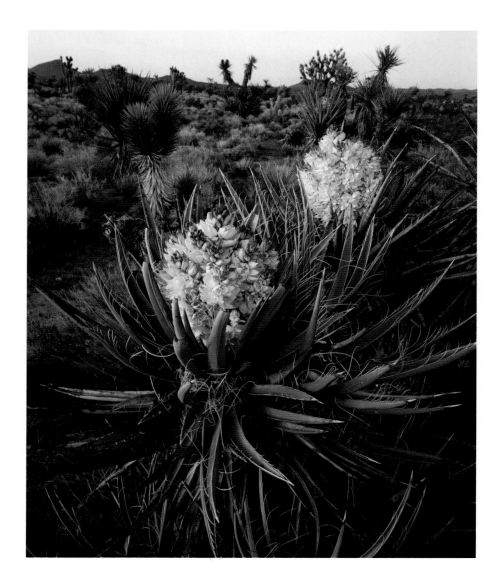

A claret cup cactus *(Echinocereus triglochidiatus)* blooms at the base of yuccas in the Mojave.

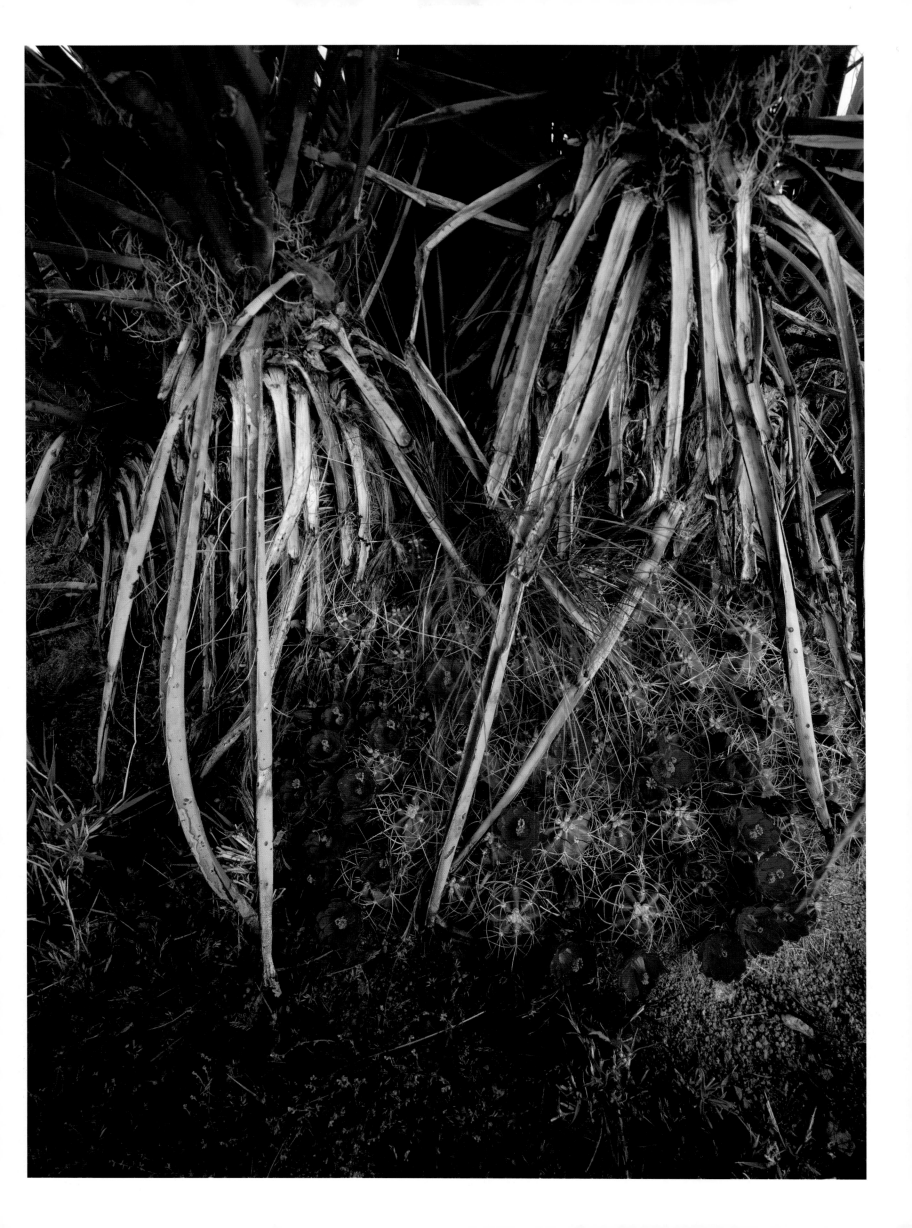

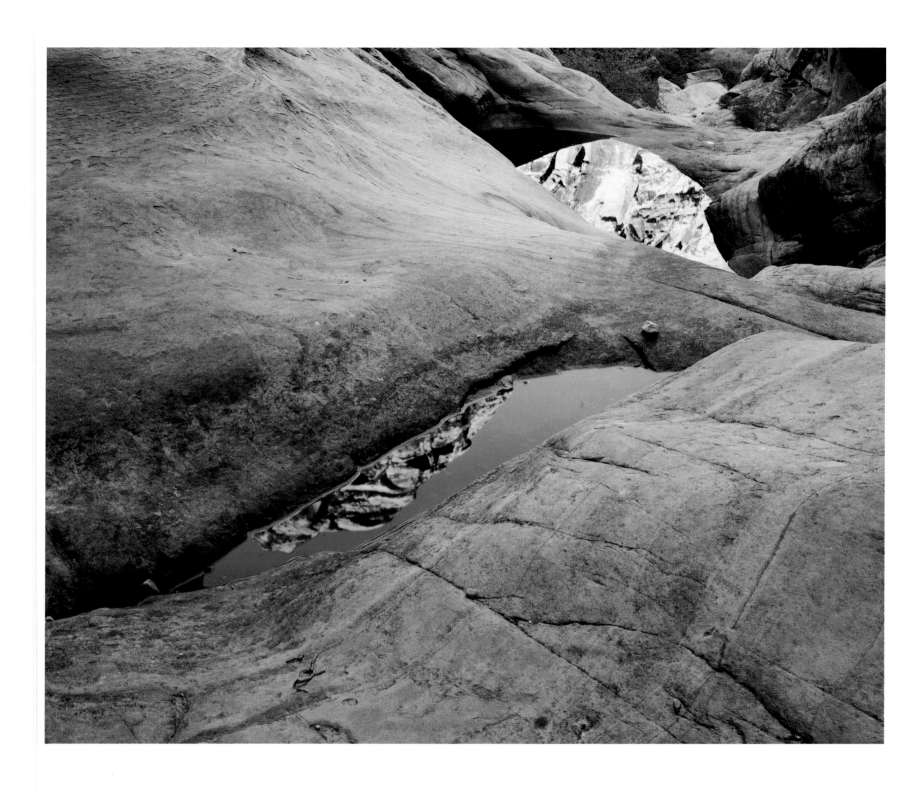

Water pockets are found all year long in the depths of Ice Box Canyon, Red Rocks Canyon National Conservation Area. The 197,000-acre park is located in the Mojave just seventeen miles west of Las Vegas.

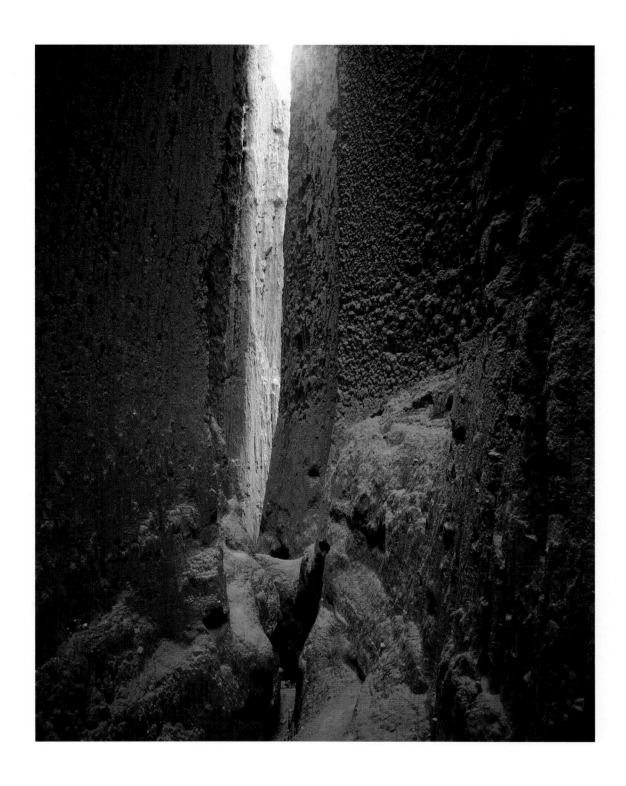

The soft bentonite clay in eastern Nevada's Cathedral Gorge State Park has been sculpted by erosion into buff-colored cliffs.

The cross-bedded Aztec and Navajo sandstones in Red Rocks (overleaf), which reach 2,500 feet in height and rival the cliffs of Yosemite in size and grandeur, are clearly visible from the Las Vegas Strip. The rocks in the foreground are remains of ancient sand dunes.

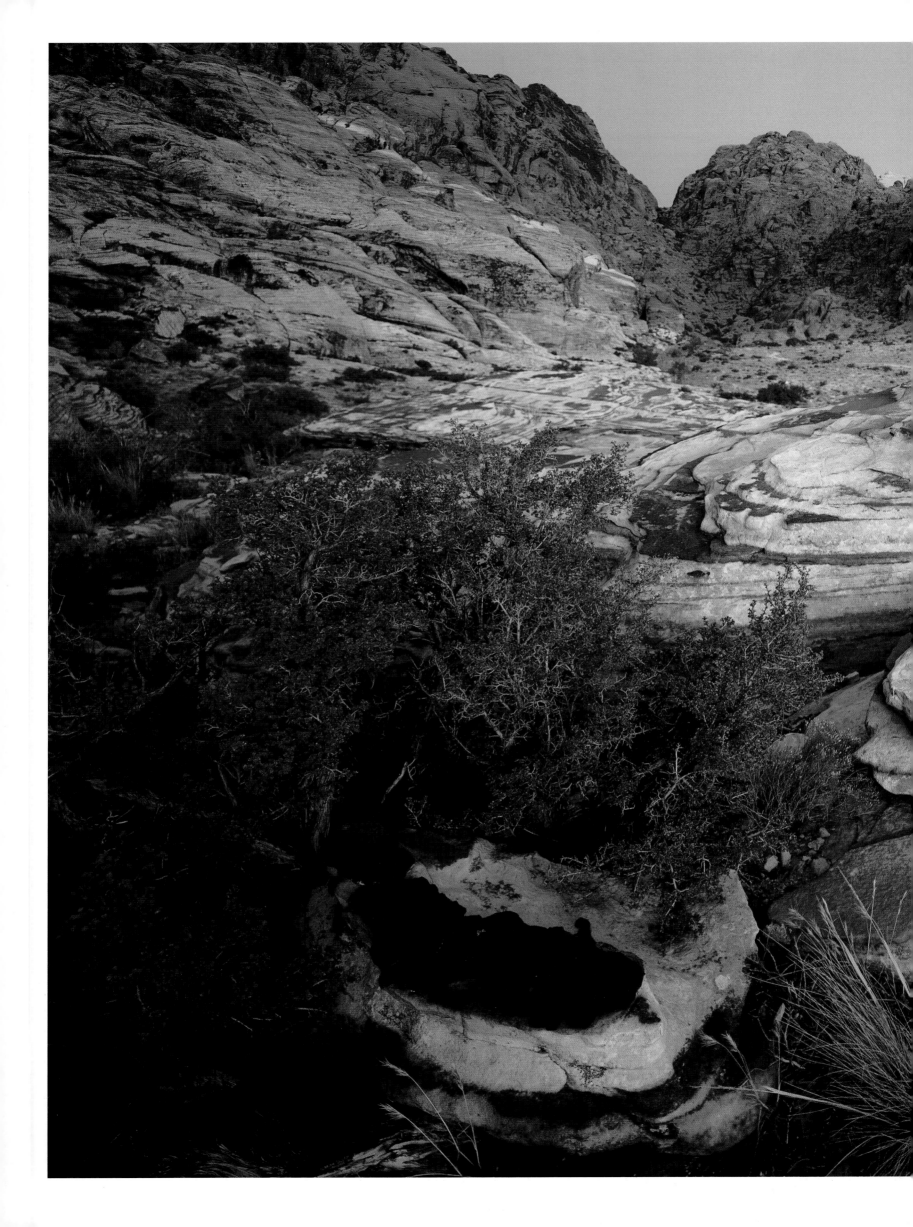

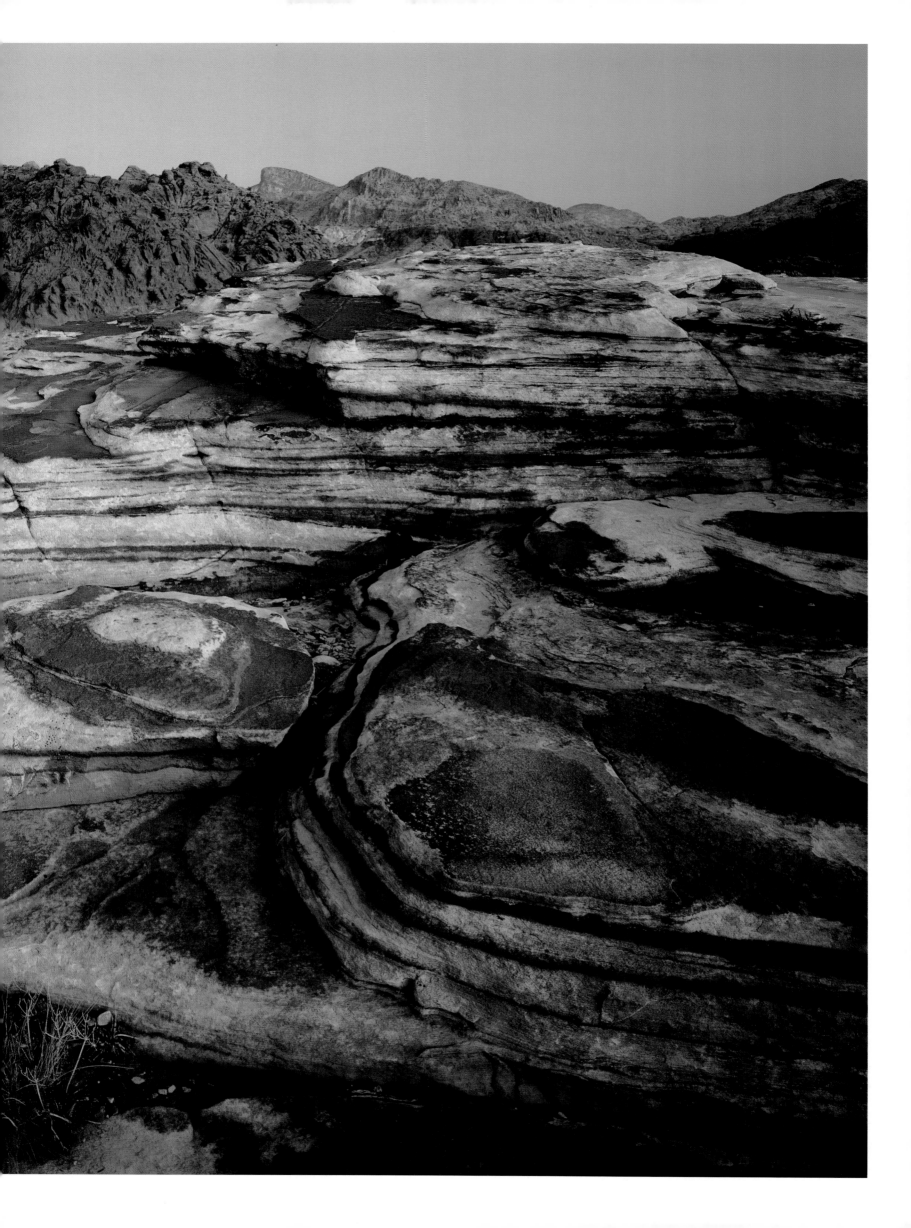

DESERT WATER

THE COLORADO PLATEAU is a vast arid region that covers 130,000 square miles, but only a quarter of it qualifies as desert by virtue of receiving less than ten inches of rain annually, most of which falls as snow in the winter. Yet the portion th udes southeastern Utah, northeastern Arizona, southwestern Colorado and northwestern New Mexico—the greatly expanded version of the Four Corners Area that is also known as Indian Country—contains some of the most vivid desert scenery in the world. The concentration of national parks is unequaled: the Grand Canyon and Painted Desert in Arizona; Canyonland, Zion, Bryce Canyon, Arches, and Capitol Reef in Utah. All are famous internationally for their scenic climaxes.

The intense scenery is mostly the result of water acting on rock over long periods of time. The stacked, uplifted, and windblown sedimentary rocks of the region, chiefly the sandstones, are everywhere deeply incised by creeks, rivers, cascades, and waterfalls. The immense Colorado River complex, which includes the Green and San Juan Rivers, cuts down through red, orange, and purple layers of rock. Volcanic cones and lava flows are also prominent in the region. The vegetation runs a gamut from the salt- and sagebrushes of the Great Basin, to rich grasslands and the mixed piñon-juniper forest of the highlands.

Lower Calf Creek Falls splay gracefully down a 130-foot cliff of Navajo sandstone to create an oasis in the Grand Staircase of the Escalante National Monument, Utah.

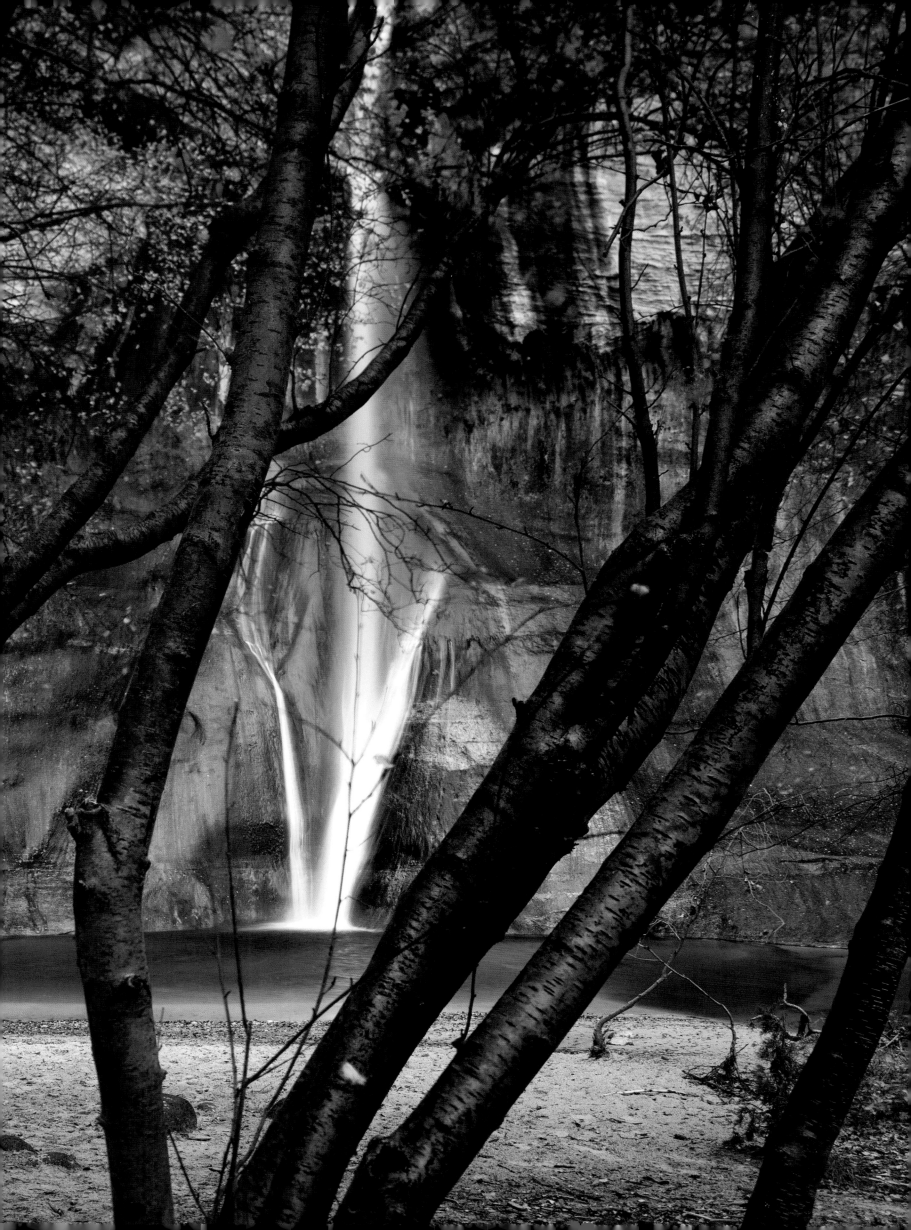

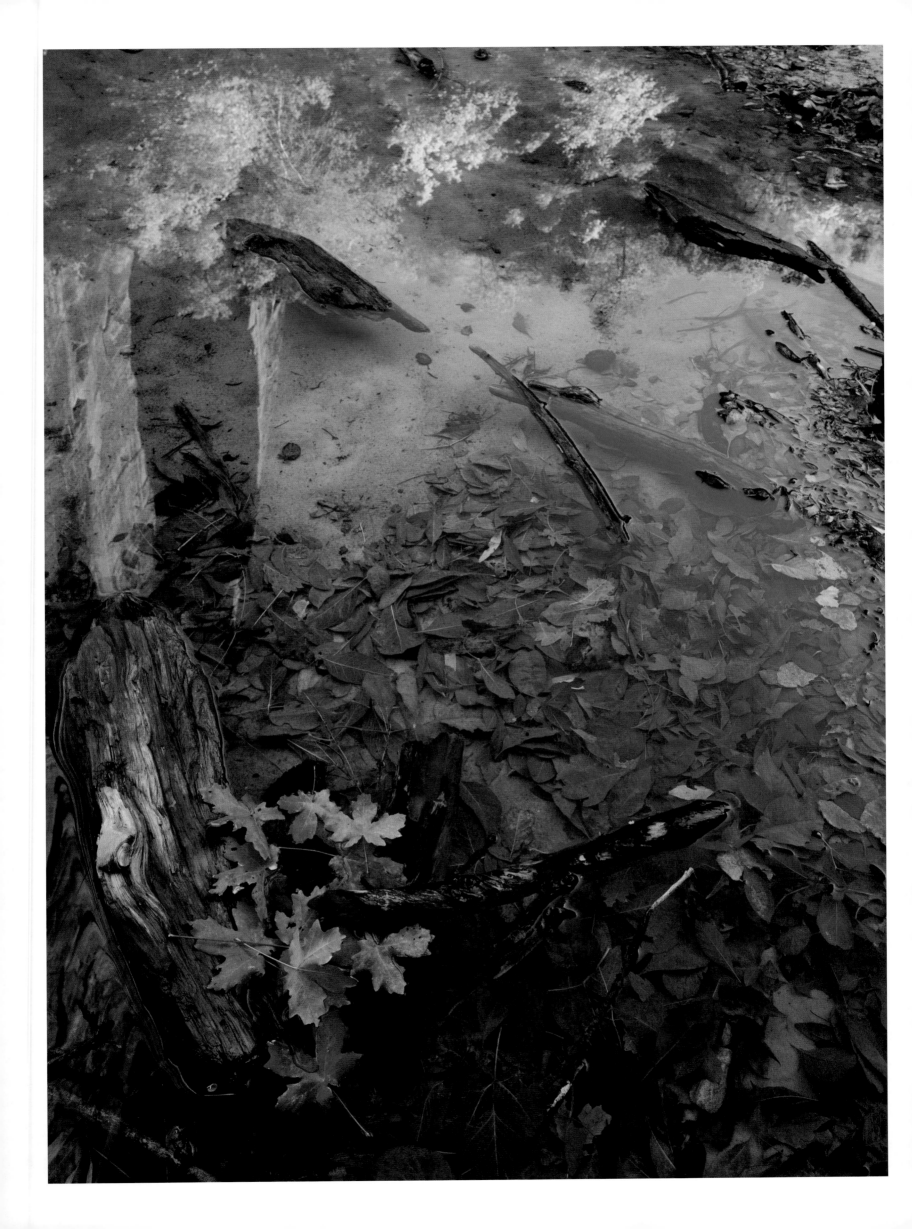

Calf Creek winds through fall foliage on its way down the Grand Staircase of the Escalante. Cottonwoods and box alder are interspersed with piñon and juniper in the canyon, which was once inhabited by the Fremont and Anasazi Indians.

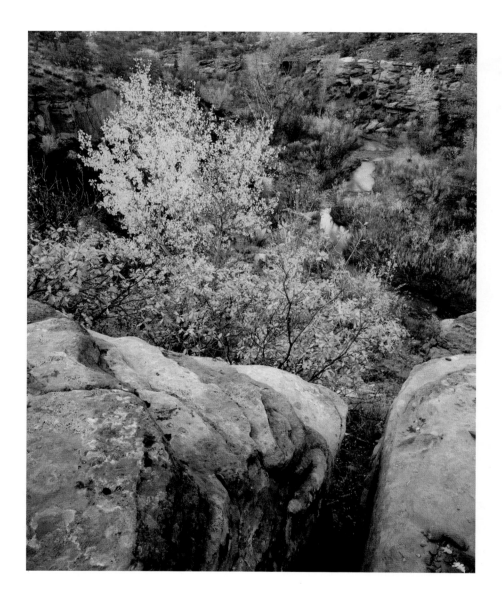

Fall foliage reflects into Upper Emerald Pool of the Zion Canyon in Zion National Park, Utah.

Sandstone monoliths in the distance stand isolated in the Cathedral Valley of Capitol Reef National Park. The soft Entrada sandstones were once sandy muds on a tidal flat, and the freestanding spires were carved by erosion from one to six million years ago.

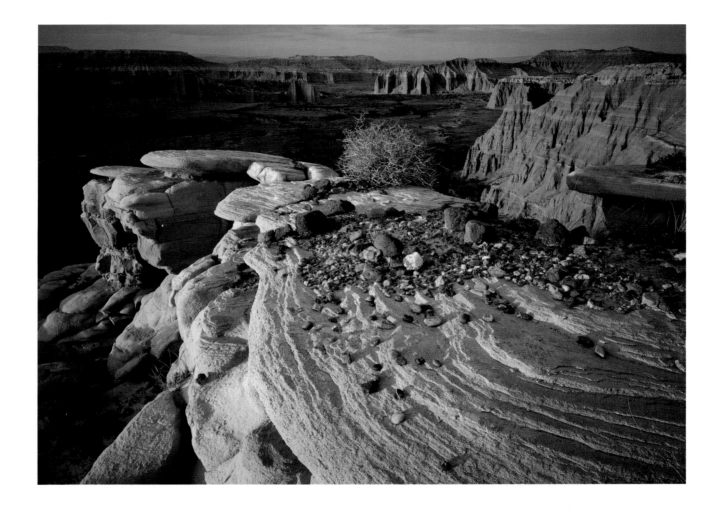

Ice hangs from a warm desert wash in Zion National Park, Utah. The park covers 229 square miles where the Great Basin and Mojave Deserts meet the Colorado Plateau.

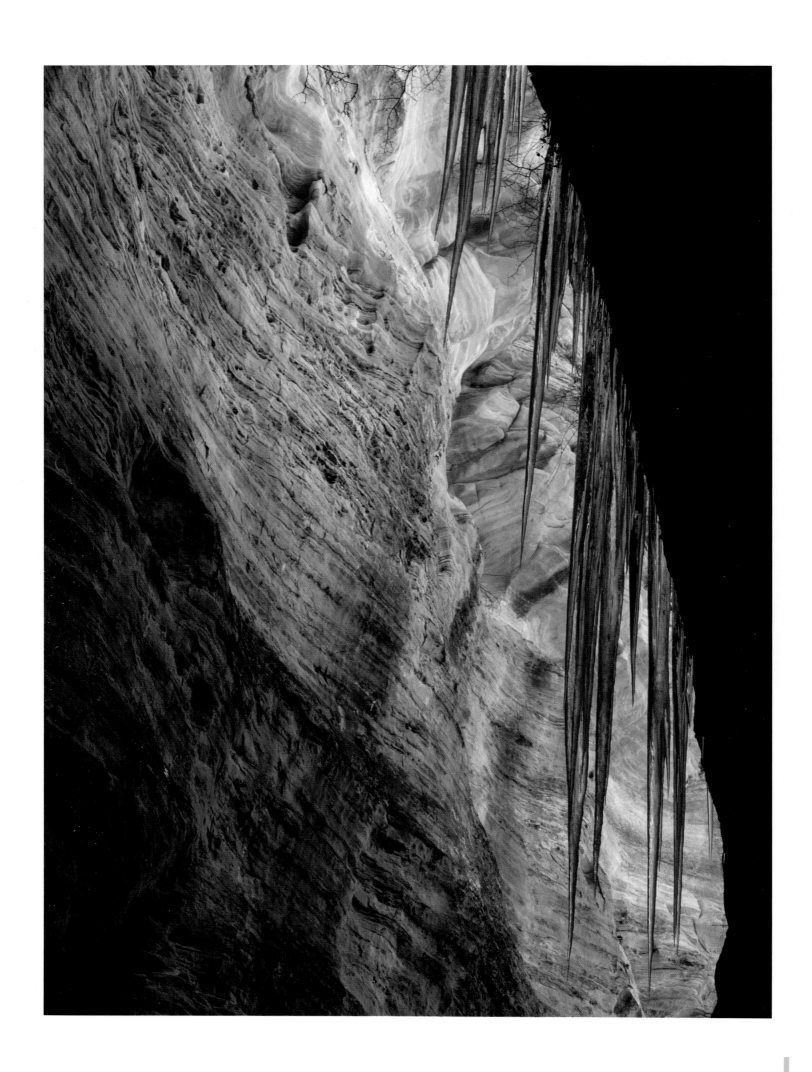

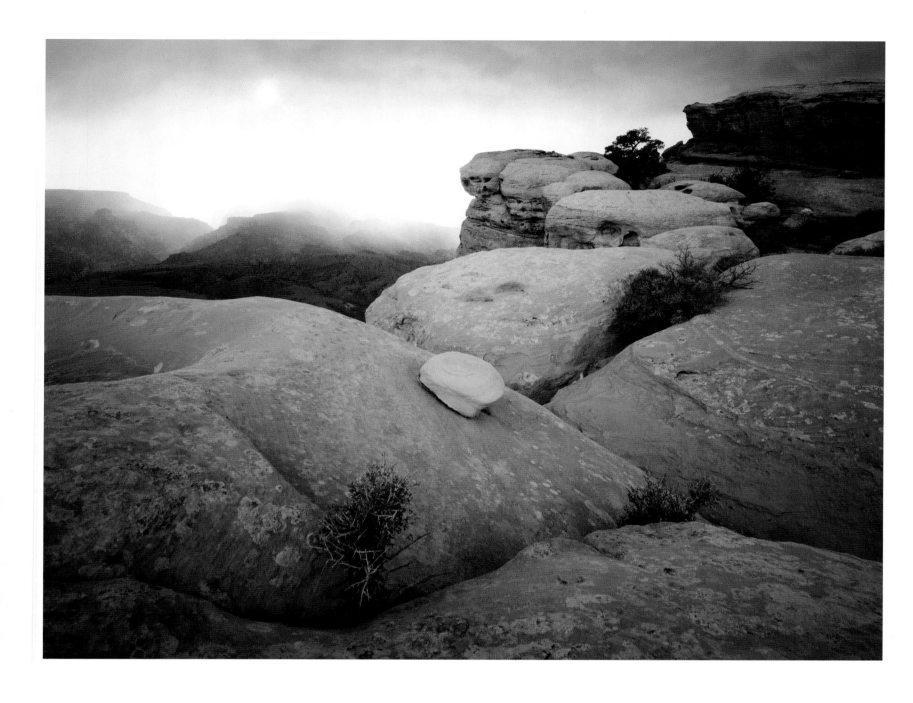

A snowstorm breaks over the cliffs and plateaus of Capitol Reef.

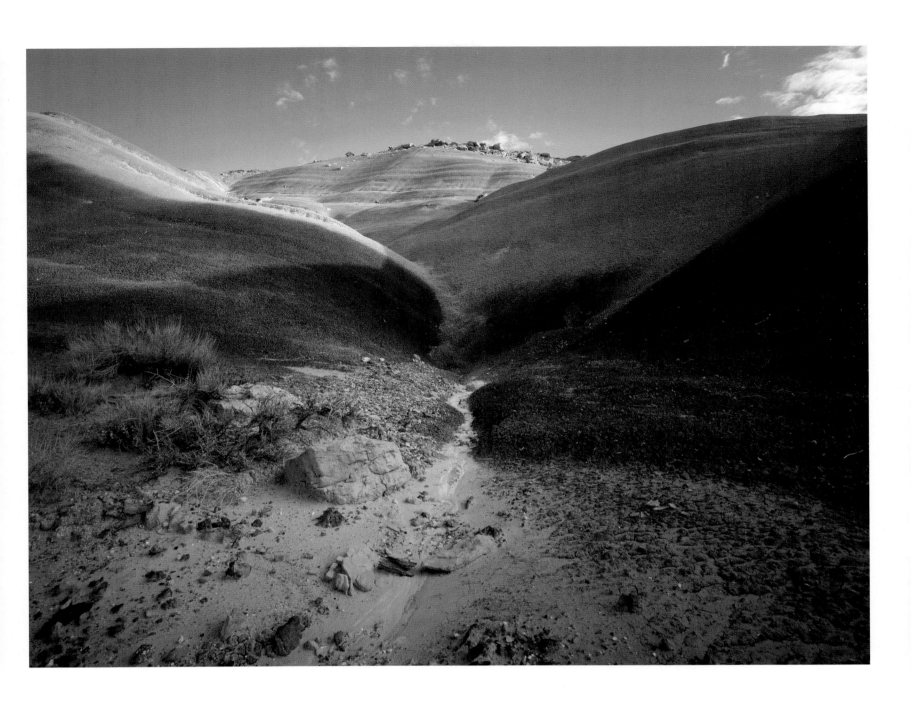

These colorful beninite cliffs in Capitol Reef are just a sample of the more than 10,000 feet of sedimentary layers found in the park, rocks that date from 80 to 270 million years old.

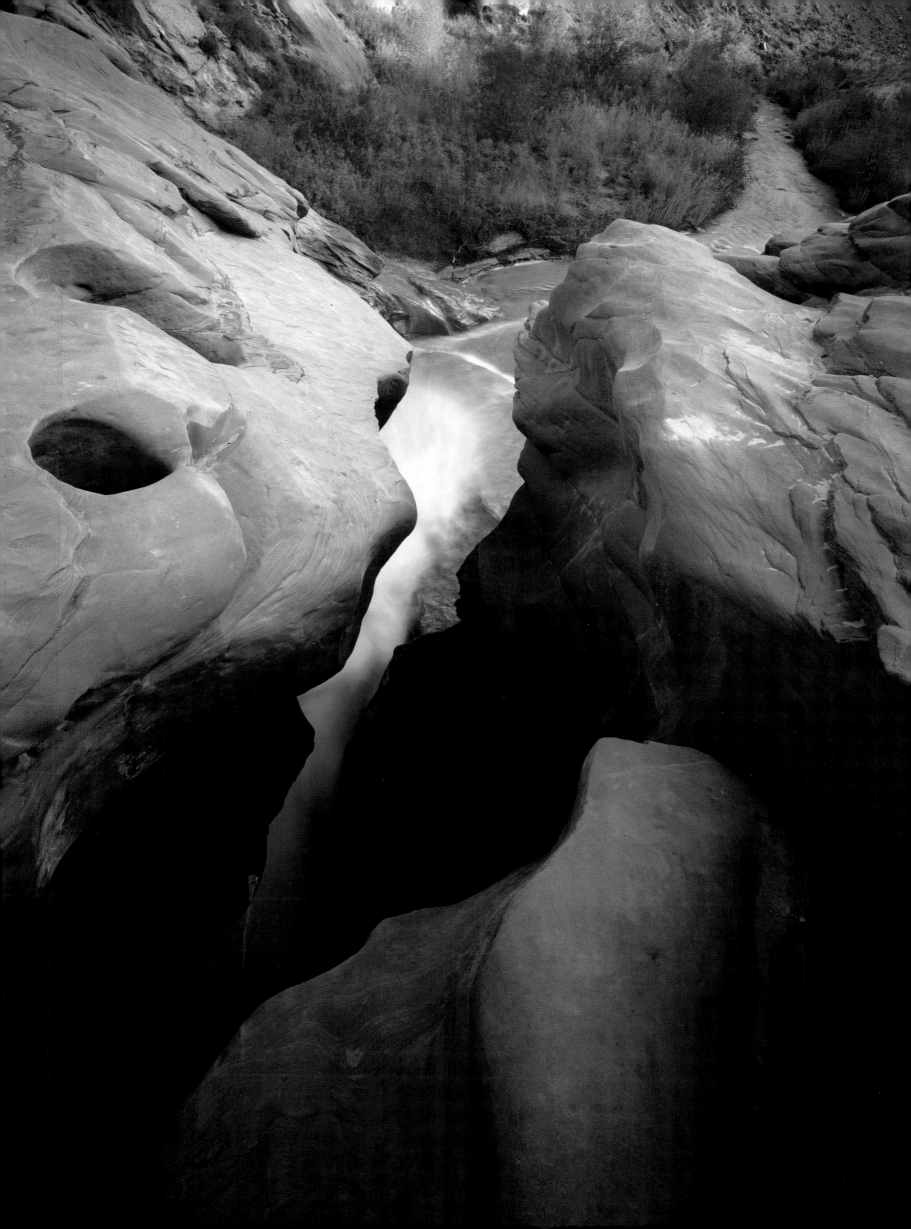

Yellow rabbitbrush *(Chrysothamnus nauseosus)* blooms at the base of a red sandstone rock in Capitol Reef National Park.

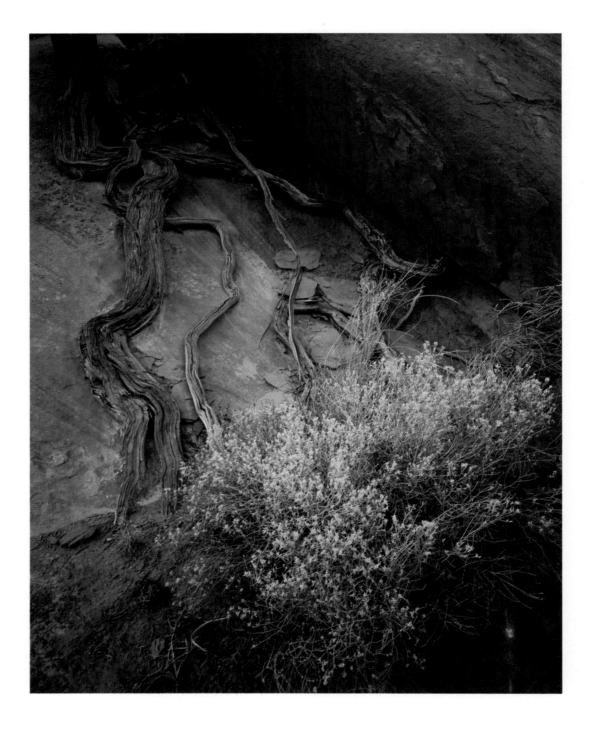

The Fremont River (left), an important drainage for Waterpocket Fold, cuts through soft sandstone in Capitol Reef.

Skyline Arch in Utah's Arches National Park (overleaf) is one of the more popular sights in the relatively small park, which nonetheless boasts more than 2,000 natural sandstone arches, the greatest density in the world. The foreground is framed by Mormon tea, an ephedra shrub, which has been used for medicinal purposes over the millennia.

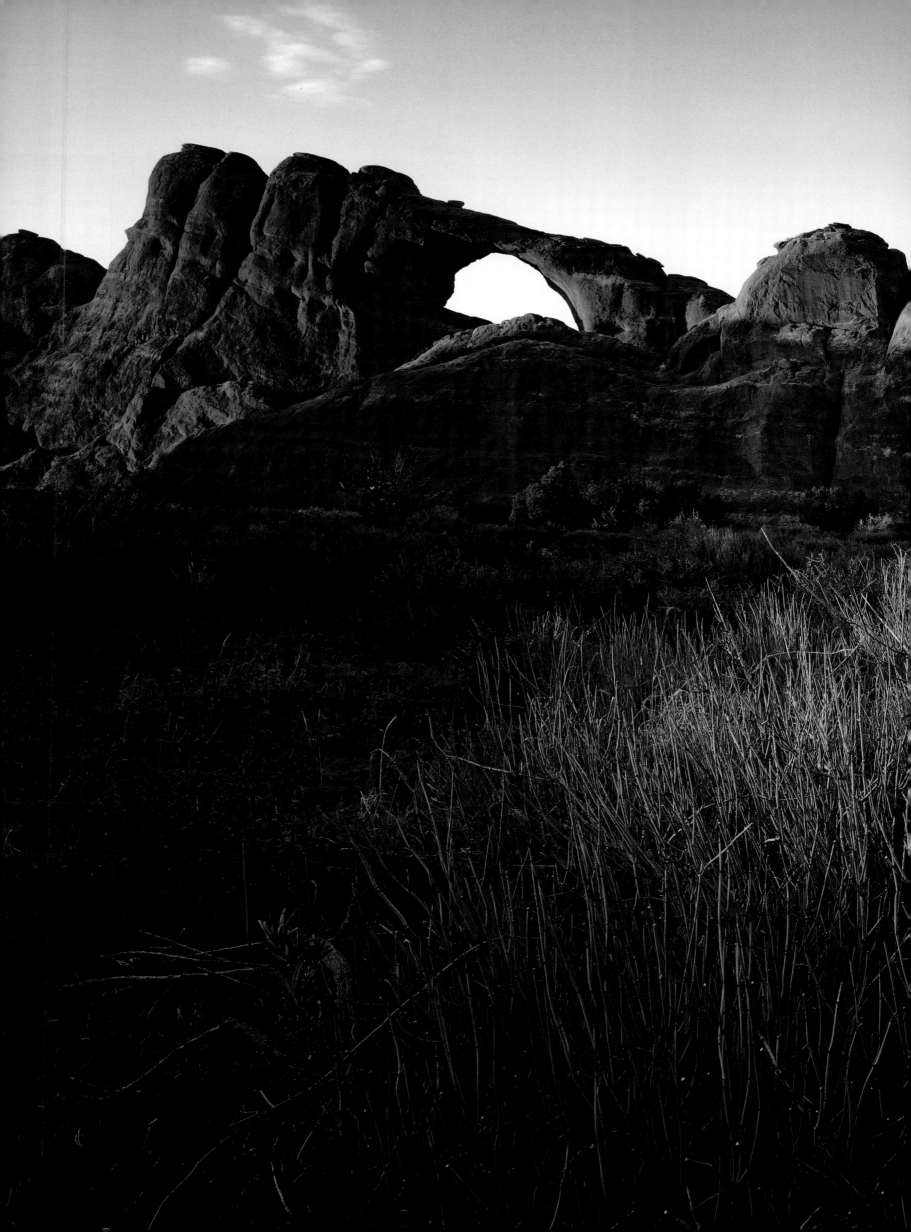

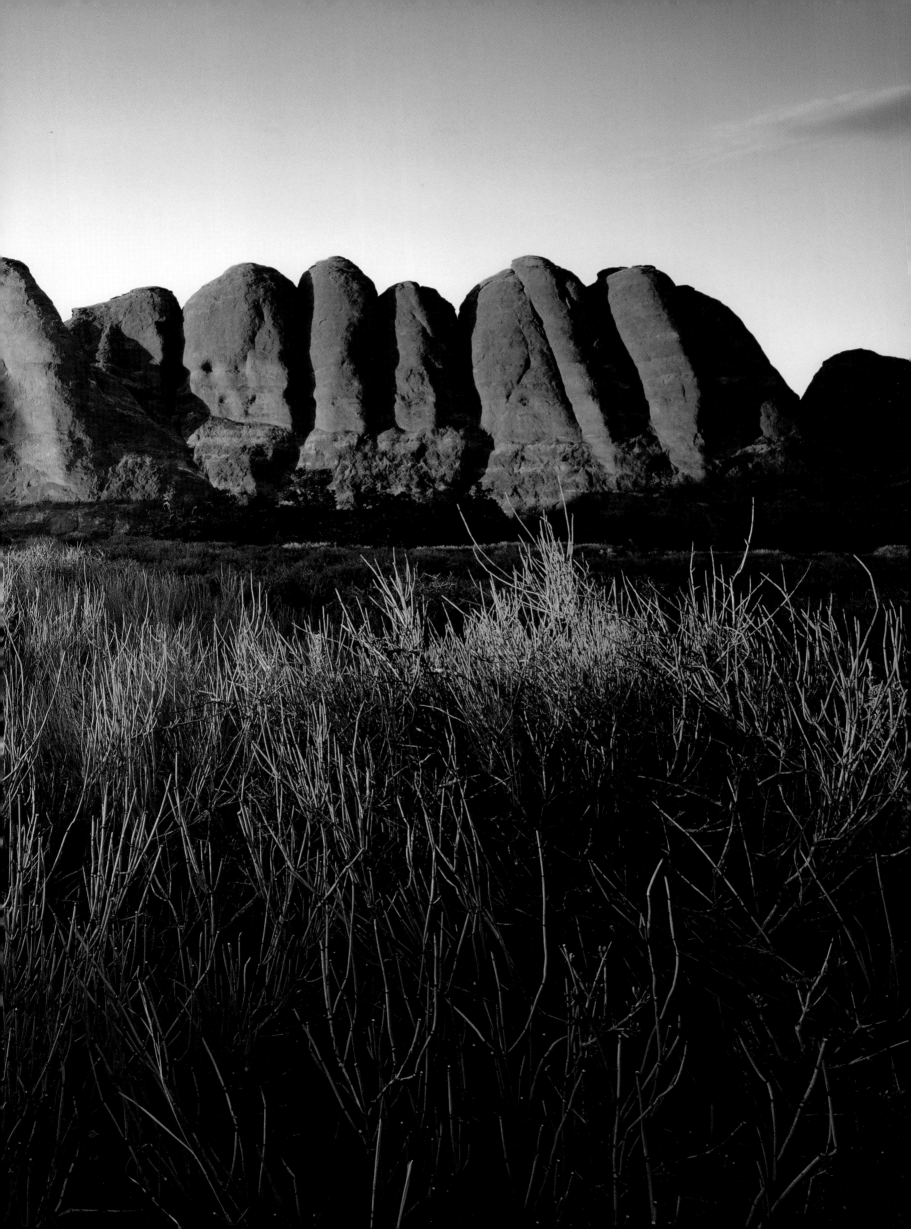

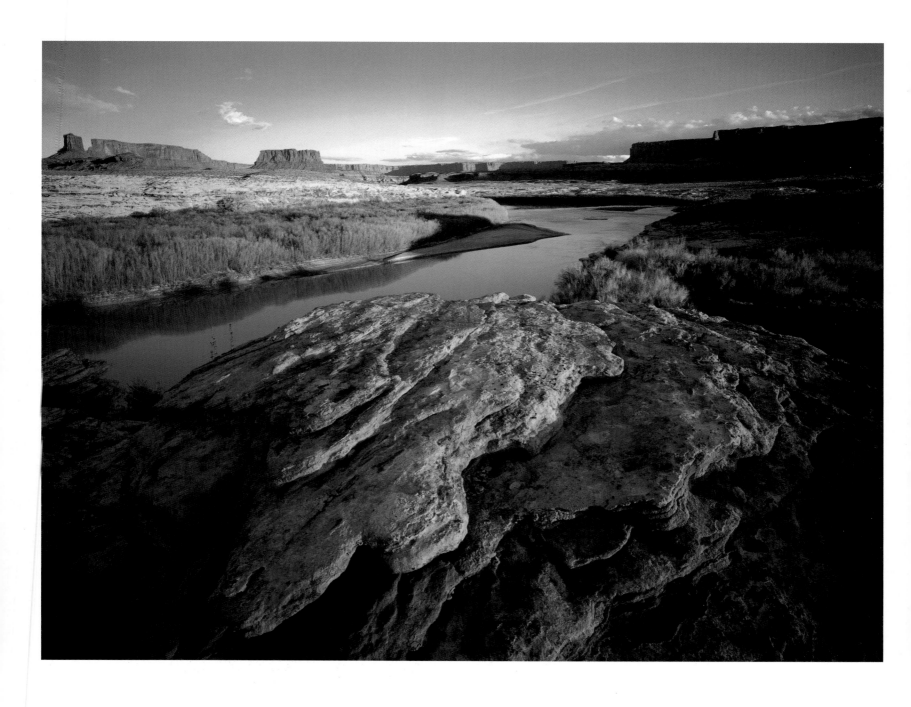

Looking down onto the Green River as it winds through Millard Canyon, Utah, it's easy to imagine John Wesley Powell floating through here in 1869 during his exploration of the Colorado River. The 730-mile-long Green River is the main stem of the Colorado, and arises in the mountains of Wyoming.

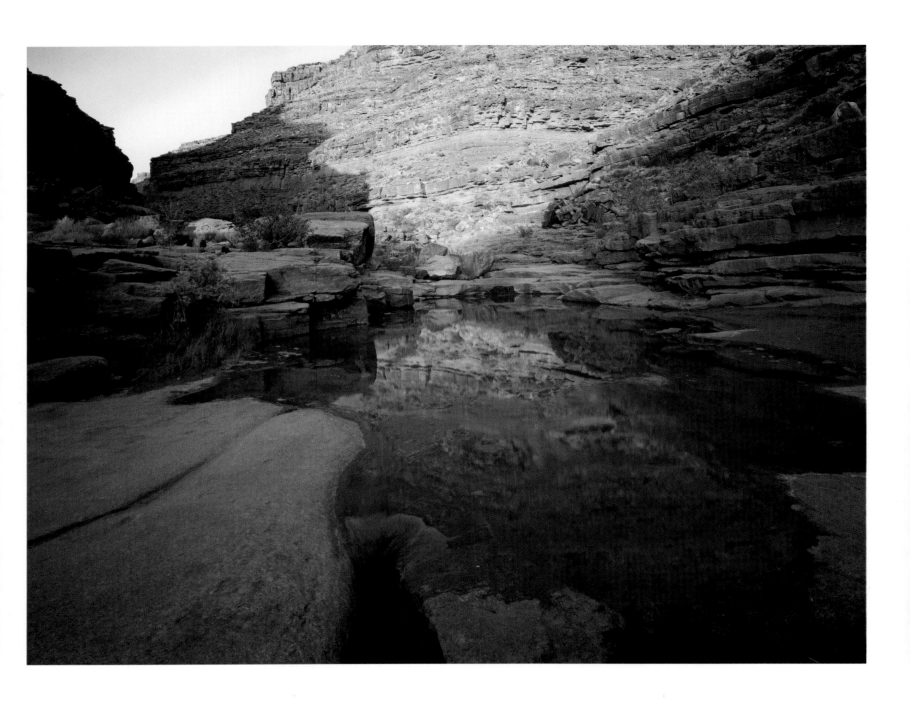

Shadows creep over a reflection pool in Slickhorn Gulch on the San Juan River, Utah. The San Juan, which is another major tributary of the Colorado, arises in Colorado, flows through northern New Mexico, picks up water from Arizona, then debouches into Lake Powell.

The moon rises over a water tank at Muley Point high above the San Juan River in the far southeastern corner of Utah. The point pushes out from Cedar Mesa and offers spectacular views of Monument Valley.

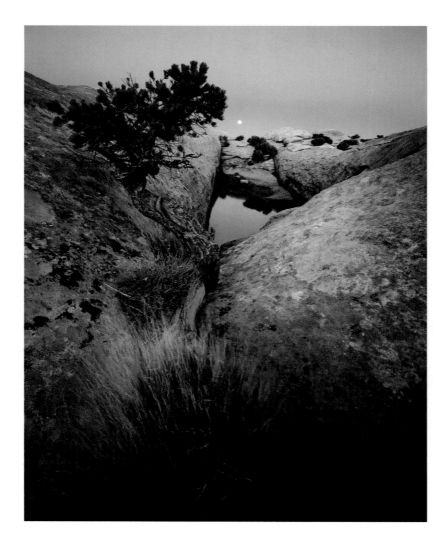

Reflection pools are a frequent reminder to travelers on foot of the steep cliffs above, as in this one near where Utah's Oljeto Wash meets the San Juan River.

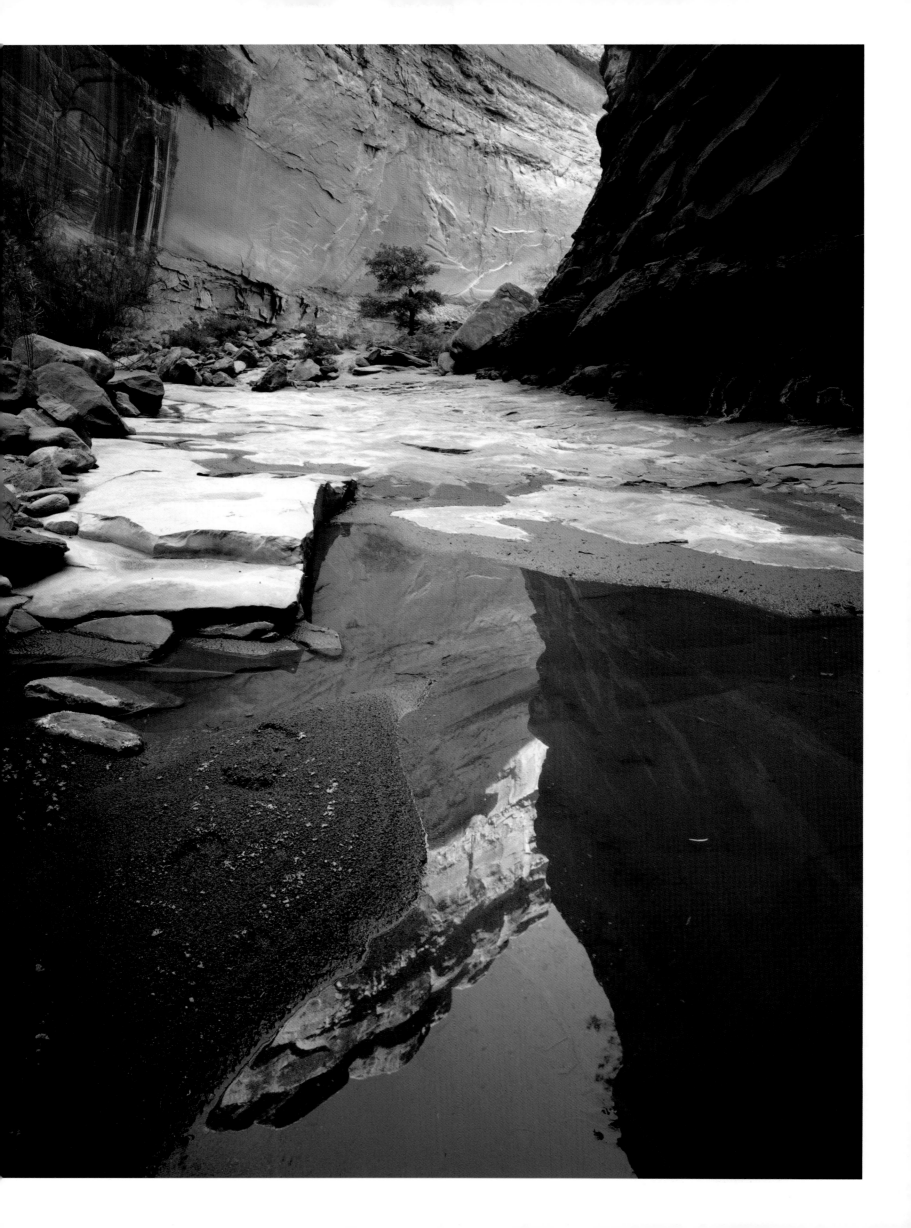

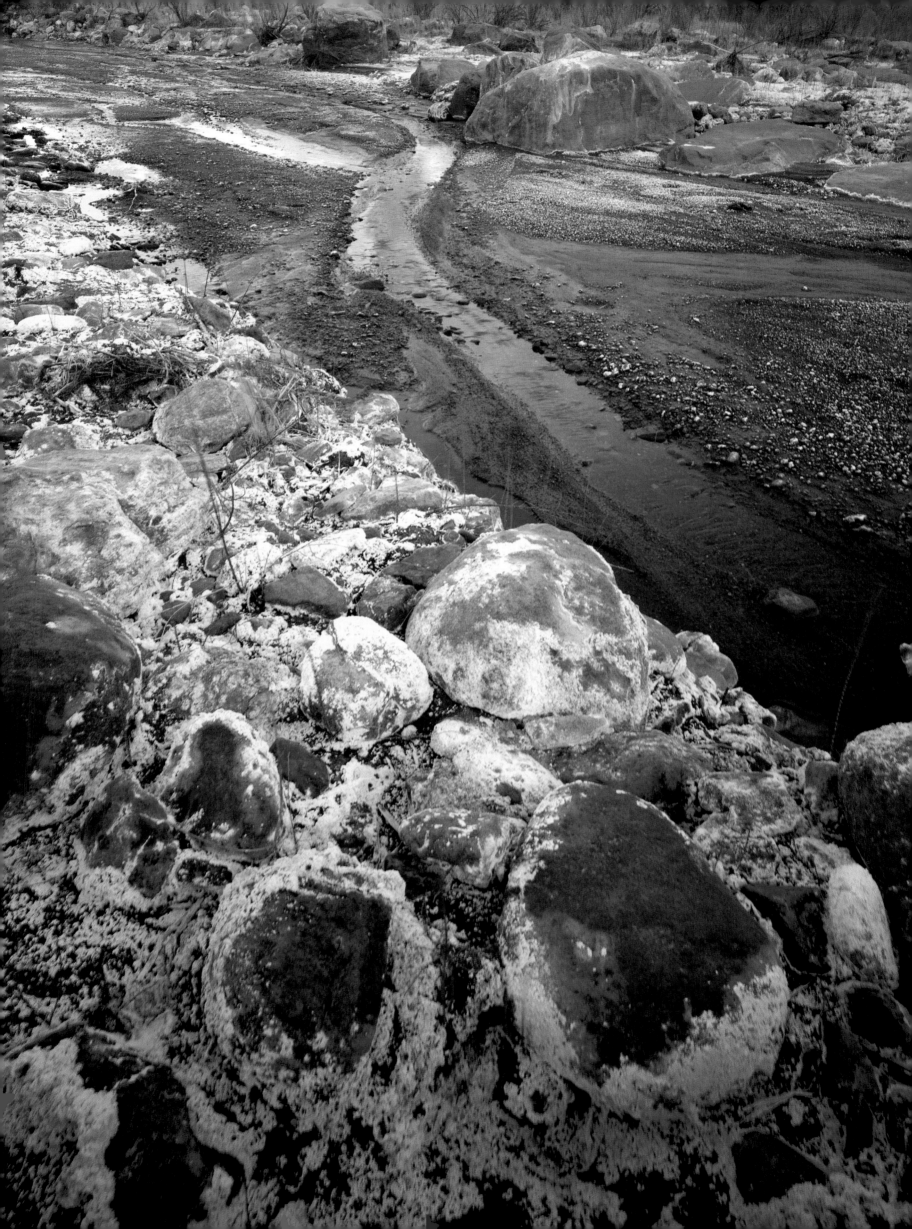

Brilliant orange cliffs are captured in a reflection pool on the shores of the Green River in Colorado's Desolation Canyon.

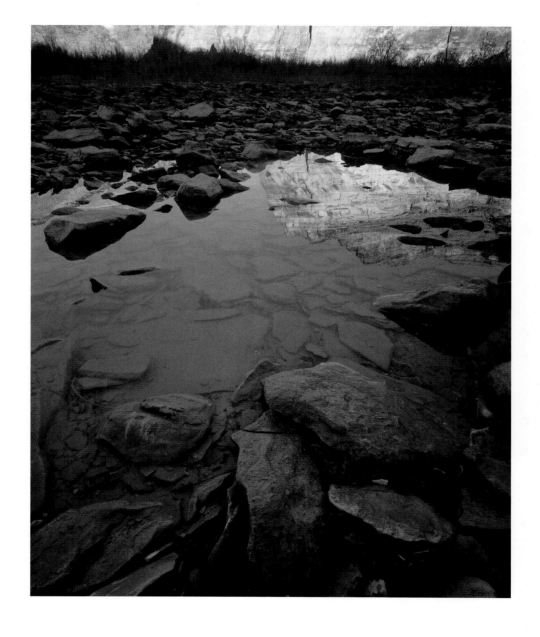

Alkali-covered stones line the banks of Rattlesnake Creek, a Colorado tributary of the Green River.

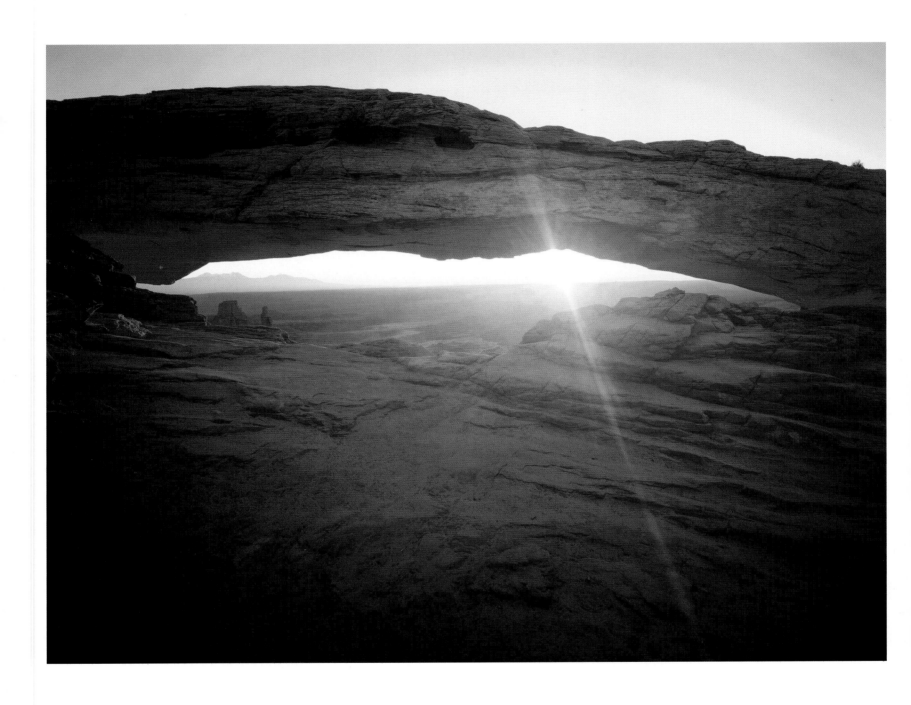

Warm sunrays of light illuminate the underside of Mesa Arch in
Canyonlands National Park, Utah. Canyonlands hosts the confluence of
the Green and Colorado Rivers, and is Utah's largest national park.

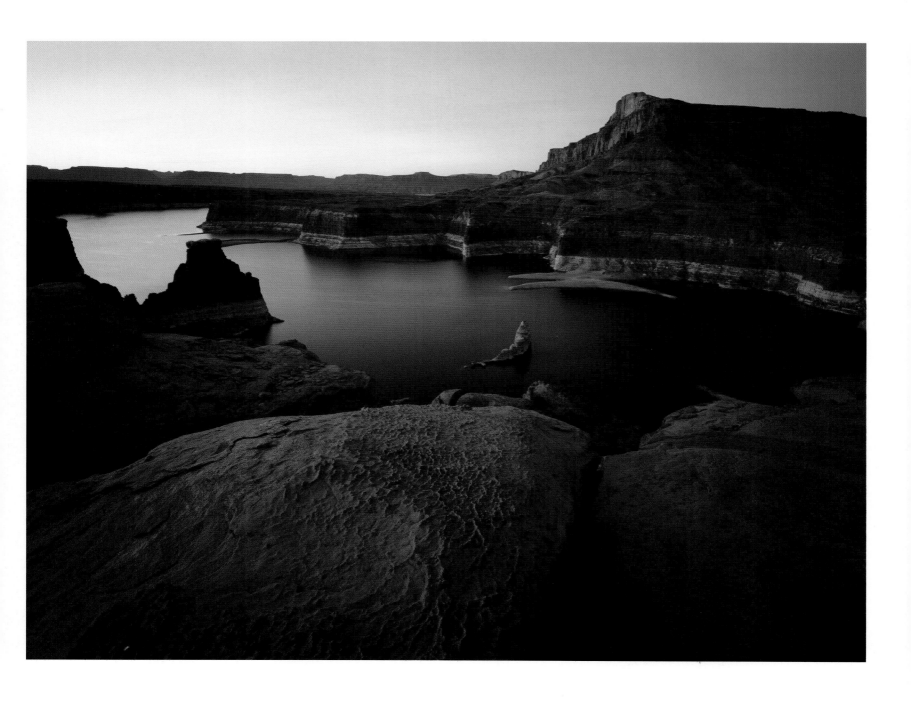

The light-colored "bathtub ring" around Lake Powell measures the drop in lake levels during the current drought. Nearby Hite Marina, located just below the confluence of the Colorado and Dirty Devil Rivers, can no longer offer access to the lake, which has lost more than 50 percent of its water.

Peering down into Canyon de Chelly National Monument from near Spider Rock Lookout (overleaf), you can trace the path of the small river a thousand feet below. The water, which currently flows year-round, has supported Indian settlements since A.D. 350.

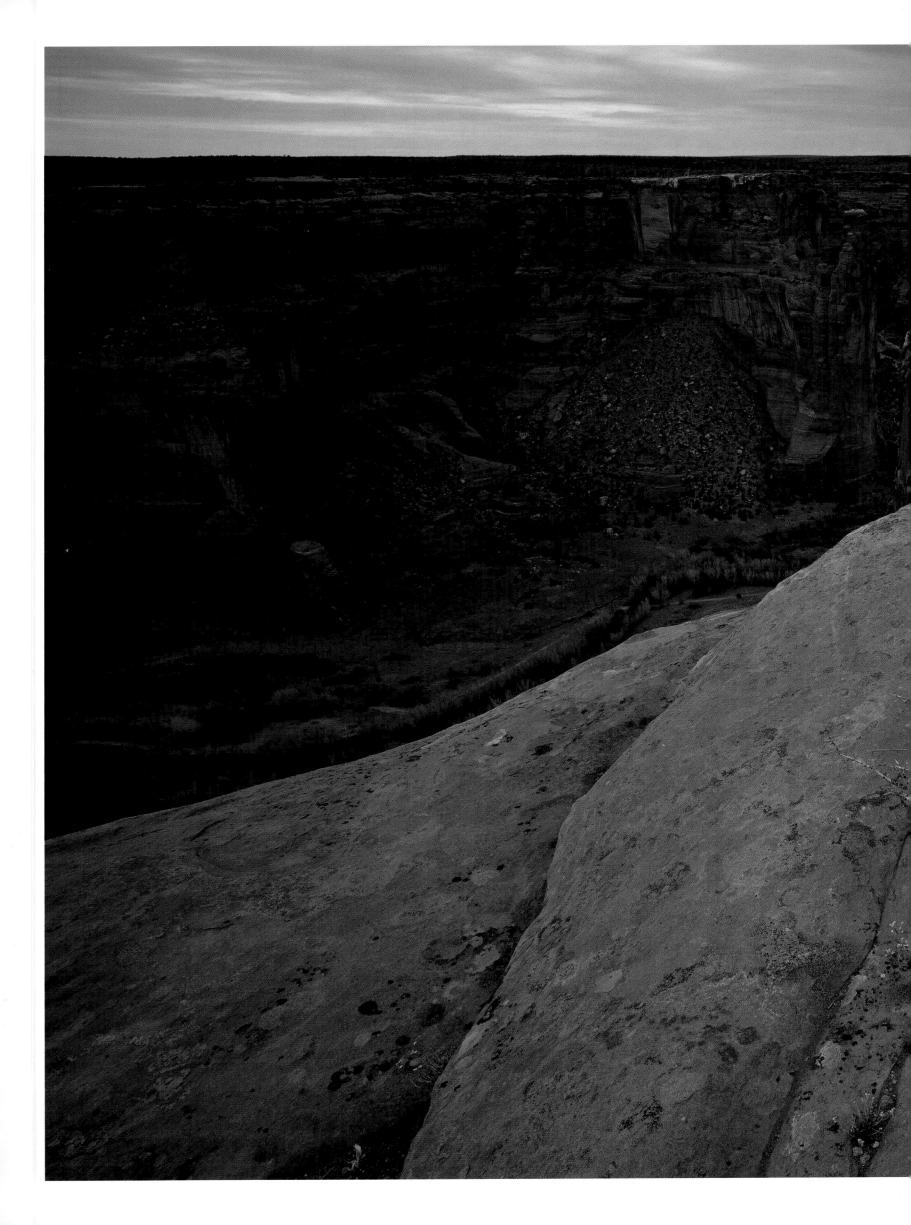

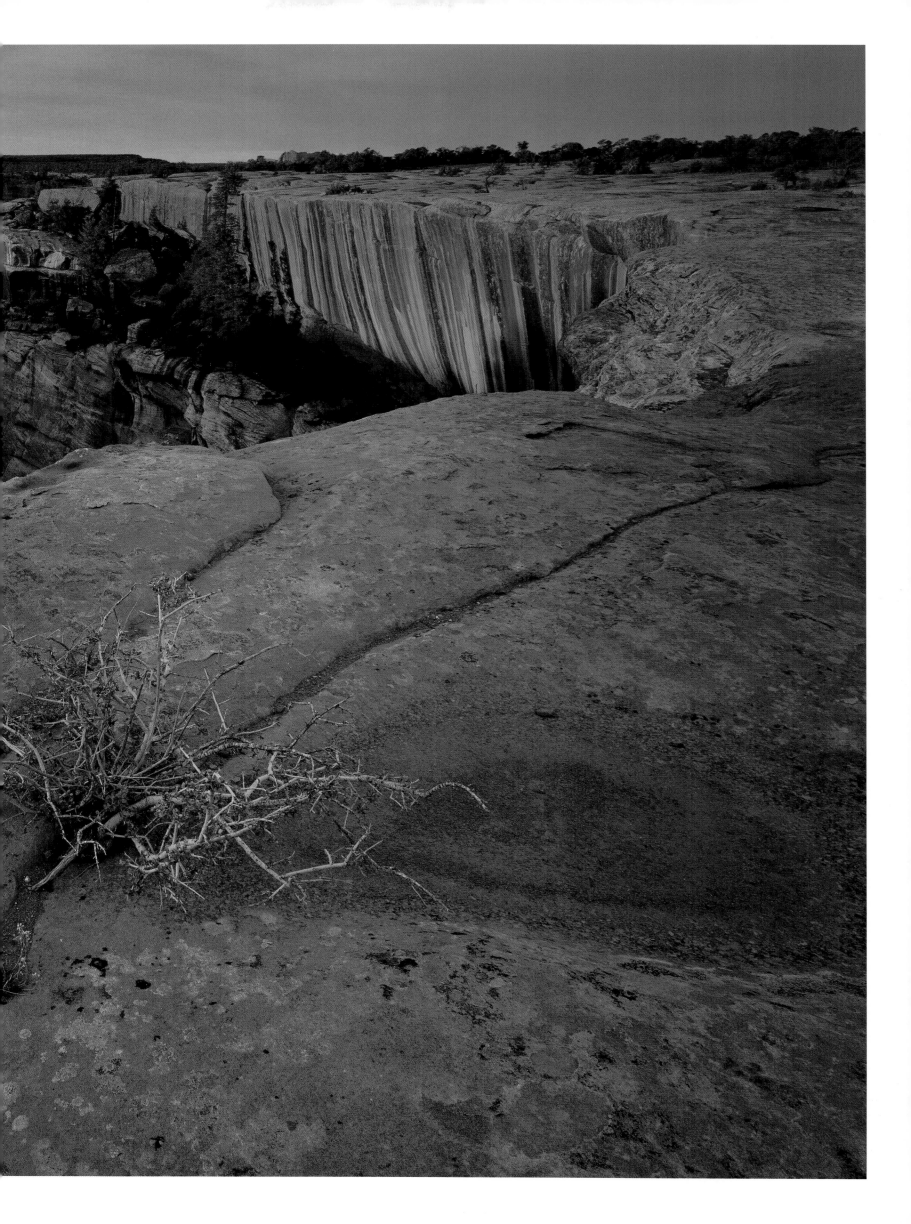

The mighty Colorado flows past South Canyon in Grand Canyon National Park.

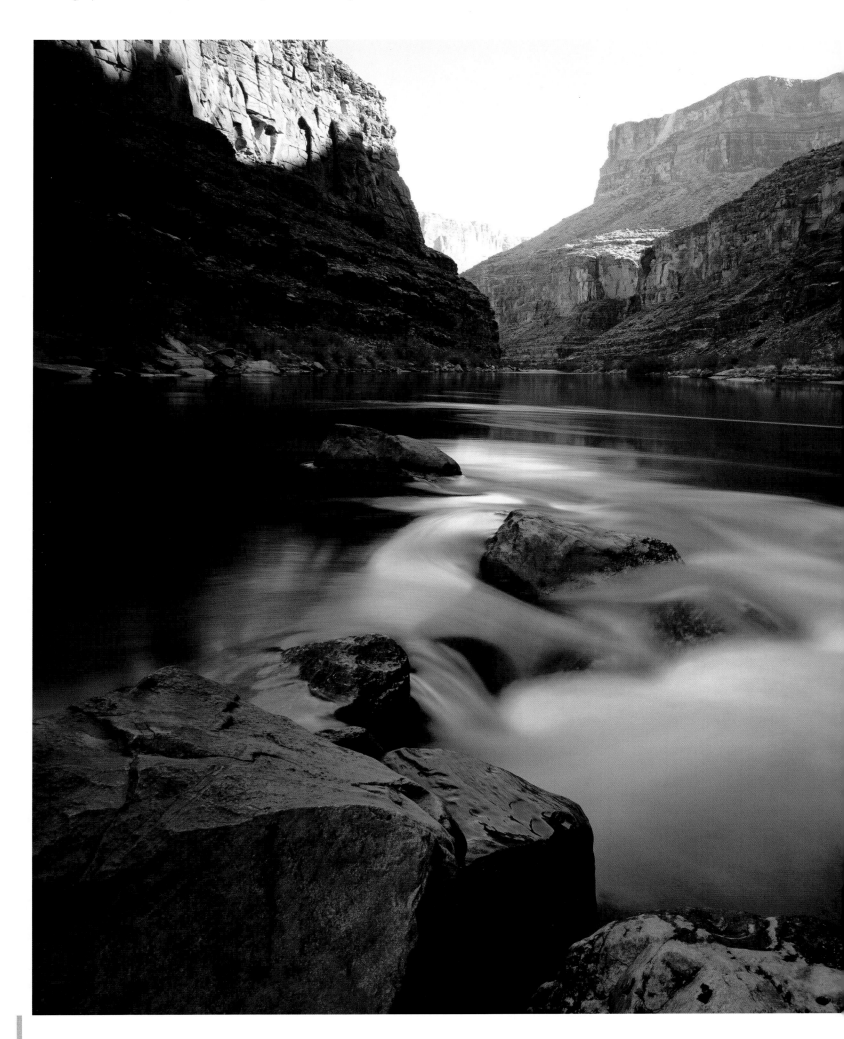

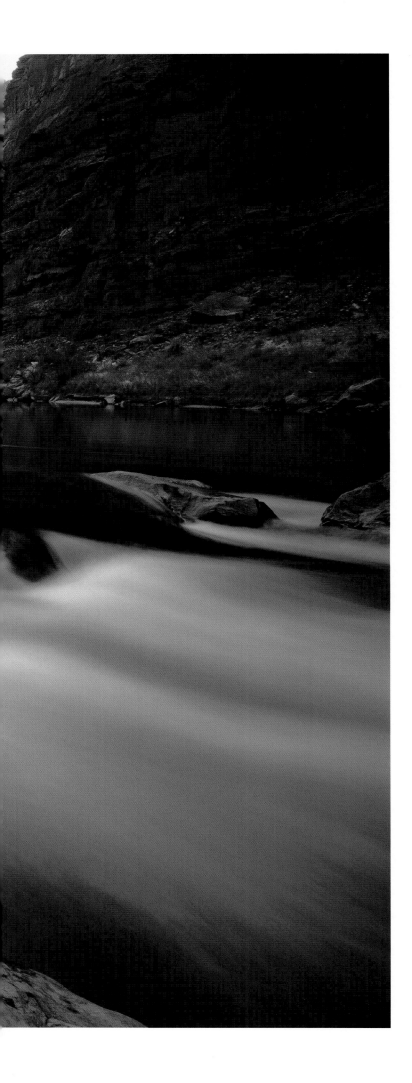

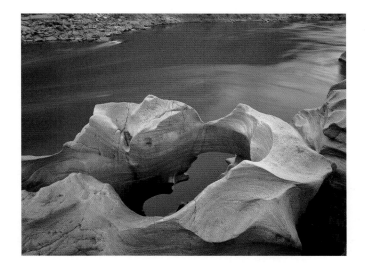

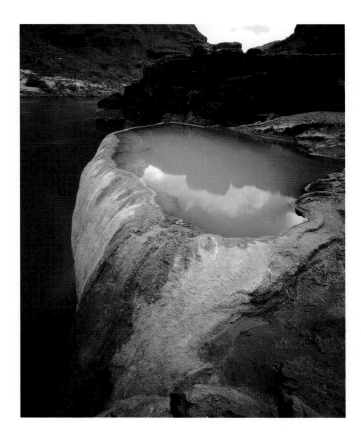

Sculpted travertine formations (top right) are shaped by the swirling water of the Colorado.

Steep walls (bottom right) are reflected in the pool at Pumpkin Springs in the Grand Canyon.

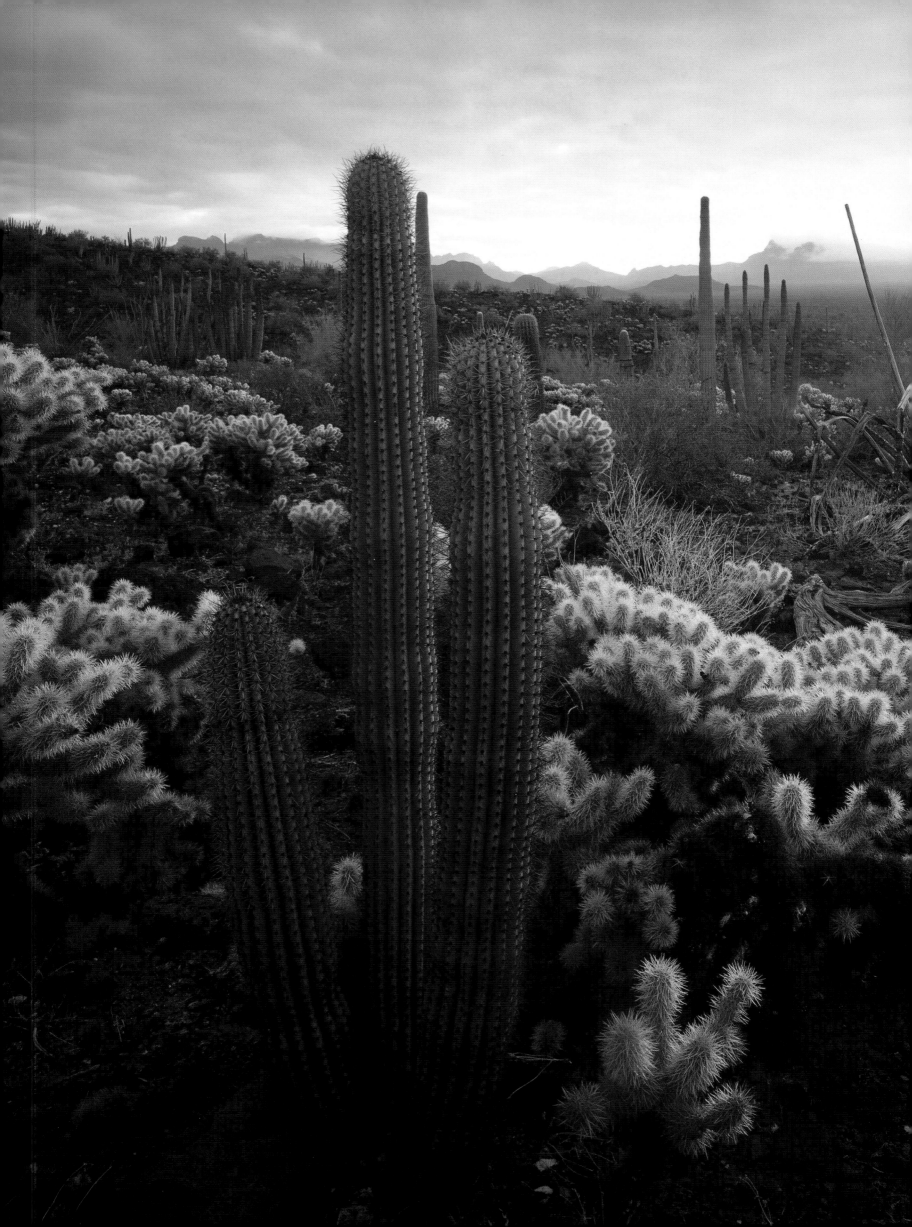

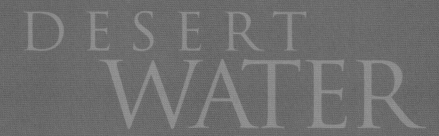

DESERT
WATER

SONORAN ◼

THE WETTEST and most diverse desert habitat in North America—and also the one with the lowest overall elevation and warmest average temperatures—is the 120,000-square-mile Sonoran. In the United States it covers only the southern third of Arizona and the southeastern corner of California, but in Mexico it extends down two-thirds of the Baja California Peninsula, and on the opposite shores of the Gulf of California (also known as the Sea of Cortez) includes more than half the state of Sonora. It is a young desert, having formed within the last 10,000 years at the end of the Pleistocene, and it owes its complexity to the fact that it is a semitropical desert receiving moisture biseasonally. Its oldest rocks, the two-billion-year-old Precambrian outcroppings in Arizona, are counterpointed by the volcanic lava flows along the U.S.-Mexican border, some of which were laid down as recently as 1,300 years ago.

The Lower Colorado River Valley and Salton Sea Trough in California are part of the Sonoran, and the former is covered up to 90 percent by creosote, making it appear as if it is part of the Mojave. But as one heads east from the sand dunes, the cholla cactus shows an increasing presence, then beavertail and barrel cacti, and finally the trademark saguaro, the northernmost species of the columnar cacti. The agave with its tall flower stalks, the multistemmed and thorny ocotillo, and the palo verde are other common denizens. Woodpeckers and owls live in the saguaro, rattlesnakes and horned lizards are common underfoot, and the number of ants, bees, beetles, and stinging creatures is staggering.

The most surreal desert on the continent is arguably the most arid part of the Sonoran on the Baja Peninsula, where gigantic cordon cactus and ancient boojum trees rise above the Sea of Cortez.

The sun rises over the Ajo Mountains near the U.S.-Mexican border in Arizona's Organ Pipe Cactus National Monument.

Mexico's Vizcaino Desert in central Baja California receives only two inches of precipitation on average per year, but nonetheless turns gold within days after a winter rain.

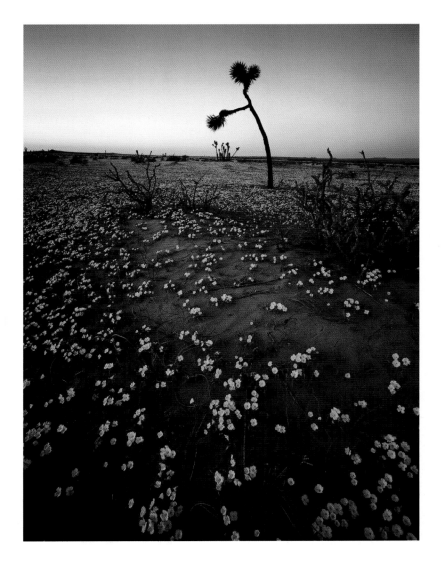

Ancient boojum trees *(Fouquieria columnaris)*, a relative of the Ocotillo, grow only in Baja California. Although they grow a mere inch or so a year, when mature they top out at more than thirty feet.

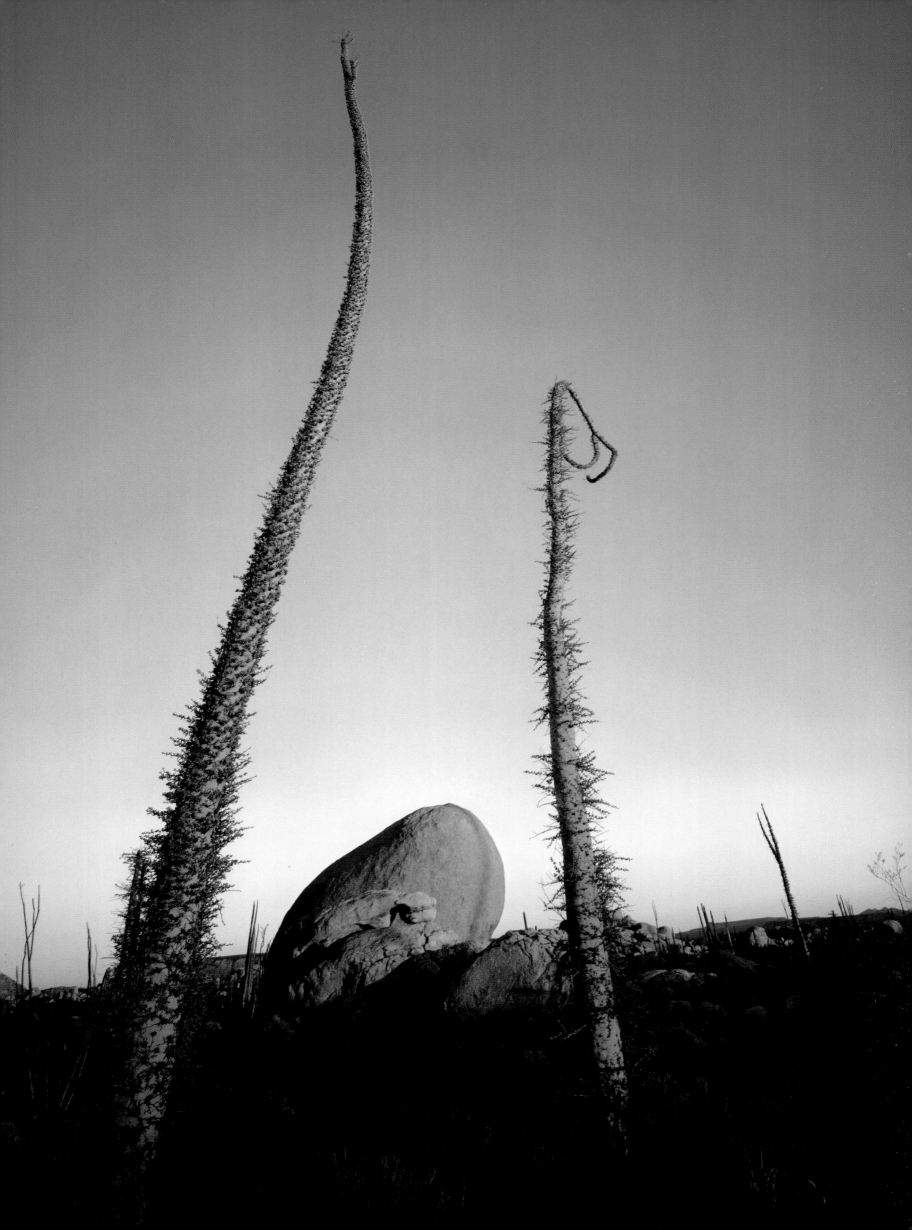

A winter rain produces a vivid rainbow in the cactus forest of Organ Pipe. The park includes a significant wilderness area, and is designated as an International Biosphere Reserve.

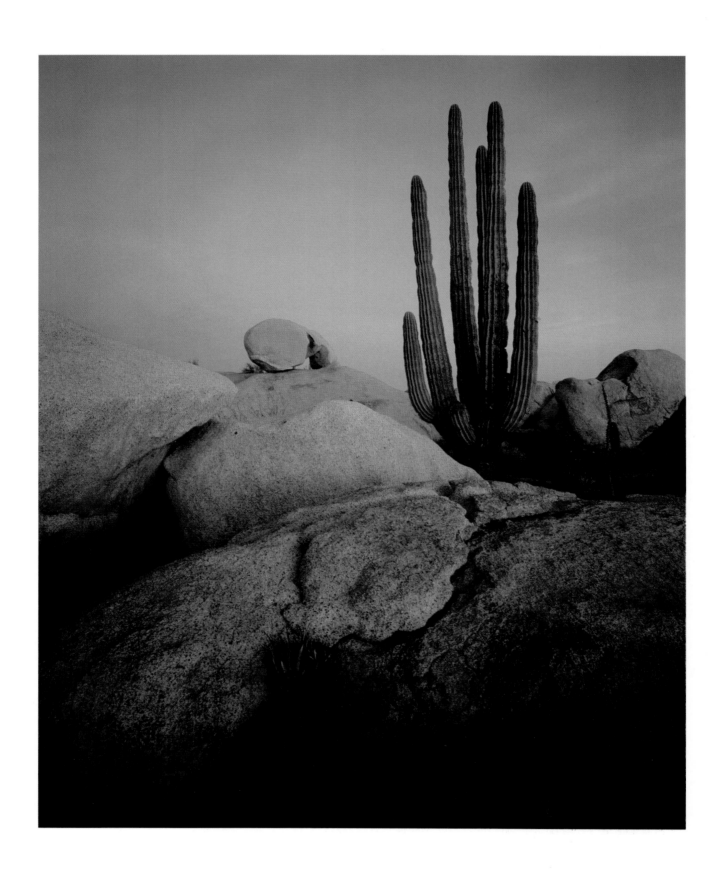

A three-hundred-year-old cardon cactus *(Pachycereus pringlei)* grows in the shelter of a boulder field in Catavina, Baja California. The cardon, which resembles the saguaro but has more and longer arms, is the world's largest cactus, and can grow to more than sixty feet tall.

Cardon *(Pachycereus pringlei)* and organ pipe *(Pachycereus marginatus)* cacti (overleaf) cover a rocky hillside on the edge of the Sea of Cortez, Baja California.

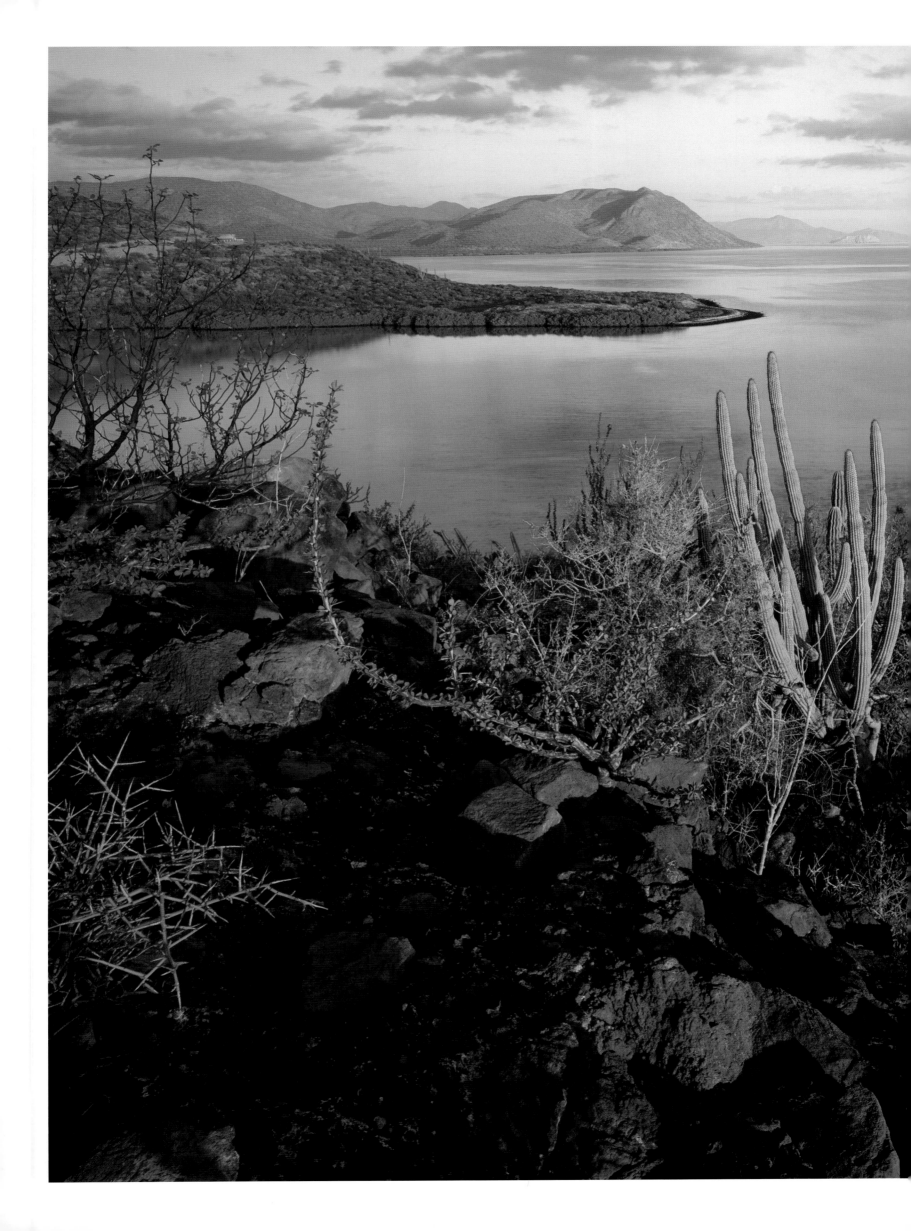

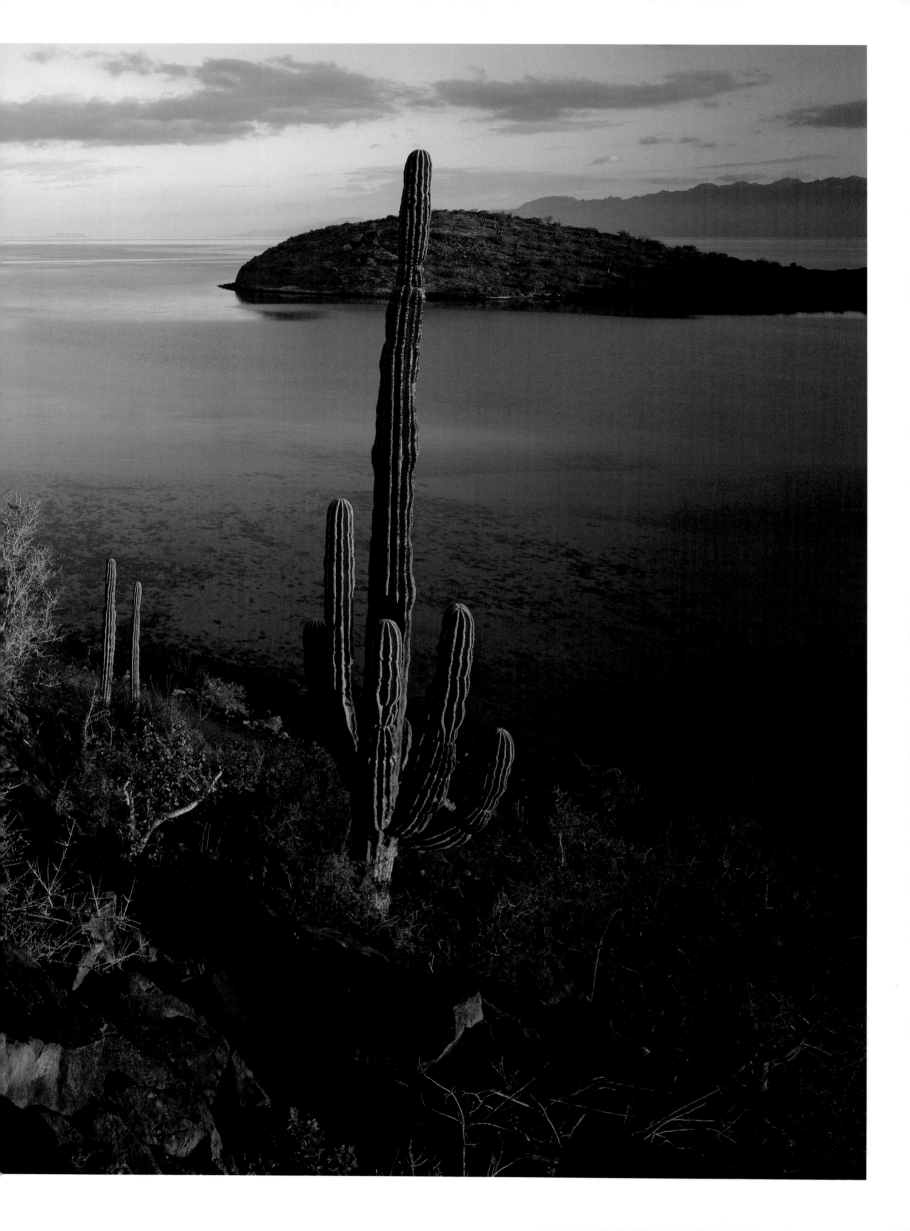

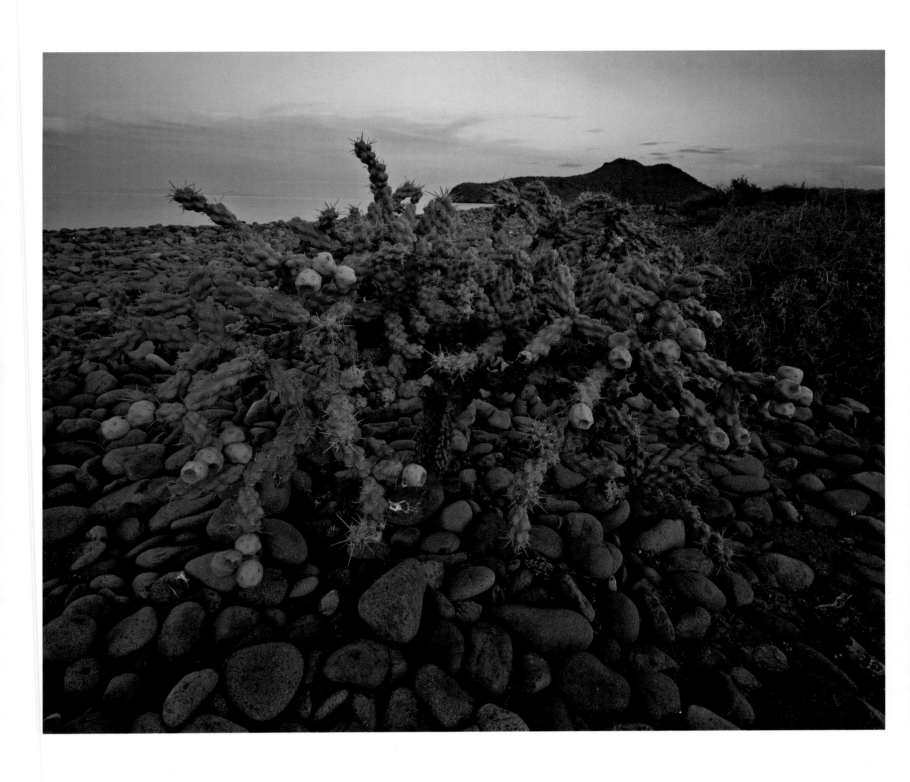

A fruit-bearing cholla cactus *(Opuntia)* makes its home on the rugged cobble shoreline of the Sea of Cortez north of Aqua Verde.

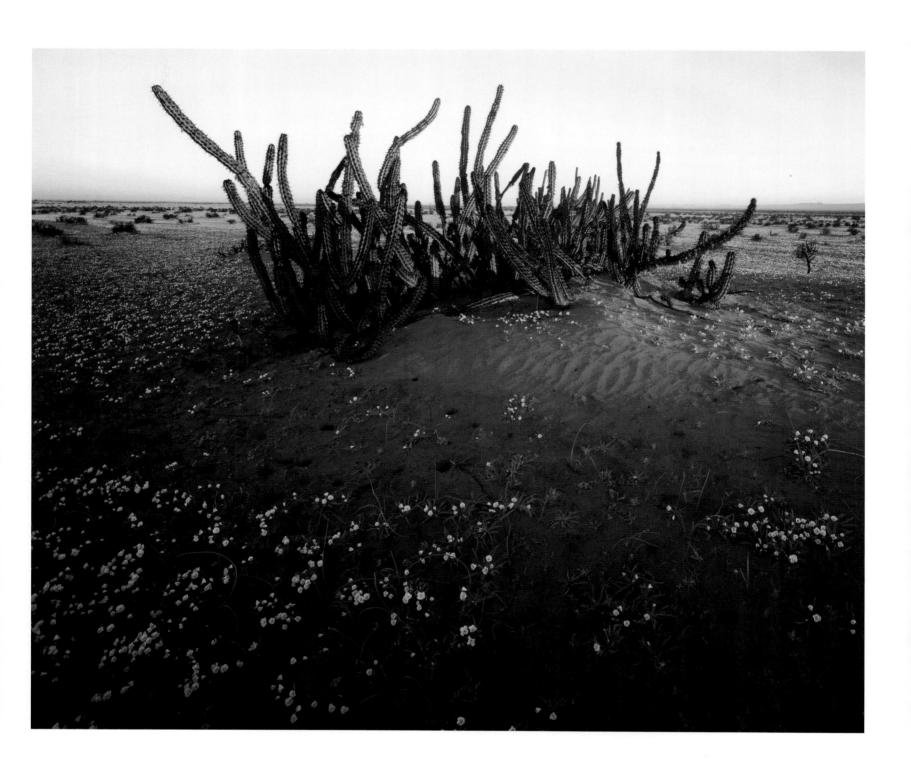

The plants of Baja's Sonoran Desert often survive for months on nothing more than humidity blown in from the Pacific Ocean. The Vizcaino Biosphere Reserve, the largest nature reserve in Latin America, covers more than six million acres and is also a UNESCO World Heritage Site in recognition of its numerous threatened and endangered species.

Each trunk of the columnar organ pipe cactus *(Pachycereus marginatus)* is surrounded by twelve to seventeen ribs that store water and provide structural integrity to the plants, which can grow to more than twenty feet in height.

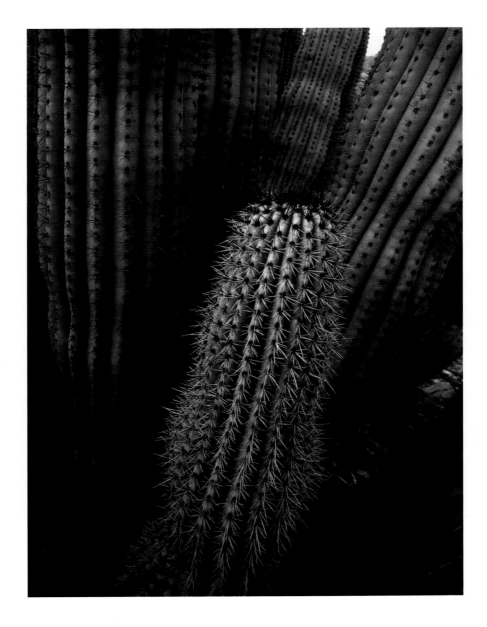

A much-needed rain wets the Sonoran Desert. The organ pipe cactus seedlings require the shade of a nurse tree in order to grow successfully into maturity, at which point they have often killed the other plant by stealing its water.

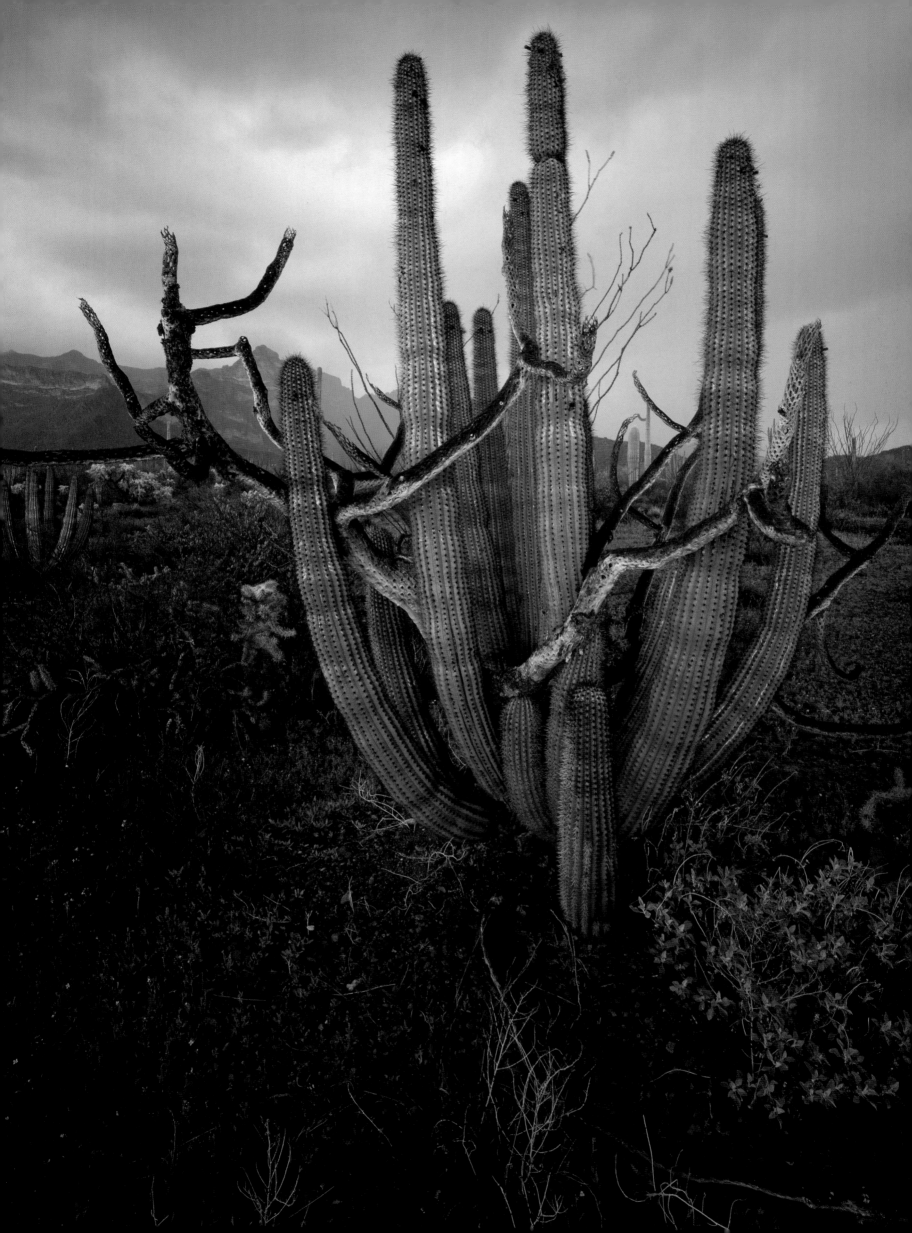

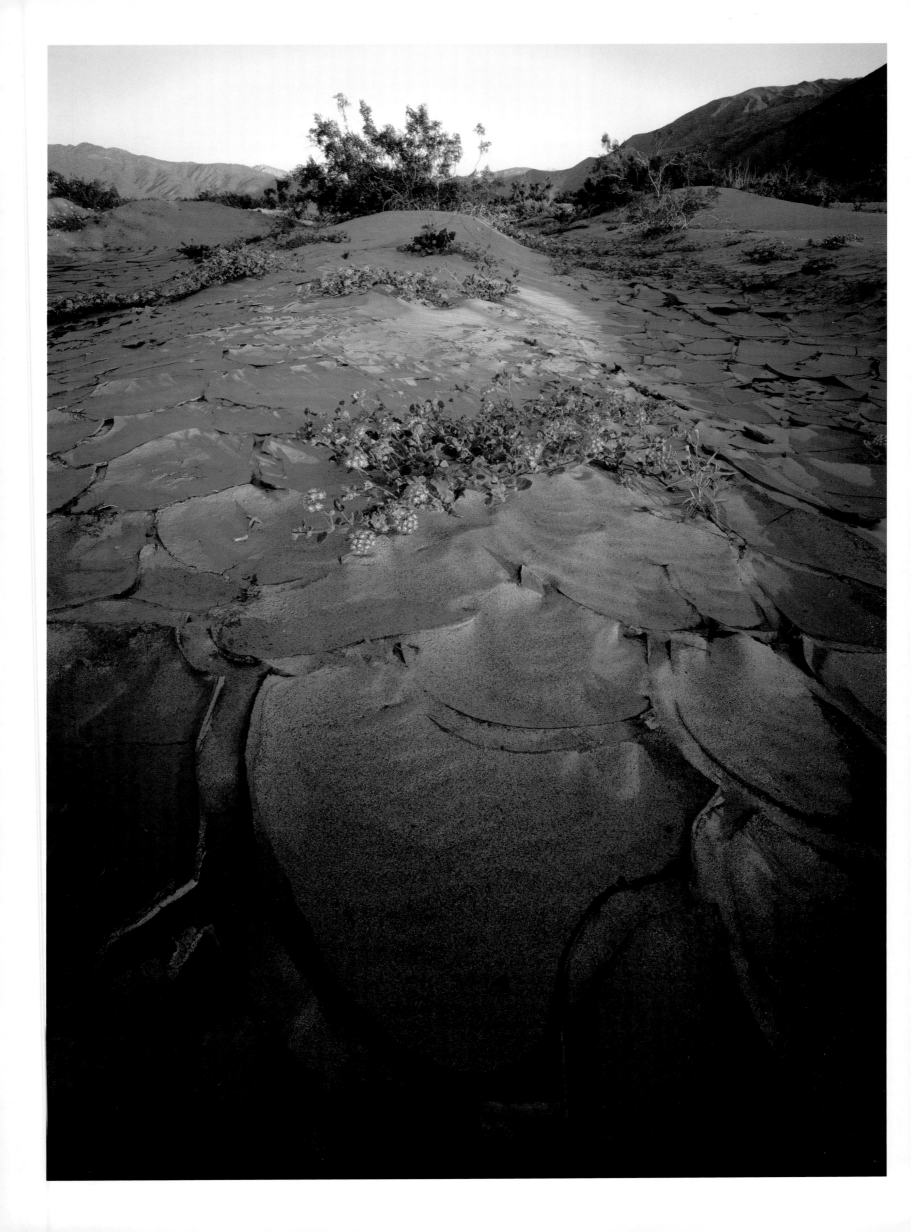

Sand verbena is a creeper fond of dunes. If the winter rains are copious enough, it can carpet the park with pink flowers.

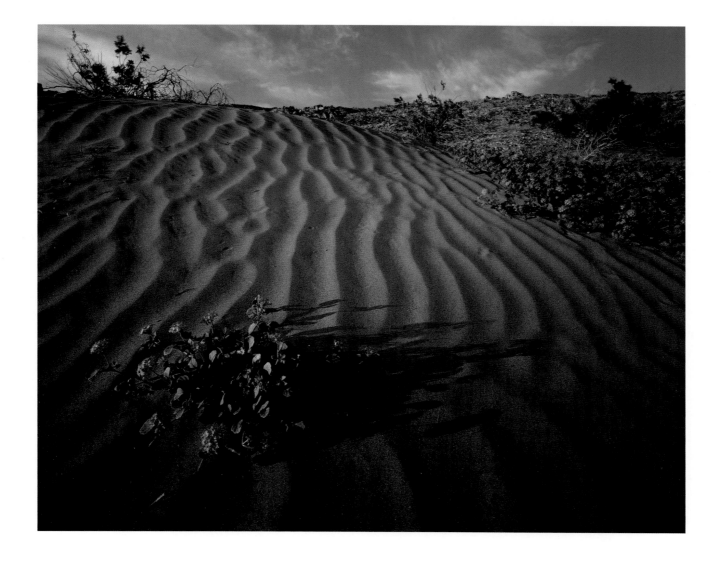

Desert sand verbena *(Abronia villosa)* blooms in the cracks of a dried streambed in California's Anza-Borrego Desert State Park. Located in eastern San Diego County, the park is known for its wildflowers, which start blooming in January and peak during March.

Aravaipa Creek flows year-round through 1,000-foot-deep red canyons in central Arizona. Along the way to the San Pedro River it winds through an extensive wilderness area that hosts more than 200 species of birds in its riparian environment.

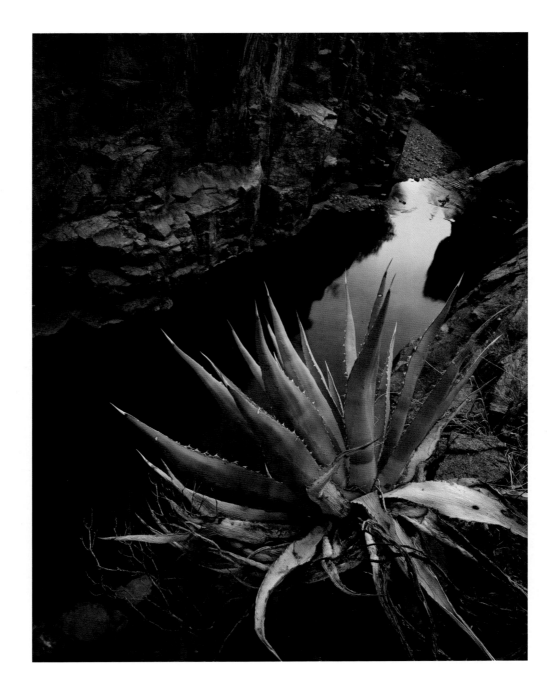

Cibeque Creek, a tributary to the Salt River on the White Mountain Apache Reservation in east central Arizona, plunges down seven waterfalls and into innumerable pools.

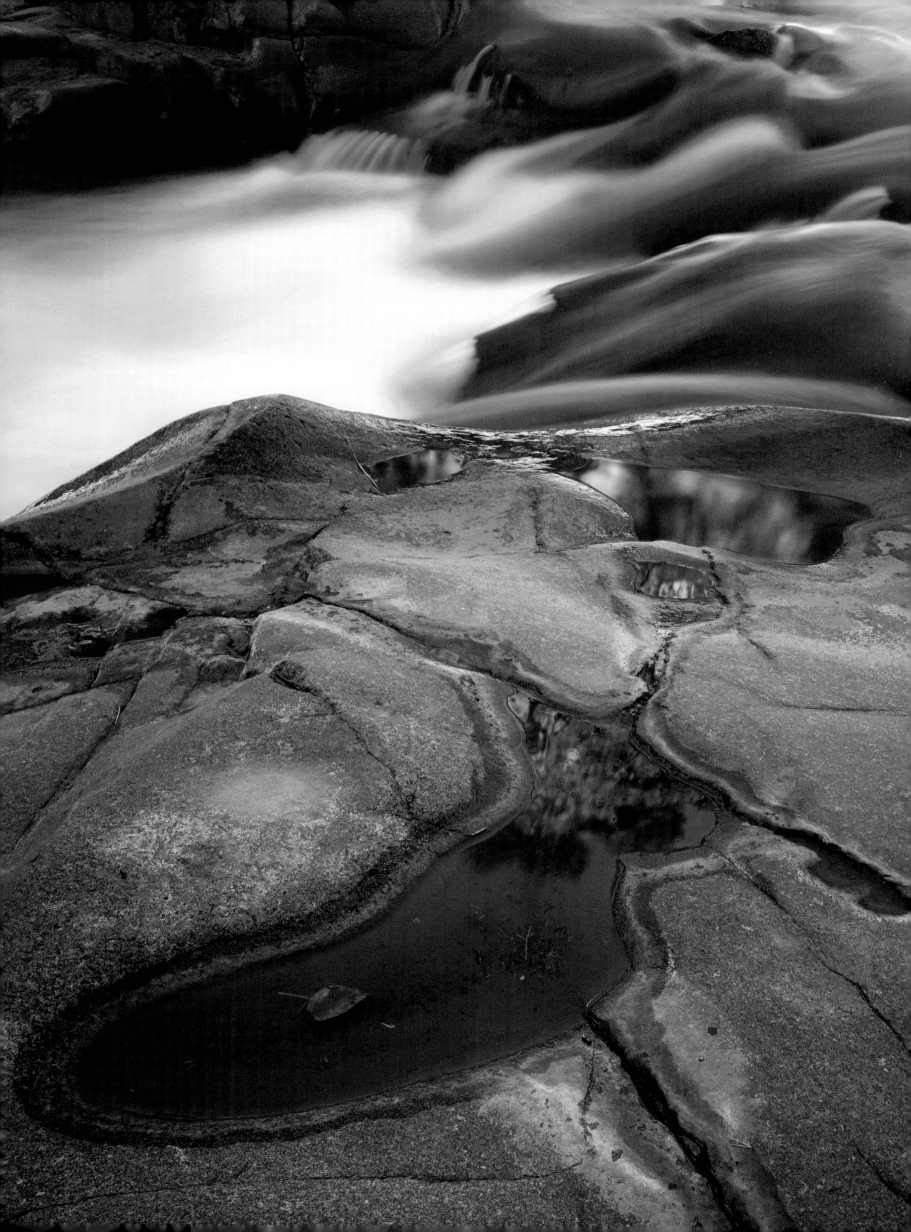

DESERT
WATER

MOST OF THE CHIHUAHUAN'S 175,000 square miles lies within Mexico, where it extends 800 miles southward almost to Mexico City, but its northern lobes push into southern New Mexico and West Texas. Because much of it lies between 3,500 and 4,200 feet, it can experience freezing nighttime temperatures for more than a quarter of the year, yet its summer daytime maximums approach that of the Mojave. Like the Sonoran, which it borders, it is a relatively wet desert, receiving from seven to twelve inches of rain annually, much of it during the summer's monsoon showers.

Among the varied landscapes of this desert are the gypsum dunes of White Sands National Monument in southern New Mexico and the southernmost mountains of the United States, the Chisos in Big Bend National Park. The lowest elevations of the Chihuahuan are along the Rio Grande on the Mexican border. The alluvial plains and fans that rise between the drainages and the scattered mountains of the Chihuahuan are dominated by creosote, although more varieties of cacti are found here than in any of the other four deserts. Yuccas, agave, and mesquite are enlivened by the presence of poppies and desert marigolds.

The relative abundance of grasses in this southernmost of the deserts supports rabbits, coyotes, mule deer, pronghorn, kit and gray foxes, and collared peccaries, which are also known as javalinas. More species of birds have been recorded in Big Bend than any other national park, although few of them are residents.

The deserts scrublands of the Chihuahuan may have grown by as much as a third of their total area during the last century due to overgrazing and the mismanagement of agriculture.

Water runs through the slots of Dog Canyon in Oliver Lee Memorial State Park, southern New Mexico. The deep ravine, through which the creek runs on the west slope of the Sacramento Mountains, was an Apache stronghold during the nineteenth century.

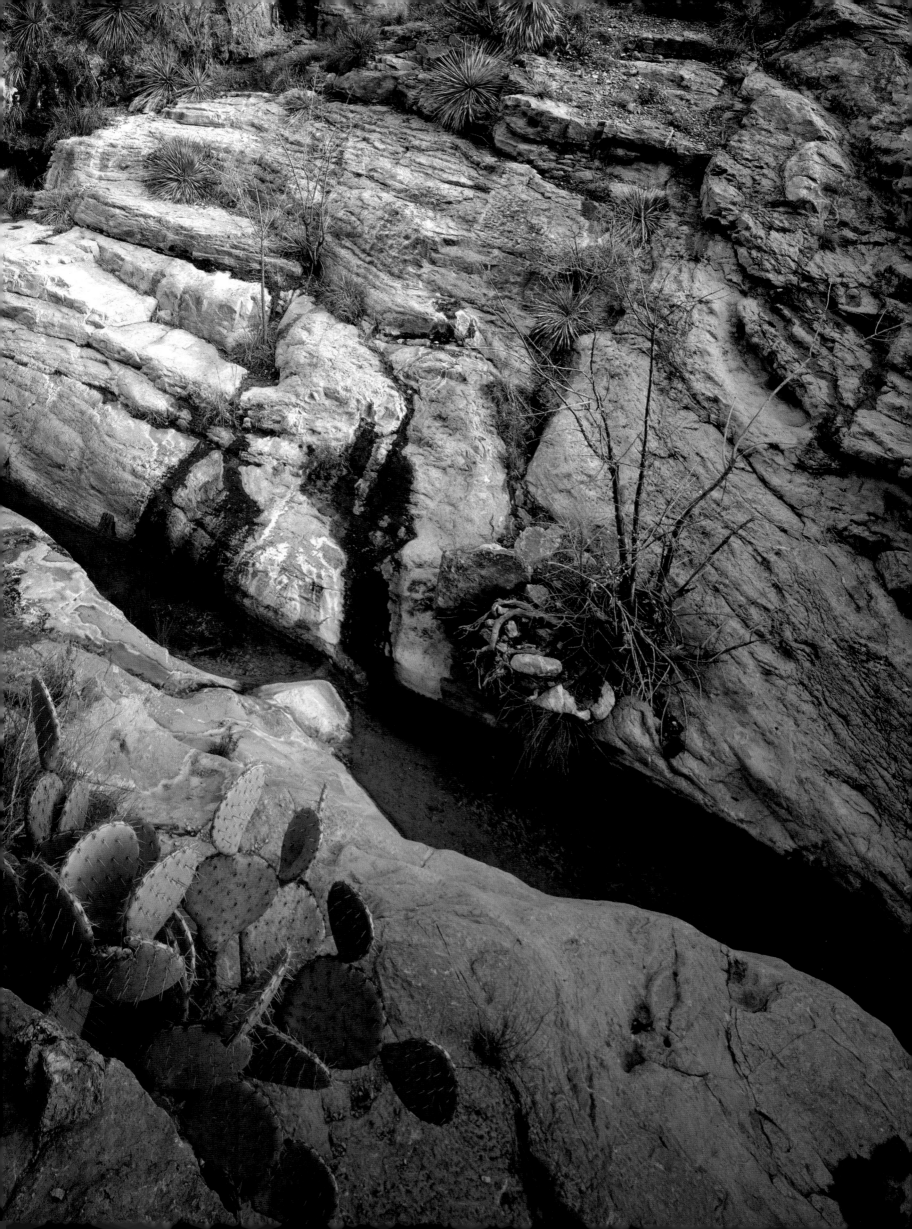

The multiple arms of a large cactus create a hemispherical mound of spines in Oliver Lee State Park.

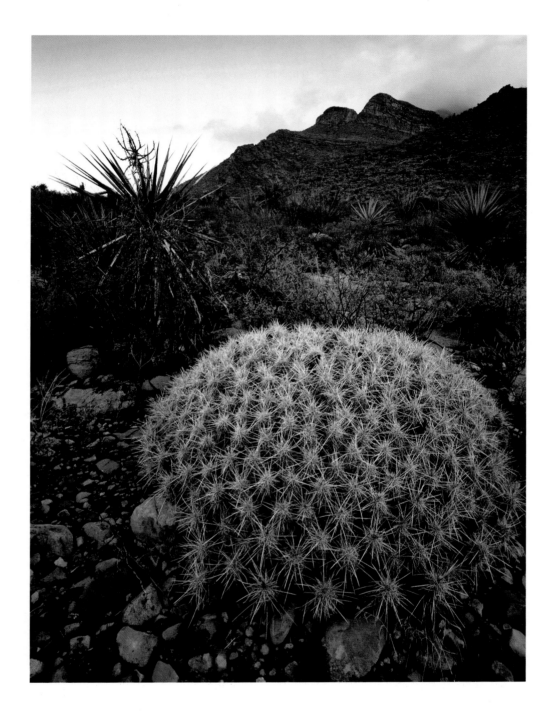

A tenacious gray oak *(Quercus grisea)* grows out of the tiny cracks in the unique volcanic tuff formations of southern New Mexico's City of Rocks State Park.

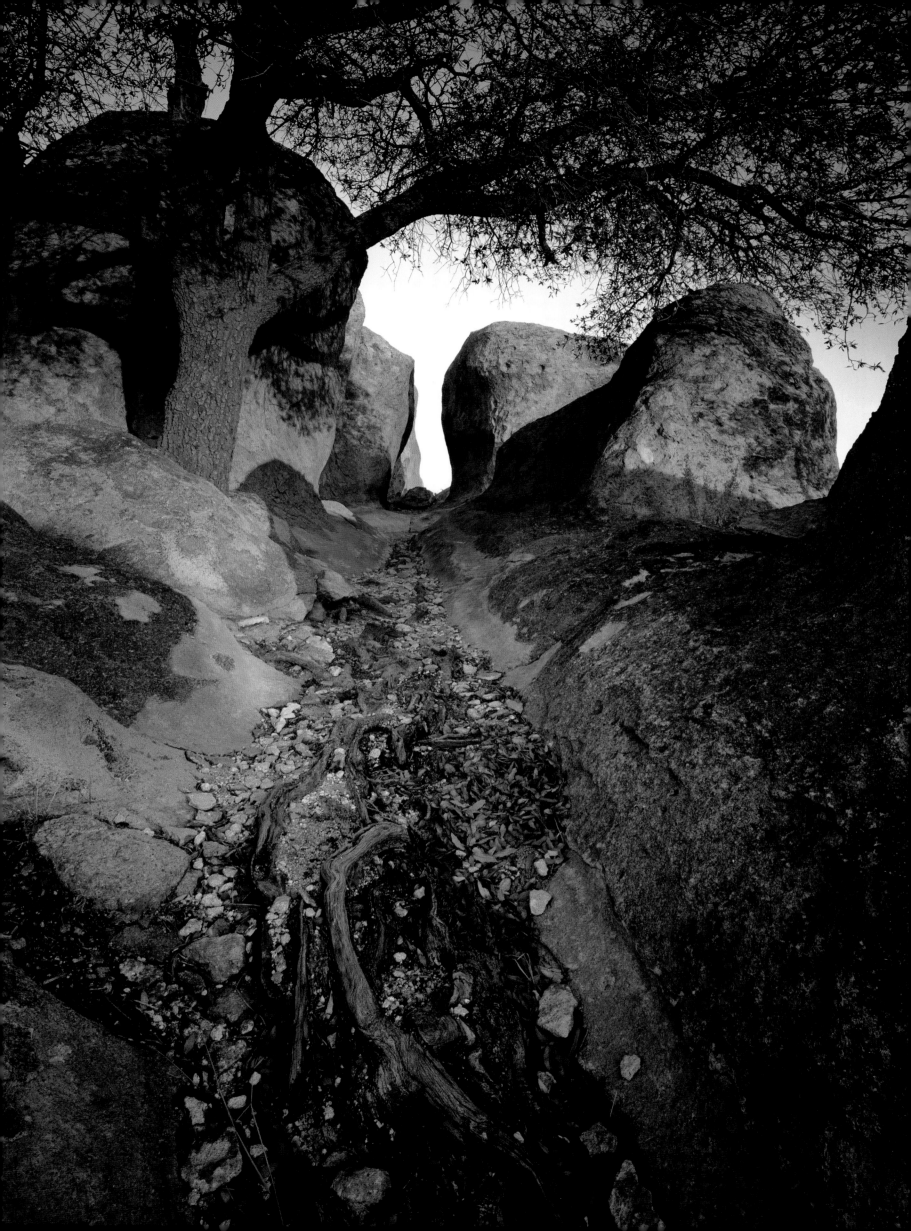

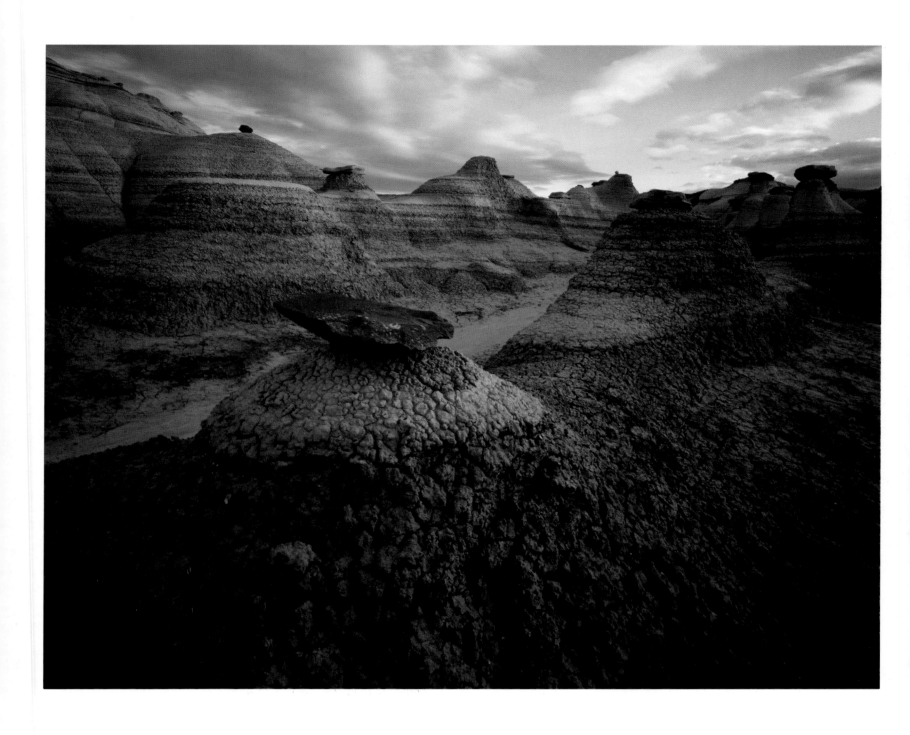

Rock shapes balance on the tops of ever-changing badlands in the
Bisti/De-Na-Zin Wilderness of northern New Mexico.

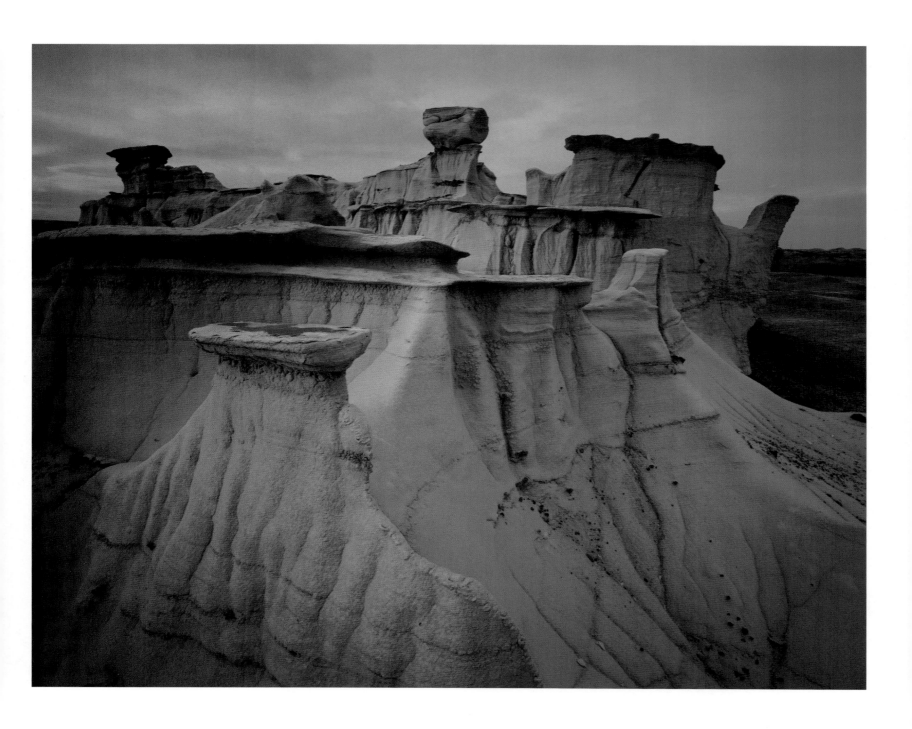

Hoodoos, eroded out of the shale hills in the De-Na-Zin, are capped by a layer of harder rock. As foreboding as the area seems, it has been continuously occupied for the last 10,000 years.

The opaque waters in Bottomless Lake State Park (overleaf) fool visitors into thinking they are deeper than they are, especially on a foggy day. In fact, the deepest of the seven lakes—which were designated in 1933 as New Mexico's first state park—is only ninety feet deep.

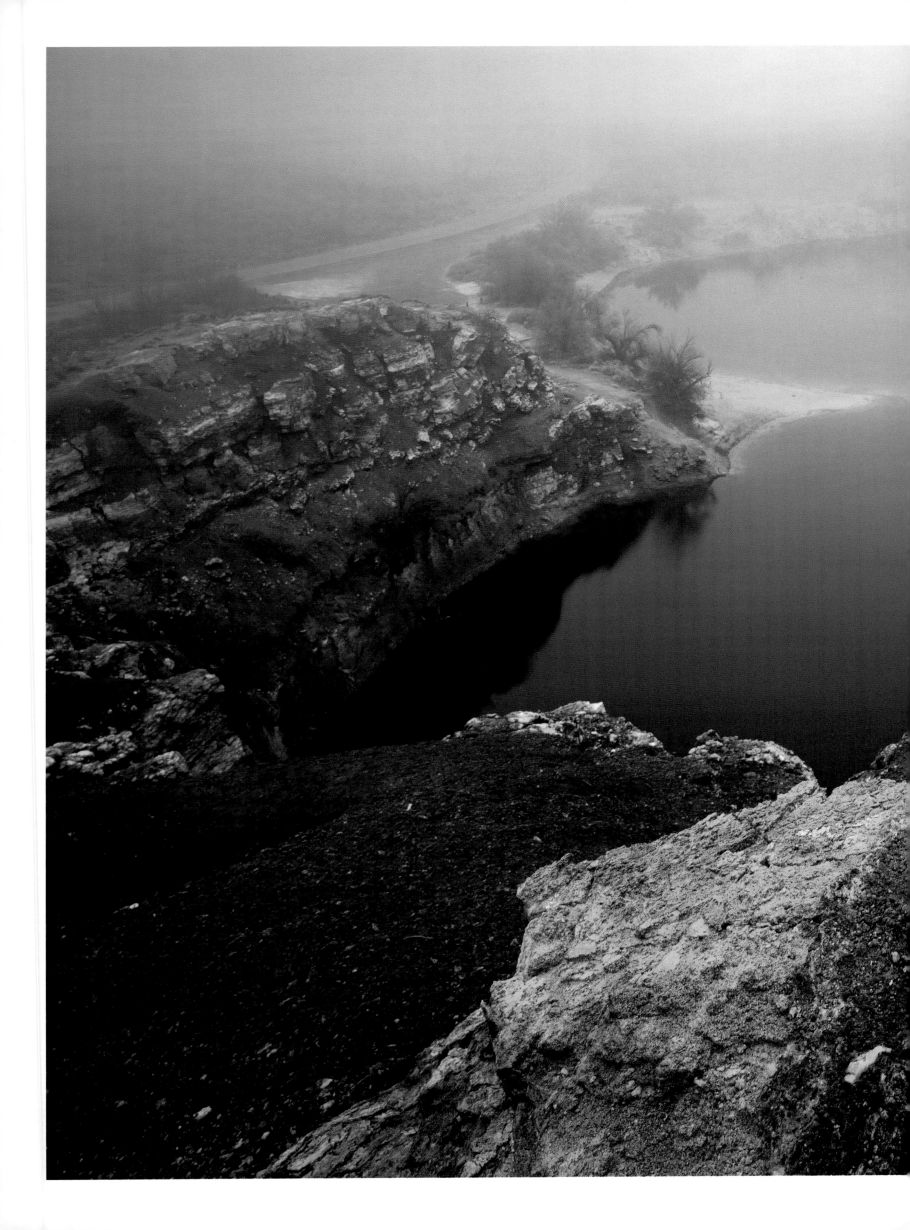

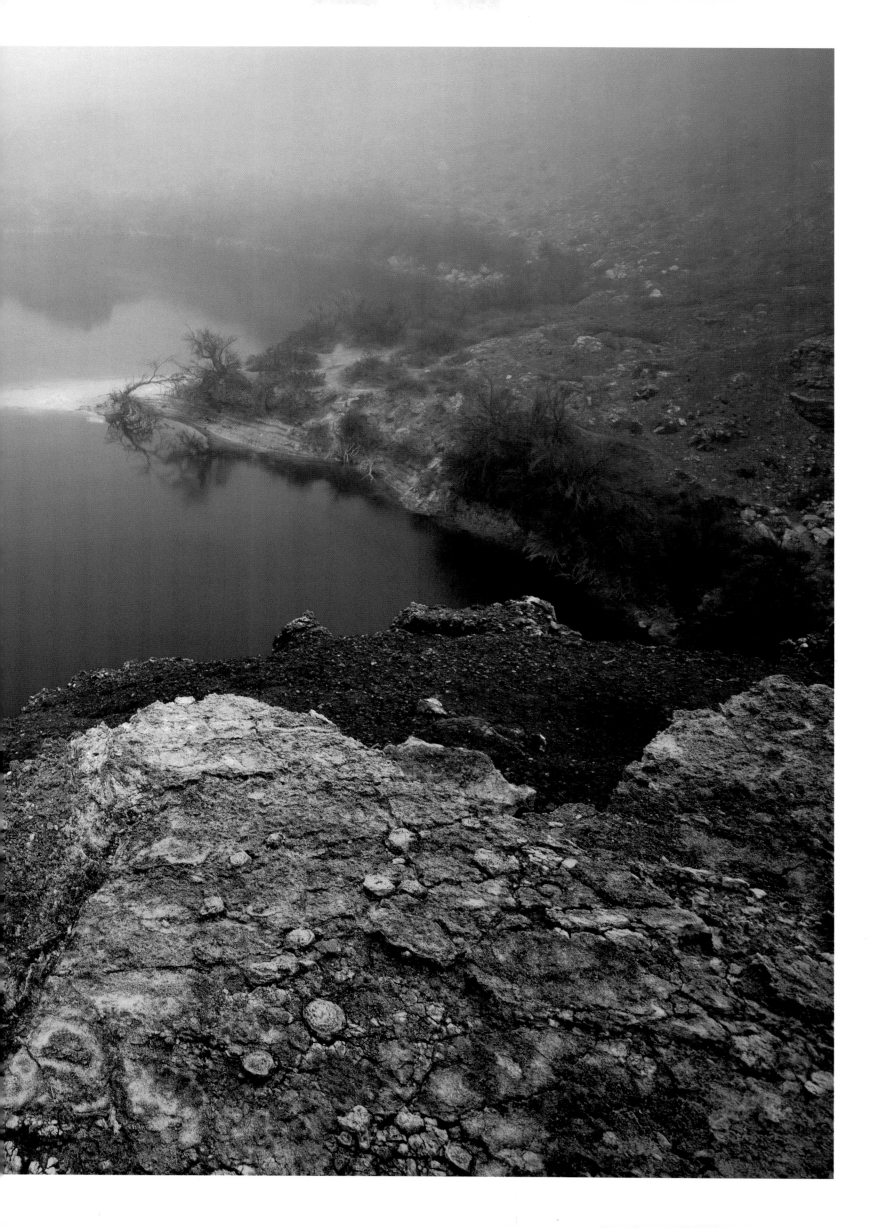

A yucca plant waits for the approaching storm in White Sands National Park. Dunes in the park can move up to thirty feet a year, and only fast-growing plants, such as the yucca, can avoid being buried while alive.

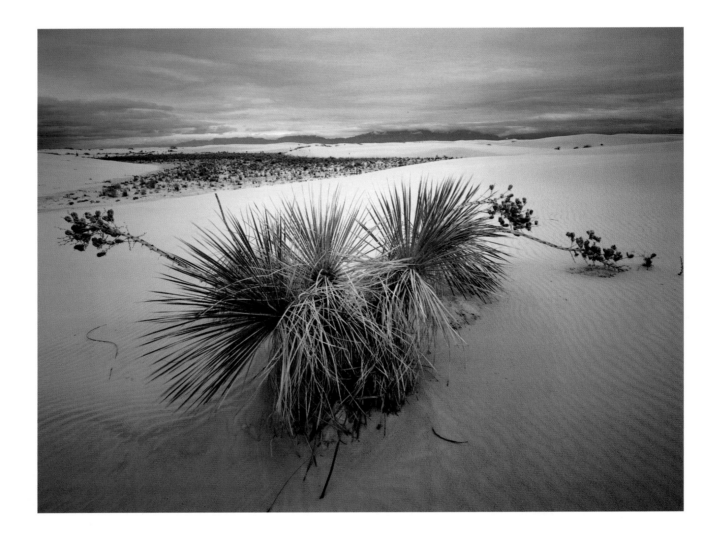

A soaptree yucca *(Yucca elata)* plant thrives on the gypsum dunes at White Sands. The gypsum was deposited in a shallow sea that covered the area 250 million years ago. Today the sands are blown off a nearby playa—the remnant of a large Pleistocene lake—and into the dunes, which cover 275 square miles and form the largest pure gypsum field in the world.

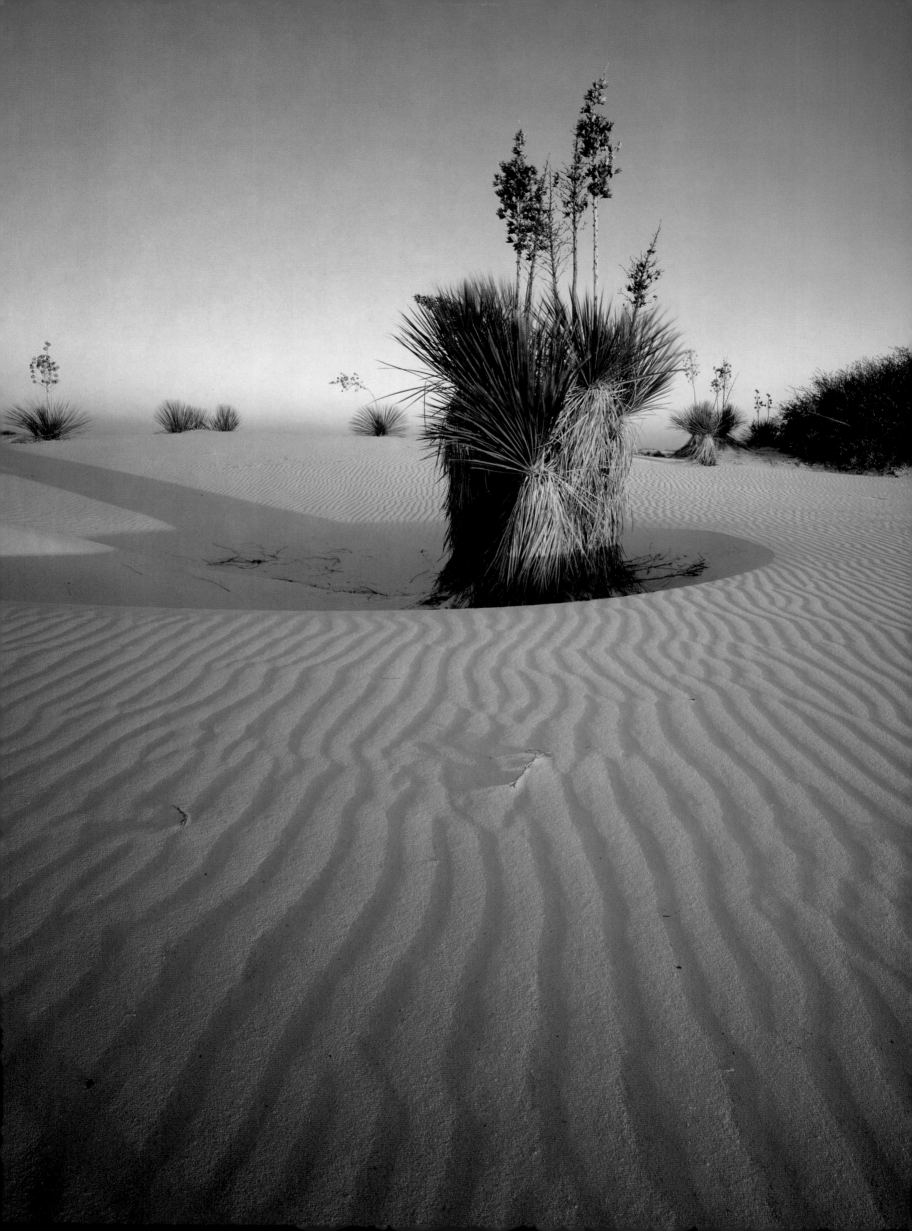

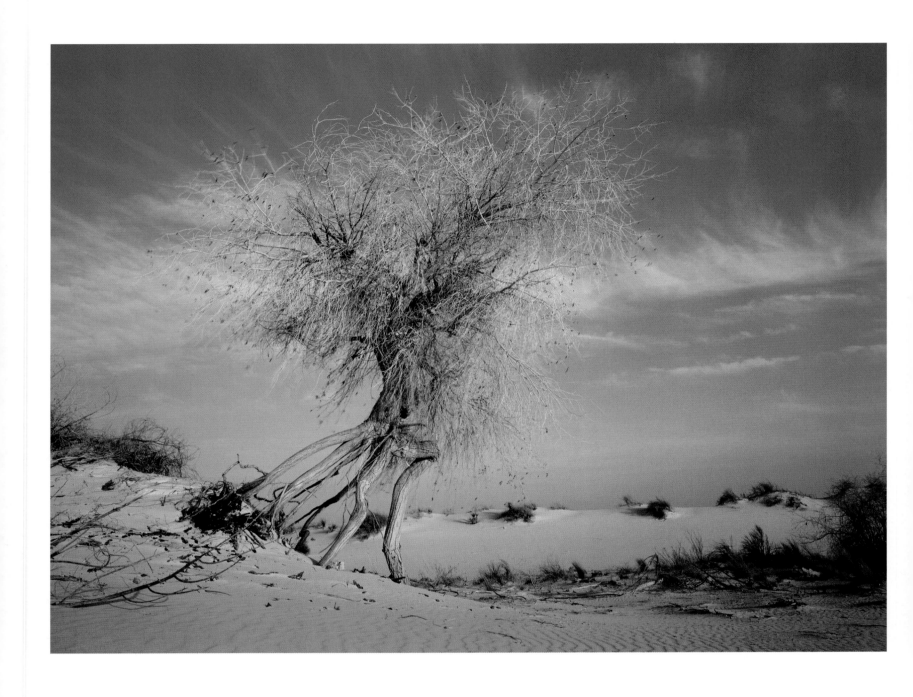

The roots of this doomed cottonwood rise nine feet above the gypsum dunes.

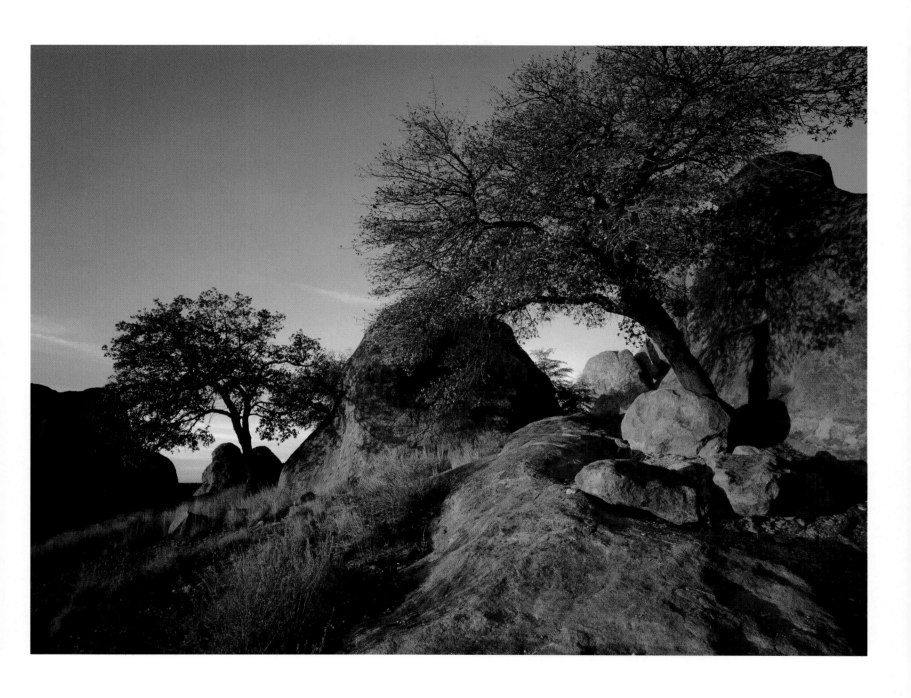

Although the City of Rocks State Park hosts yuccas, barrel and hedgehog cacti, and ocotillo, the gray and Emory oaks growing among the rocks can reach fifty feet in height.

Poppies bloom (overleaf) in the 7,400-foot-high Florida Mountains of southwestern New Mexico.

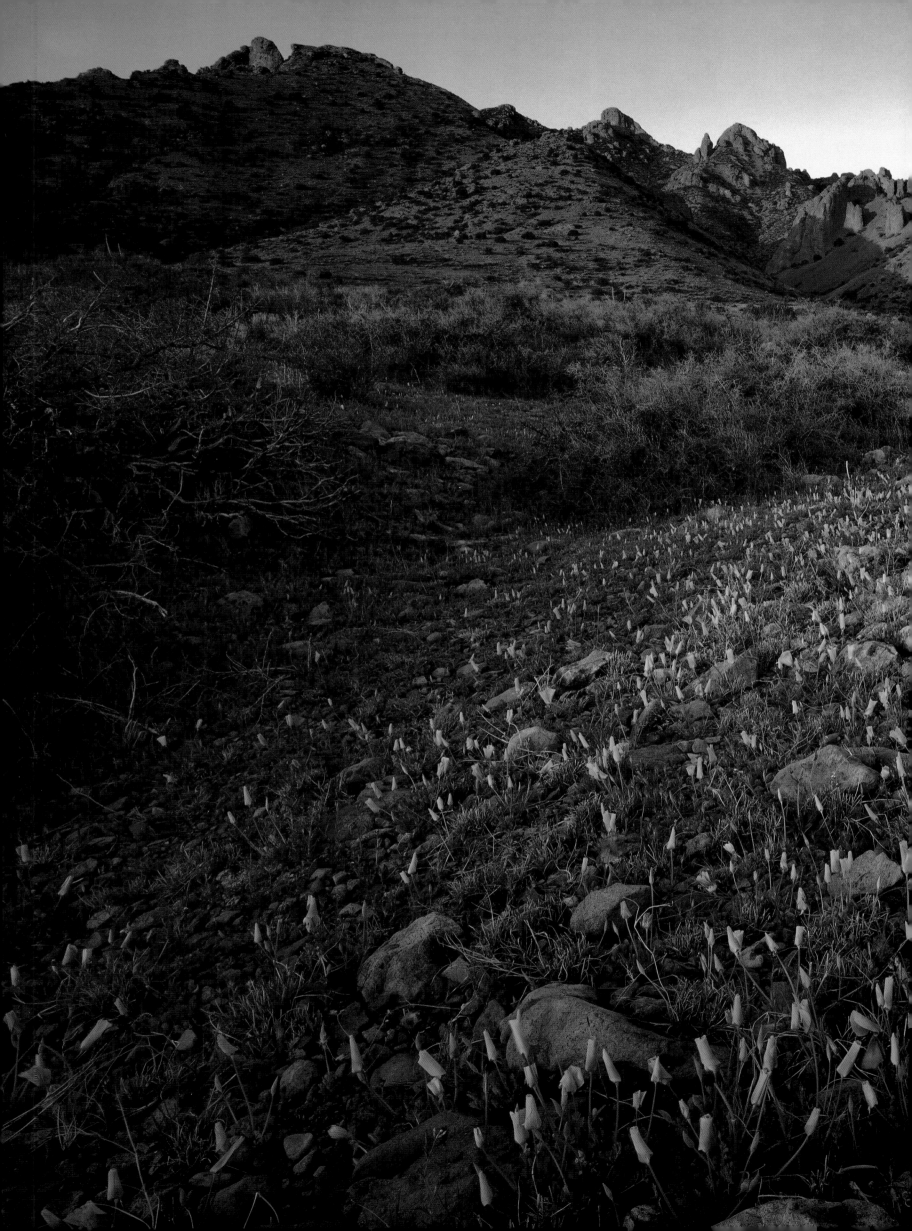

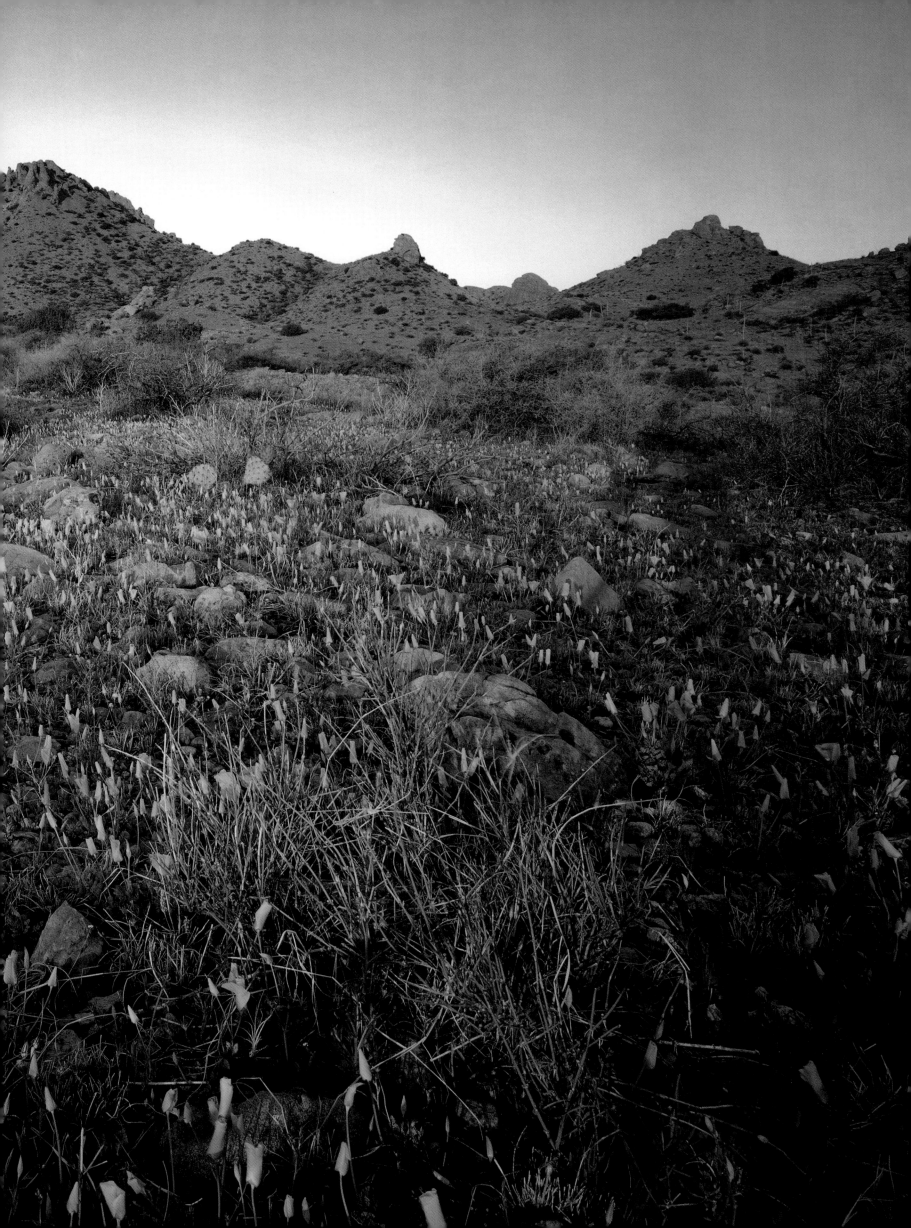

The volcanic tuff formations in New Mexico's City of Rocks are found in only six other locations in the world, and are a magnet for climbers and scramblers.

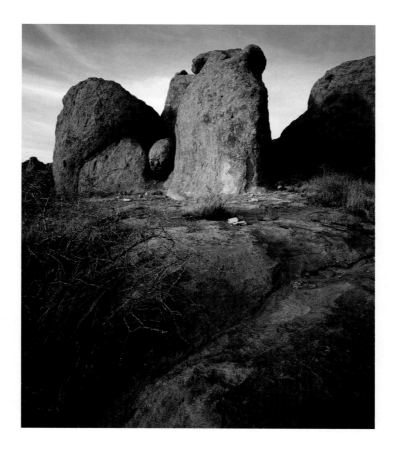

Claret cup cactus flowers bloom underneath ocotillo on the hillsides of the Guadalupe Mountains in Guadalupe Mountains National Park, Texas.

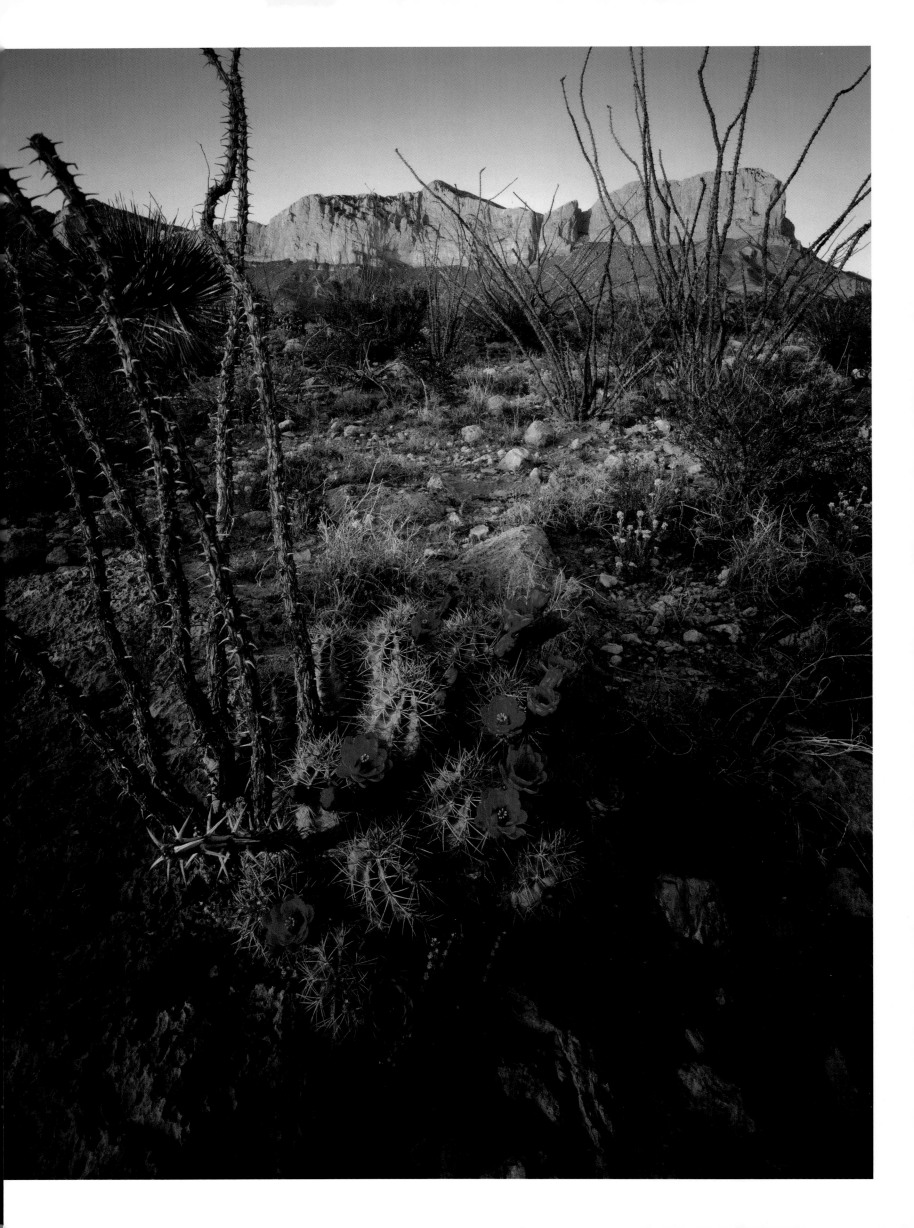

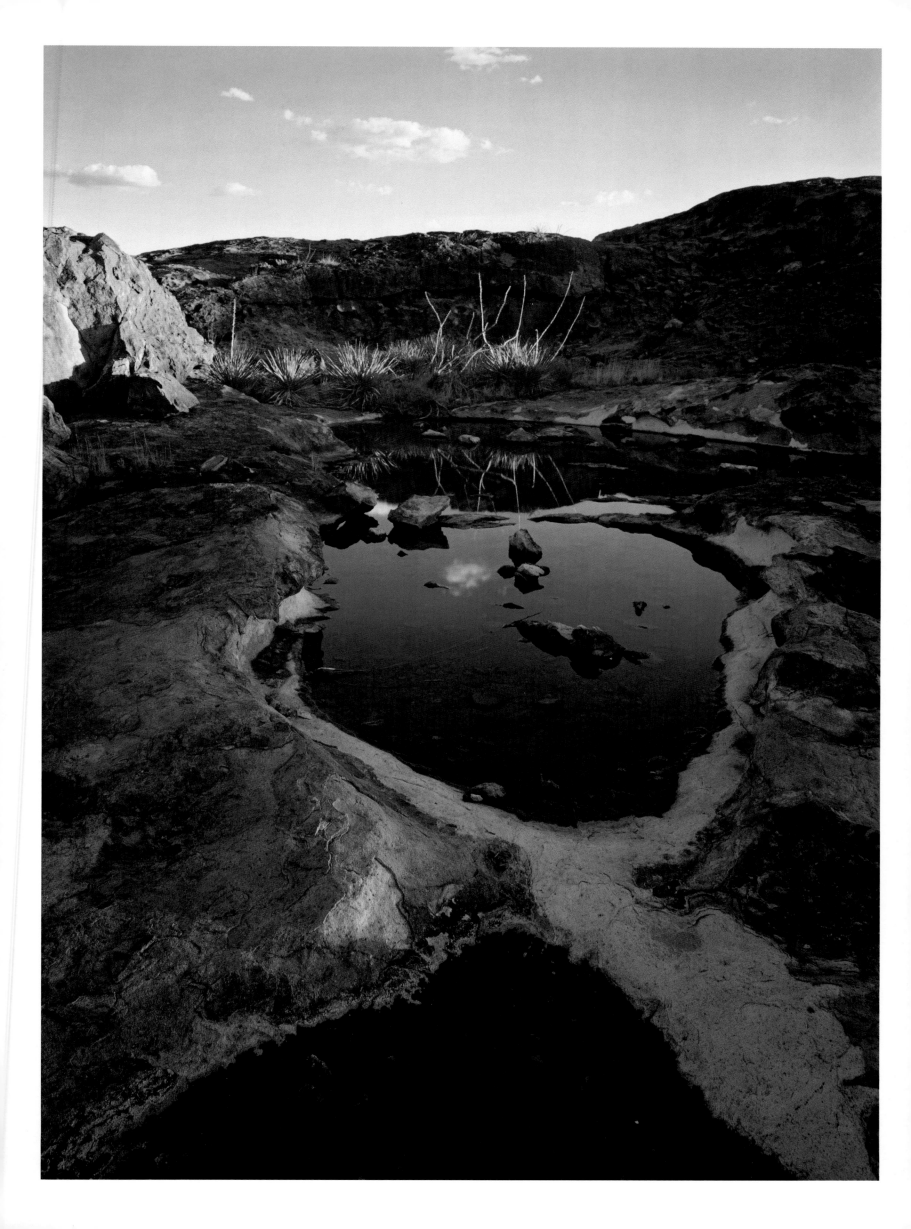

Oval-shaped rocks of petrified mud cover the Chihuahuan desert floor in Big Bend National Park, Texas.

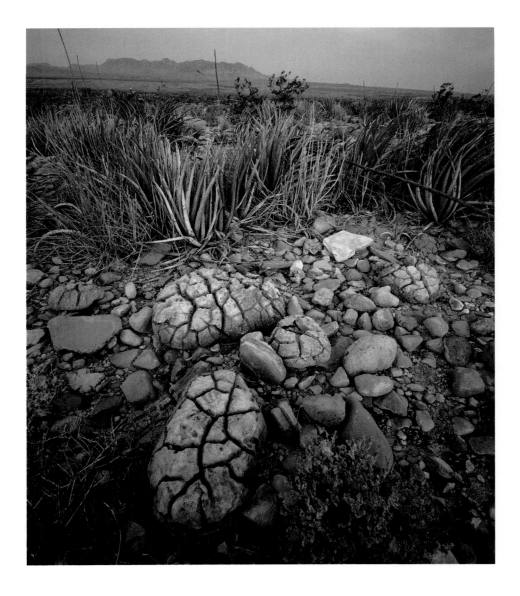

"Hueco" means "hollow" in Spanish, and Hueco Tanks State Historical Park (left) in the granite hills, thirty miles northeast of El Paso, Texas, has so many of them that during the 1860s they held a year's supply of rainwater for local residents. When the huecos fill, several species of freshwater shrimp hatch, a food source for gray foxes, bobcats, prairie falcons, eagles, and lizards.

Cover, Santa Elena Canyon—4x5 view camera, Fuji Velvia, 50 ASA, 65mm Nikon lens, 4 seconds at f45. 2 stop neutral density filter.

Pages 1 and 7, Bruneau Sand Dunes River—4x5 view camera, Fuji Velvia, 50 ASA, 65mm Nikon lens, 4 seconds at f45.5.

Pages 2–3, Bonneville Salt—4x5 view camera, Fuji Velvia, 50 ASA, 65mm Nikon lens, 15 seconds at 32.5. 2 stop neutral density filter.

Page 5, Snake River Canyon—4x5 view camera, Fuji Velvia, 50 ASA, 65mm Nikon lens, 8 seconds at f45.

Page 6, San Juan River—4x5 view camera, Fuji Velvia, 50 ASA, 65 mm Nikon lens, 4 seconds at f32.5.

Pages 8–9, Grand Canyon—4x5 view camera, Fuji Velvia, 50 ASA, 65mm Nikon lens, 15 seconds at f32.5. 2 Stop neutral density filter.

Page 10, Pyramid Lake—4x5 view camera, Fuji Velvia, 50 ASA, 65mm Nikon lens, 15 seconds at f 45. 2 stop neutral density filter.

Page 13, Willow Tanks—4x5 view camera, Fuji Velvia, 50 ASA, 65mm Nikon lens, 4 seconds at f32.5. 2 stop neutral density filter.

Page 15, Alvord Desert—4x5 view camera, Fuji Velvia, 50 ASA, 90mm Nikon lens, 1 seconds at f64.

Page 16, Oljeto Wash—4x5 view camera, Fuji Velvia, 50 ASA, 65mm Nikon lens, 1 seconds at f45.

Page 17, Mono Lake—4x5 view camera, Fuji Velvia, 50 ASA, 210mm Nikon lens, 1/2 second at f64.

Pages 18–19 Lake Powell—4x5 view camera, Fuji Velvia, 50 ASA, 65mm Nikon lens, 1/4 second at f32.5. 2 stop neutral density filter.

Page 21, Little Colorado—4x5 view camera, Fuji Velvia, 50 ASA, 65mm Nikon lens, 1/8 second at f45.

Page 22, Stone Creek—4x5 view camera, Fuji Velvia, 50 ASA, 65mm Nikon lens, 2 second at f45. 2 stop neutral density filter.

Page 24, Lake Mead—4x5 view camera, Fuji Velvia, 50 ASA, 65mm Nikon lens, 4 seconds at f32.5. 2 stop neutral density filter.

Page 27, Rio Grande—4x5 view camera, Fuji Velvia, 50 ASA, 65mm Nikon lens, 8 second at f45.

Page 28, Baja—4x5 view camera, Fuji Velvia, 50 ASA, 65mm Nikon lens, 15 seconds at f45. 2 stop neutral density filter.

Pages 30–31, Stillwater Marsh—4x5 view camera, Fuji Velvia, 50 ASA, 65mm Nikon lens, 8 seconds at f32.5. 2 stop neutral density filter.

Page 33, Mono Lake—4x5 view camera, Fuji Velvia, 50 ASA, 65mm Nikon lens, 8 seconds at f45. 1 stop neutral density filter.

Page 34, Montana Plains—4x5 view camera, Fuji Velvia, 50 ASA, 65mm Nikon lens, 1/15 second at f32.5.

Page 35, City of Rocks—4x5 view camera, Fuji Velvia, 50 ASA, 65mm Nikon lens, 8 seconds at 45.5. 2 stop neutral density filter.

Page 36, Hells Canyon—4x5 view camera, Fuji Velvia, 50 ASA, 90mm Nikon lens, 4 seconds at f45. 2 stop neutral density filter.

Page 37, Birds of Prey Area—4x5 view camera, Fuji Velvia, 50 ASA, 65mm Nikon lens, 15 seconds at 45. 2 stop neutral density filter.

Page 38, Crater of the Moon—4x5 view camera, Fuji Velvia, 50 ASA, 90mm Nikon lens, 1/2 second at f64.

Page 39, Bruneau Dunes—4x5 view camera, Fuji Velvia, 50 ASA, 65mm Nikon lens, 4 seconds at f32.5. 1 stop neutral density filter.

Page 40, John Day Fossil Beds—4x5 view camera, Fuji Velvia, 50 ASA, 65mm Nikon lens, 1 second at f32. 2 stop neutral density filter.

Page 41, Painted Hills—4x5 view camera, Fuji Velvia, 50 ASA, 90mm Nikon lens, 2 seconds at f45. 2 stop neutral density filter.

Pages 42–43, Leslie Gulch—4x5 view camera, Fuji Velvia, 50 ASA, 90mm Nikon lens, 1/4 second at f32. 3 stop neutral density filter.

Page 44, Owyhee Desert—4x5 view camera, Fuji Velvia, 50 ASA, 65mm Nikon lens, 1/4 seconds at f45.

Page 45, Owyhee Canyonlands—4x5 view camera, Fuji Velvia, 50 ASA, 90mm Nikon lens, 8 seconds at f32.5.

Pages 46–47, Snake River—4x5 view camera, Fuji Velvia, 50 ASA, 65mm Nikon lens, 2 seconds at f45. 2 stop neutral density filter.

Page 48, Camas Prairie—4x5 view camera, Fuji Velvia, 50 ASA, 210mm Nikon lens, 1/4 seconds at f45.5.

Page 49, Ice crystals—4x5 view camera, Fuji Velvia, 50 ASA, 90mm Nikon lens, 1 seconds at f32.5.

Page 50, Balsamroot—4x5 view camera, Fuji Velvia, 50 ASA, 65mm Nikon lens, 4 seconds at f32.5.

Page 51, TOP, Purple Camas—4x5 view camera, Fuji Velvia, 50 ASA, 65mm Nikon lens, 1/4 second at f32.5.

Page 51, BOTTOM, Steens Mountain—4x5 view camera, Fuji Velvia, 50 ASA, 90mm Nikon lens, 1/2 seconds at f45.5.

Pages 52–53, The Racetrack—4x5 view camera, Fuji Velvia, 50 ASA, 65mm Nikon lens, 1/15 seconds at f32.5.

Page 54, Granite crags—4x5 view camera, Fuji Velvia, 50 ASA, 65mm Nikon lens, 1/4 seconds at f32.

Page 55, Joshua Tree—4x5 view camera, Fuji Velvia, 50 ASA, 65mm Nikon lens, 2 seconds at f32. 3 stop neutral density filter.

Pages 56–57, Antelope Valley—4x5 view camera, Fuji Velvia, 50 ASA, 65mm Nikon lens, 8 seconds at f32.5. 2 stop neutral density filter.

Page 58, Devils Golf Course—4x5 view camera, Fuji Velvia, 50 ASA, 65mm Nikon lens, 4 seconds at f45. 2 stop neutral density filter.

Page 59, Death Valley—4x5 view camera, Fuji Velvia, 50 ASA, 65mm Nikon lens, 15 seconds at f32.5. 2 stop neutral density filter.

Page 60, Death Valley—4x5 view camera, Fuji Velvia, 50 ASA, 65mm Nikon lens, 8 seconds at f32.5. 2 stop neutral density filter.

Page 61, Desert Primrose—4x5 view camera, Fuji Velvia, 50 ASA, 65mm Nikon lens, 2 seconds at f45. 1 stop neutral density filter.

Page 62, Stillwater Marsh—4x5 view camera, Fuji Velvia, 50 ASA, 90mm Nikon lens, 1 seconds at f32.5.

Page 63, Stillwater Marsh—4x5 view camera, Fuji Velvia, 50 ASA, 90mm Nikon lens, 4 seconds at f45.

Page 64, Ice Box Canyon—4x5 view camera, Fuji Velvia, 50 ASA, 65mm Nikon lens, 1/4 second at 45. 2 stop neutral density filter.

Page 65, Cathedral Gorge—4x5 view camera, Fuji Velvia, 50 ASA, 65mm Nikon lens, 2 seconds at f32.

Pages 66–67, Calico Basin—4x5 view camera, Fuji Velvia, 50 ASA, 65mm Nikon lens, 15 seconds at f32.5. 2 stop neutral density filter.

Pages 68–69, Calf Creek Falls—4x5 view camera, Fuji Velvia, 50 ASA, 90mm Nikon lens, 8 seconds at f64.

Page 70, Upper Emerald Pool—4x5 view camera, Fuji Velvia, 50 ASA, 65mm Nikon lens, 2 seconds at f32.5.

Page 71, Calf Creek—4x5 view camera, Fuji Velvia, 50 ASA, 90mm Nikon lens, 1/2 second at f32.5

Page 72, Cathedral Valley—4x5 view camera, Fuji Velvia, 50 ASA, 65mm Nikon lens, 1 second at f45. 2 stop neutral density filter.

Page 73, Zion ice—4x5 view camera, Fuji Velvia, 50 ASA, 210mm Nikon lens, 1/2 second at f32.

Page 74, Capitol Reef—4x5 view camera, Fuji Velvia, 50 ASA, 65mm Nikon lens, 2 seconds at f32.5. 3 stop neutral density filter.

Page 75, Beninite Cliffs—4x5 view camera, Fuji Velvia, 50 ASA, 65mm Nikon lens, 1/2 seconds at f45. 2 stop neutral density filter.

Page 76, Freemont River—4x5 view camera, Fuji Velvia, 50 ASA, 65mm Nikon lens, 2 seconds at f32.5. 1 stop neutral density filter.

Page 77, Rabbitbrush—4x5 view camera, Fuji Velvia, 50 ASA, 210mm Nikon lens, 1 seconds at f64.

Pages 78–79, Skyline Arch—4x5 view camera, Fuji Velvia, 50 ASA, 65mm Nikon lens, 4 seconds at f32. 2 stop neutral density filter.

Page 80, Millard Canyon—4x5 view camera, Fuji Velvia, 50 ASA, 65mm Nikon lens, 1/8 seconds at f32.5.

Page 81, Slickhorn Gulch—4x5 view camera, Fuji Velvia, 50 ASA, 65mm Nikon lens, 4seconds at f32.5. 2 stop neutral density filter.

Page 82, Muley Point—4x5 view camera, Fuji Velvia, 50 ASA, 90mm Nikon lens, 30 seconds at f22.

Page 83, Oljeto Wash—4x5 view camera, Fuji Velvia, 50 ASA, 90mm Nikon lens, 2 seconds at f32.5.

Page 84, Rattlesnake Creek—4x5 view camera, Fuji Velvia, 50 ASA, 65mm Nikon lens, 8 seconds at 45.

Page 85, Green River—4x5 view camera, Fuji Velvia, 50 ASA, 65mm Nikon lens, 2 seconds at f32.5. 3 stop neutral density filter.

Page 86, Mesa Arch—4x5 view camera, Fuji Velvia, 50 ASA, 65mm Nikon lens, 4 seconds at 22. 2 stop neutral density filter.

Page 87, Hite Marina—4x5 view camera, Fuji Velvia, 50 ASA, 65mm Nikon lens, 15 seconds at f45. 2 stop neutral density filter.

Pages 88–89, Spider Mesa—4x5 view camera, Fuji Velvia, 50 ASA, 65mm Nikon lens, 4 seconds at f32. 2 stop neutral density filter.

Page 90, Grand Canyon—4x5 view camera, Fuji Velvia, 50 ASA, 65mm Nikon lens, 1/4 second at f32. 2 stop neutral density filter.

Page 91, TOP, Travertine formation—4x5 view camera, Fuji Velvia, 50 ASA, 905mm Nikon lens, 2 seconds at f32.5.

Page 91, BOTTOM, Pumpkin Springs—4x5 view camera, Fuji Velvia, 50 ASA, 65mm Nikon lens, 4 seconds at f45. 2 stop neutral density filter.

Pages 92–93, Organ Pipe Monument—4x5 view camera, Fuji Velvia, 50 ASA, 65mm Nikon lens, 2 seconds at f32.5. 2 stop neutral density filter.

Page 94, Vizcaino Desert—4x5 view camera, Fuji Velvia, 50 ASA, 65mm Nikon lens, 15 seconds at f32.5.

Page 95, Boojum trees—4x5 view camera, Fuji Velvia, 50 ASA, 65mm Nikon lens, 1 second at f45.

Page 96, Organ Pipe rainbow—4x5 view camera, Fuji Velvia, 50 ASA, 210mm Nikon lens, 1/4 second at f32.5.

Page 97, Catavina—4x5 view camera, Fuji Velvia, 50 ASA, 65mm Nikon lens, 15 seconds at f32.5. 1 stop neutral density filter.

Pages 98–99, Sea of Cortez—4x5 view camera, Fuji Velvia, 50 ASA, 65mm Nikon lens, 1/4 second at f45.

Page 100, Cholla cactus—4x5 view camera, Fuji Velvia, 50 ASA, 65mm Nikon lens, 15 seconds at f32.5. 2 stop neutral density filter.

Page 101, Baja Mexico—4x5 view camera, Fuji Velvia, 50 ASA, 65mm Nikon lens, 8 seconds at f32.5. 2 stop neutral density filter.

Page 102, Cactus detail—4x5 view camera, Fuji Velvia, 50 ASA, 90mm Nikon lens, 1/4 second at f32.

Page 103, Organ Pipe cactus—4x5 view camera, Fuji Velvia, 50 ASA, 90mm Nikon lens, 1 second at f45.

Page 104, Anza-Borrego—4x5 view camera, Fuji Velvia, 50 ASA, 65mm Nikon lens, 2 seconds at f32.5.

Page 105, Sand Verbena—4x5 view camera, Fuji Velvia, 50 ASA, 90mm Nikon lens, 1/4 seconds at 45.

Page 106, Aravaipa Creek—4x5 view camera, Fuji Velvia, 50 ASA, 65mm Nikon lens, 1 second at f32.5.

Page 107, Cibeque Creek—4x5 view camera, Fuji Velvia, 50 ASA, 90mm Nikon lens, 2 seconds at f45.

Pages 108–9, Dog Canyon—4x5 view camera, Fuji Velvia, 50 ASA, 65mm Nikon lens, 2 seconds at f32.5.

Page 110, Oliver Lee State Park—4x5 view camera, Fuji Velvia, 50 ASA, 65mm Nikon lens, 8 seconds at f45. 2 stop neutral density filter.

Page 111, Gray oaks—4x5 view camera, Fuji Velvia, 50 ASA, 65mm Nikon lens, 1 second at f32.5. 2 stop neutral density filter.

Page 112, De-Na-Zin—4x5 view camera, Fuji Velvia, 50 ASA, 65mm Nikon lens, 2 seconds at f45.

Page 113, Bisti Badlands—4x5 view camera, Fuji Velvia, 50 ASA, 65mm Nikon lens, 15 seconds at f32.5. 2 stop neutral density filter.

Pages 114–15, Bottomless Lake—4x5 view camera, Fuji Velvia, 50 ASA, 90mm Nikon lens, 8 seconds at f32.5.

Page 116, White Sands—4x5 view camera, Fuji Velvia, 50 ASA, 65mm Nikon lens, 2 seconds at f45. 2 stop neutral density filter.

Page 117, White Sands—4x5 view camera, Fuji Velvia, 50 ASA, 90mm Nikon lens, 1 seconds at f32.5.

Page 118, Walking Tree—4x5 view camera, Fuji Velvia, 50 ASA, 65mm Nikon lens, 1/8 seconds at f32.5.

Page 119, City of Rocks—4x5 view camera, Fuji Velvia, 50 ASA, 90mm Nikon lens, 1 second at f45. 2 stop neutral density filter.

Pages 120–21, Florida Mountains—4x5 view camera, Fuji Velvia, 50 ASA, 65mm Nikon lens, 8 seconds at f32.5. 2 stop neutral density filter.

Page 122, Volcanic tuff—4x5 view camera, Fuji Velvia, 50 ASA, 90mm Nikon lens, 1 seconds at f32.5.

Page 123, Guadalupe National Park—4x5 view camera, Fuji Velvia, 50 ASA, 65mm Nikon lens, 4 seconds at f32.5. 2 stop neutral density filter.

Page 124, Hueco Tanks—4x5 view camera, Fuji Velvia, 50 ASA, 90mm Nikon lens, 1/2 seconds at f32.5. 2 stop neutral density filter.

Page 125, Big Bend National Park—4x5 view camera, Fuji Velvia, 50 ASA, 65mm Nikon lens, 15seconds at f32.

Page 128, Eroding ash—4x5 view camera, Fuji Velvia, 50 ASA, 65mm Nikon lens, 1/4 second at f45. 2 stop neutral density filter.

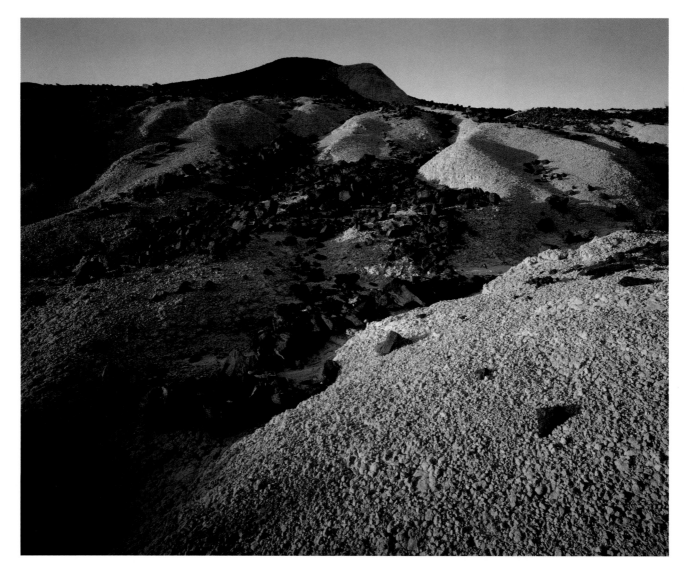

Volcanic lava rocks sit atop an exposed and slowly eroding ash layer in Big Bend National Park.

Further Reading

Sources used in writing this essay that readers might be interested in pursuing were as follows.

Philip Ball, *Life's Matrix: A Biography of Water* (New York: Farrar, Straus and Giroux, 2000) is currently the definitive lay text available on the nature of water.

Eliot Porter: *The Color of Wildness* (Denville, New Jersey: Aperture Foundation, 2001) demonstrates how he shaped contemporary nature photography.

And for a powerful evocation in prose of the presence of water in the desert Southwest, no finer job is done than by Craig Childs in *The Secret Knowledge of Water* (Boston: Little, Brown & Co., 2000).

Figures for water consumption in America can be found in Marc Reisner's *Cadillac Desert: The American West and Its Disappearing Waters* (New York: Penguin, 1993).

Acknowledgments

The author wishes to thank the John Simon Guggenheim Memorial Foundation for fellowship support during the writing of this essay, as well as a residency in Marfa, Texas, hosted by the Lannan Foundation.